DOG

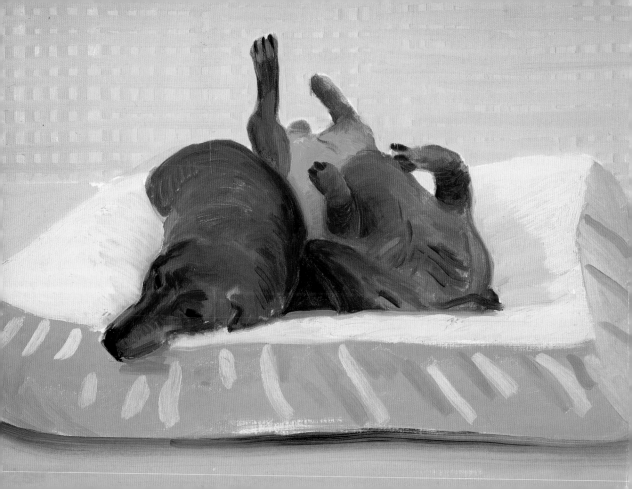

DOG

A DOG'S LIFE IN ART AND LITERATURE

IAIN ZACZEK

WATSON-GUPTILL
PUBLICATIONS
New York

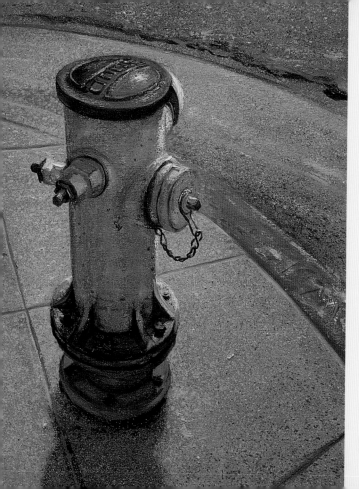

First published in the United States in 2000
by Watson-Guptill Publications
a division of BPI Communications, Inc.
1515 Broadway, New York, NY 10036

This book was conceived, designed and produced by
THE IVY PRESS LIMITED
The Old Candlemakers, West Street
Lewes, East Sussex, BN7 2NZ

Art Director: PETER BRIDGEWATER
Editorial Director: SOPHIE COLLINS
Designer: CLARE BARBER
DTP Designer: CHRIS LANAWAY
Senior Project Editor: ROWAN DAVIES
Editor: MANDY GREENFIELD
Picture research: LIZ EDDISON

Library of Congress Catalog
Card Number: 99-66082

ISBN 0-8230-1298-0

Reproduction and printing in China by
Hong Kong Graphic and Printing Ltd

First printing, 2000

1 2 3 4 5 6 7 8 9/07 06 05 04 03 02 01 00

Page 2 illustration: David Hockney, *Dog Painting 25* (1995)
Pages 3 & 5 illustrations: Gaylen Hansen,
Two Dogs, One Green (1985)
Page 4 illustration: Anthony Holdsworth,
Green Hydrant (1993)

contents

introduction

Since the moment when humanity first began to make use of the dog, artists have been eager to produce images of this four-legged friend. In Spain and North Africa there are cave paintings that depict primitive, doglike creatures hunting alongside prehistoric man. Hunting remained the primary function of the dog for many centuries and, thus, the chief source of artistic inspiration. The Assyrians and Hittites, in particular, produced marvelous sculpted reliefs of lion hunts, in which dogs were featured prominently.

Gradually the repertoire expanded to include religious and mythological themes. Egyptian hieroglyphs often depicted Anubis, the jackal-headed god of the dead, while classical artists portrayed such figures as Diana the Huntress with her hounds, and Cerberus, the triple-headed guardian of Hades.

EGYPTIAN
FIGURE OF A JACKAL

PIERO
DI COSIMO
CEPHALUS
AND PROCRIS

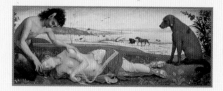

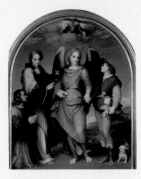

ANDREA
DEL SARTO
THE ARCHANGEL
RAPHAEL
WITH TOBIAS,
ST. LEONARD,
AND A DONOR

With the onset of the Middle Ages, canine themes became even more diverse. Dogs were depicted in a variety of Christian subjects, such as the story of Tobias and the Angel (*see page 328*), or the Last Supper, at which Judas Iscariot was traditionally shown with a dog sitting at his feet. The same period also witnessed the appearance of artworks that focused specifically on animals.

These included bestiaries—illuminated manuscripts portraying creatures allegorically, in order to put across a moralizing message—as well as specialized treatises on hunting. The most famous of these was the *Livre de la Chasse* (*Book of the Hunt*, c. 1405) by Gaston III, Count of Foix and Béarn (1331–91), which featured early illustrations of canine diseases and scenes of hounds being used to track down criminals.

Medieval manuscripts also furnish us with fascinating evidence of the role that dogs played in everyday life. Most Books of

LUTTRELL
PSALTER
PERFORMING DOG

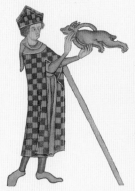

7

Hours (prayer books) contained a calendar, adorned with charming depictions of the changing seasons. In the *Très Riches Heures* (*Very Rich Hours*) produced for the Duc de Berry (1340–1416), for example, different breeds of dog can be seen eating off their

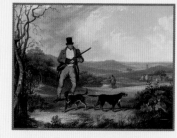

REINAGLE
THE AFTERNOON SHOOT

master's table (January), warming themselves by a peasant's fire (February), rounding up sheep (March), and taking part in a boar hunt (December).

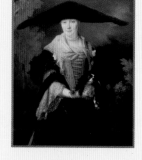

LARGILLIÈRE
THE PRETTY
STRASBOURG GIRL

From the Renaissance onward, dogs began to feature extensively in portraits. Rulers and aristocrats were normally shown with hunting dogs. This reinforced their status, since the possession of such animals implied that the sitter owned suitable estates, where hunting could take place. Ladies, by contrast, were portrayed with small lapdogs, reflecting their refinement and fidelity. In a few instances the dog appeared to mirror the personality of the subject, as in William Hogarth's striking *Self-Portrait with Dog*.

During the eighteenth century hunting scenes became, once again, the favorite pretext for depictions of dogs. By this time, however, there were artists who concentrated specifically on this field. As a result, many of the canine portraits display a remarkable degree of anatomical accuracy, shedding valuable light on the development of individual breeds. Set against this objective approach there was also a growing tendency to use dogs in scenes of heightened emotion. Pictures of thwarted lovers, tearful departures, and tragic bereavements were all endowed with an added sense of pathos when a doleful hound was added to the composition.

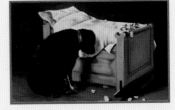

ARCHER
A DOG MOURNING
ITS LITTLE MASTER

With the flight from naturalism in the twentieth century, dogs have played a less important role in recent painting. Even so, their influence is still apparent in many popular art forms, such as cinema, animation, and advertising posters. Clearly, man's best friend can—and will continue to—provide a fertile source of inspiration for artists of every kind.

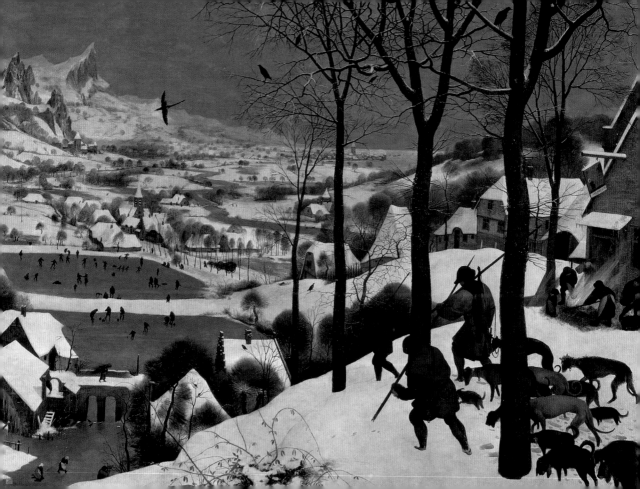

sporting dogs

PIETER BRUEGEL
HUNTERS IN THE SNOW

In a canine context, sporting is almost synonymous with hunting. For thousands of years this was the predominant function of the domestic dog; one that tapped into its most basic instincts.

From a very early stage a distinction was made between those dogs that hunt by scent and those that hunt by sight. The latter rely on speed alone to capture their prey. In the West, the most popular breeds are greyhounds and whippets, trained to course for hares. Elsewhere, Afghan hounds and salukis can also display devastating bursts of speed, when used to hunt larger types of game.

Dogs that hunt by scent fall into a number of different categories. Pointers and setters locate the prey and indicate its whereabouts to the huntsmen, but do not flush it out. Retrievers, as the name suggests, are best at fetching birds that have already

BEARD
A GREYHOUND IN
A HILLY LANDSCAPE

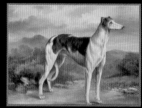

FRENCH
THE WOLF HUNT

been shot. Spaniels, on the other hand, are adept at flushing out game and then retrieving it. Both hounds and terriers are normally used in packs. The former are trained to pursue foxes single-mindedly, ignoring all other scents, while terriers (literally "earth dogs") are set upon animals that try to escape by going underground.

The desire to catch specific types of game led some huntsmen to experiment with new breeds. The Sealyham terrier, for example, was introduced in the mid-nineteenth century by Captain John Edwardes. His estates at Sealyham in Wales were infested with polecats, and this prompted him to breed a new strain of terrier, which would be small enough to work its way into burrows and lairs. The Parson Jack Russell terrier took its name from a nineteenth-century

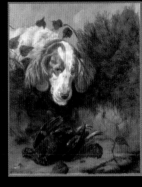

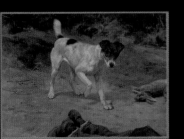

BARKER
A JACK RUSSELL
BY A RABBIT HOLE

GRAEME
"JUST SHOT"—SPANIEL
WITH A DEAD GROUSE

Devonshire clergyman who wanted to create a dog that would pursue foxes that had gone to ground.

Although hunting in its various forms has undoubtedly been the principal canine sport, dogs have also been used in a number of other leisure activities. Dog racing, although it is a comparatively recent development, has become increasingly popular. The idea originated in the US in the early years of the twentieth century and was imported into Europe in the 1920s. The pioneering figure was Owen Smith (d. 1927), an engineer from Illinois, who wanted to produce a spectacle that could offer the excitement of coursing without the bloodshed. The sport has attracted a snobbish reaction in some quarters, but it is a sobering thought that, while very few people will recognize the name of any Cruft's champion, many

members of the British public will have heard of "Mick the Miller," who won the Greyhound Derby in 1929 and 1930.

A very different type of race takes place in the frozen North. The All-Alaska Sweepstakes is a grueling sledge race, involving teams of huskies or malamutes. The event lasts for five days, during which the dogs cover a course of 420 miles/676 km. Needless to say, stamina rather than speed is the crucial factor.

In the past there have been other, far more unsavory dog sports. Bullbaiting and bearbaiting were both legal in Britain until as recently as 1835, while ratting went on for even longer. In 1825 a dog named Billy became something of a celebrity, after disposing of 100 rats at the Westminster Pit in just over five minutes. Dog-fighting has been illegal in France and Britain since the 1830s, but has proved far harder to suppress.

ALKEN
BULLBAITING

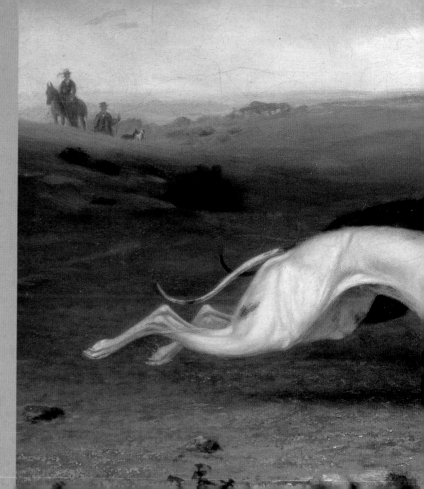

MARSHALL
HARE COURSING IN A LANDSCAPE
1870

Coursing is an ancient sport in Britain—there was even a reference to it in the Canute Laws of 1016. The Duke of Norfolk (1558–1603) drew up a set of rules for the pastime, and these regulations were still largely in force in 1858, when the National Coursing Club Committee (the sport's international governing body) was founded. The Waterloo Cup, the so-called "Derby" of the coursing world, was instituted in 1836.

JOHN MARSHALL, fl. 1840–96

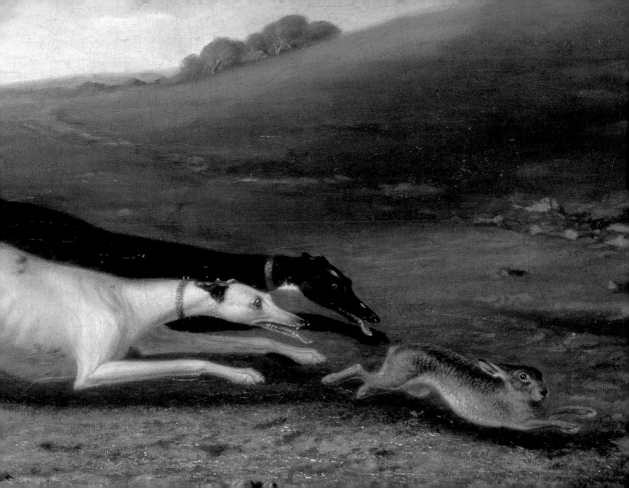

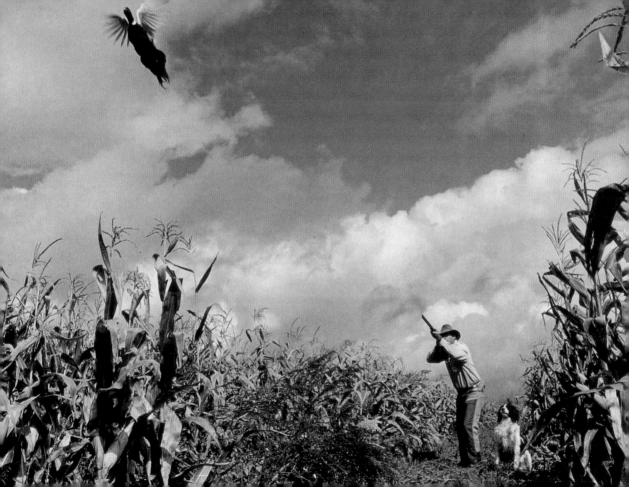

BAILEY

MAN AND DOG IN A CORNFIELD,
SHOOTING AT A BIRD
1990s

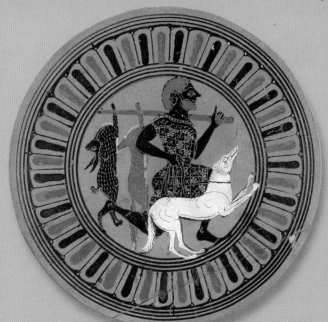

Training is crucial where gundogs are concerned. They have to be taught to wait patiently by their master's side until the bird is ready to be retrieved. The value of a dog is particularly evident in terrain such as this, where visibility on the ground is restricted. The animal's keen sense of smell will enable it to find the dead bird far more quickly than any huntsman could.

BRIAN BAILEY, 20th Century

GREEK

HUNTSMAN
RETURNING HOME
C. 500 BC

The greyhound is one of the oldest-known breeds of dog. The Ancient Egyptians and Greeks both used it extensively for hunting a variety of small animals, and recognizable depictions of it can be found on a huge number of their artifacts.

19

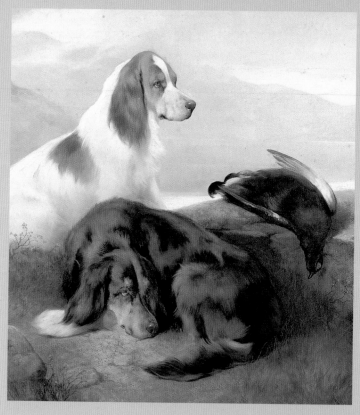

DOUGLAS
BY THE DAY'S BAG
19th Century

Douglas was a Scottish painter who trained at the Royal Academy Schools and worked in the same vein as Sir Edwin Landseer (1802–73). With their sleek, well-groomed coats and their doleful eyes, these creatures appear more like pampered pets than working dogs.

EDWIN J. DOUGLAS, 1848–1914

EMMS
HOUNDS WITH A HARE
c. 1890s

Emms came from an artistic family—his father, Henry William Emms, was also a painter. A native of the county of Norfolk, John moved to London in the 1860s, working for a time as a studio assistant to Frederic, Lord Leighton (1830–96). He swiftly found a ready market for his dog portraits, impressing patrons with his painterly approach and his obvious talent for capturing canine expressions.

JOHN EMMS, 1843–1912

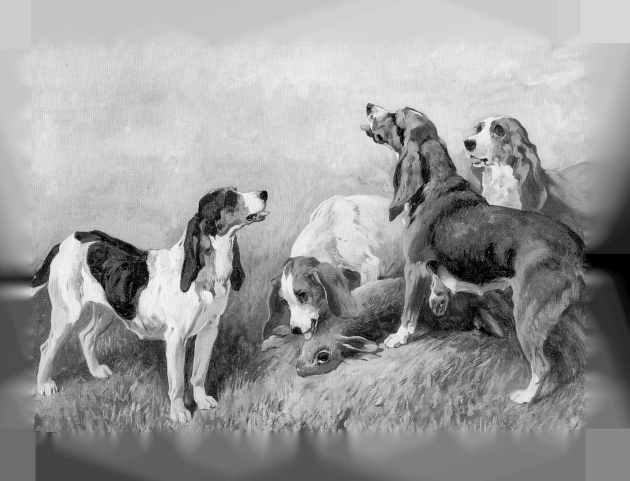

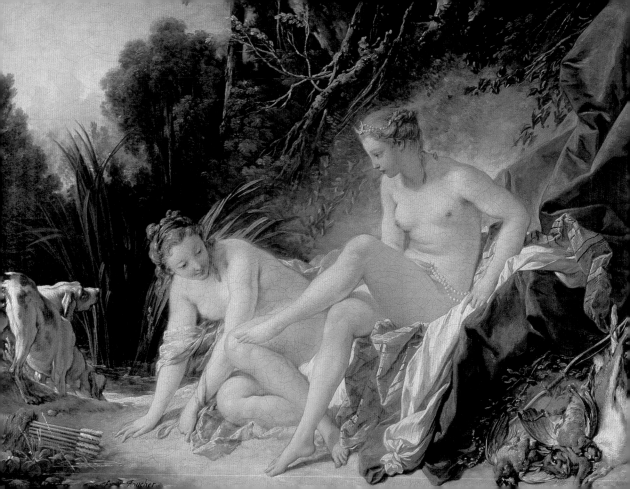

BOUCHER
DIANA AFTER BATHING ·
1742

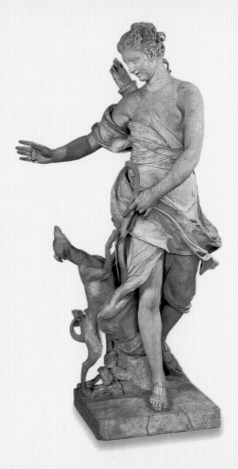

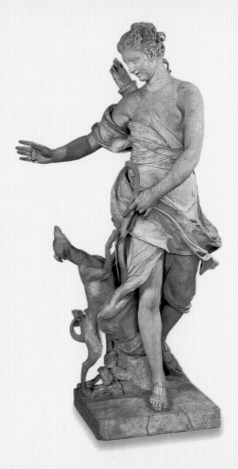 Boucher was a leading rococo painter, the favorite artist of Louis XV's mistress, Madame de Pompadour (1721–64). He liked portraying mythological goddesses, since this offered a pretext for painting sensuous nudes. Here, Diana can be identified both by the trappings of the hunt and by the crescent-shaped jewel on her brow (she was also the goddess of the moon).

FRANÇOIS BOUCHER, 1703–70

FRÉMIN
DIANA WITH A HOUND
18th Century

A playful hound leaps up at the goddess, as she reaches for her bow. The dogs of Greek legend were rather less friendly: mortals who intruded upon the goddess's activities were liable to be torn to pieces by her pack of hunting dogs.

RENÉ FRÉMIN, 1672–1744

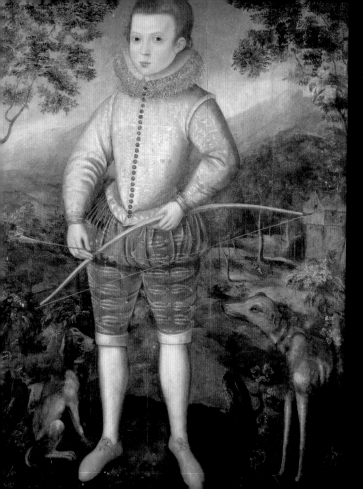

PEAKE
PORTRAIT OF A BOY
17th Century

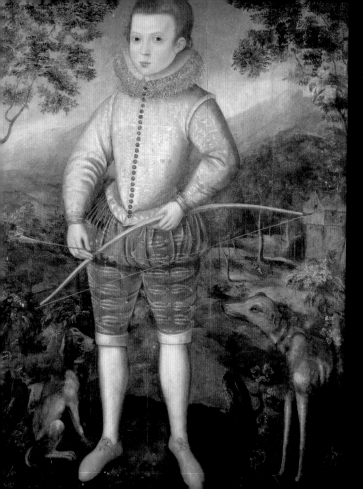 Dogs were often included in early portraits of children, but they were rarely regarded as pets. In aristocratic households, the primary use of dogs was for hunting and it is no accident that, in this picture, the boy is carrying weapons for the chase. The fact that his family owns hunting dogs underlines both its wealth and status.

ROBERT PEAKE, fl. 1580–1626

BEARD
A GREYHOUND IN A HILLY LANDSCAPE
19th Century

Beard is a little-known artist, who devoted the early part of his career to portraiture. Then, in 1846, he moved to New York and began painting animals. His dog pictures are very much in the English mold, usually consisting of a single figure in a detailed, landscape setting.

JAMES HENRY BEARD, 1814–93

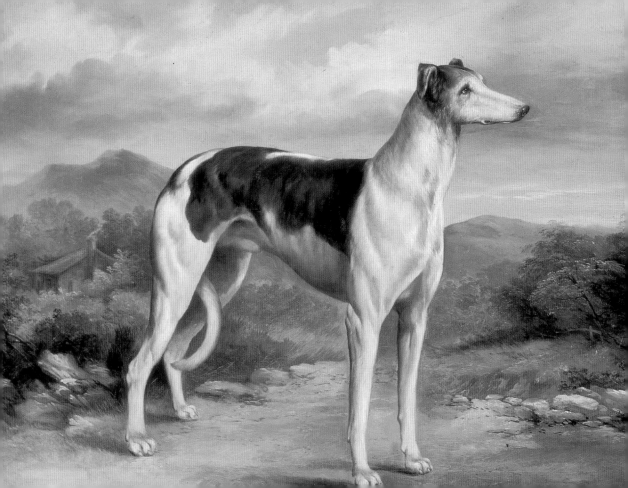

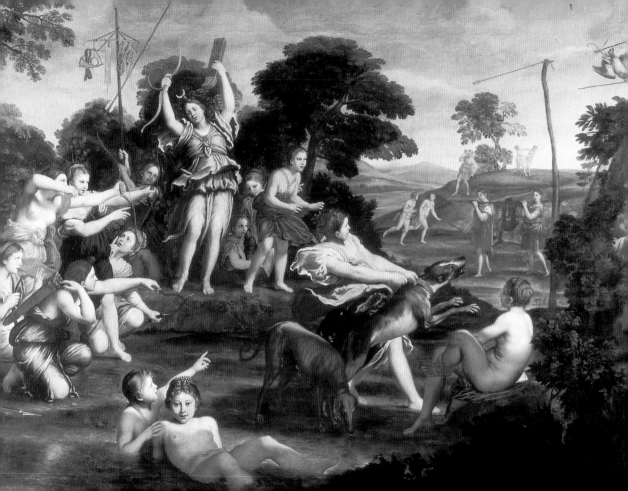

DOMENICHINO
DIANA'S HUNT
1617

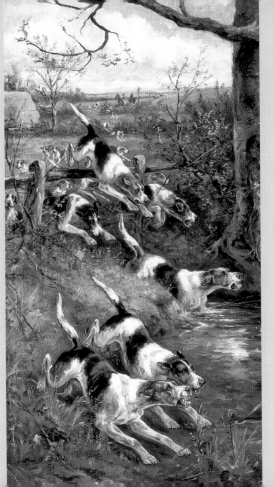

Diana was the virgin huntress, a traditional emblem of chastity. To spy upon her or her maidens usually spelled death for any interloper. Undeterred by this, two youths have been watching from the bushes on the far right. Now, however, they have been spotted. The dog nearest to them rears up, ready to attack, while Diana (identifiable by her crescent-moon headdress) calls her women to arms.

DOMENICHINO (properly DOMENICO ZAMPIERI), 1581–1641

DAVIS
FULL CRY
1891

The practice of hunting in packs unleashes the most primitive canine instincts. The hounds trail the fox from the ground-scent left by its feet, rather than its body-scent, and they communicate their findings by baying to their companions. They can only sniff a strong scent for short periods, so they take turns to lead or follow.

ARTHUR ALFRED DAVIS, fl. 1877–91

next pages ▶
LANDSEER
OTTER HOUNDS
c. 1843

This is related to a large and gruesome picture called *Otter Hunt*, commissioned by Lord Aberdeen (1784–1860). The hounds are gazing upward, greedily, because (in the full-size version) the huntsman has just speared the otter and is waving it aloft, prior to tossing its carcass to the pack.

SIR EDWIN LANDSEER, 1802–73

27

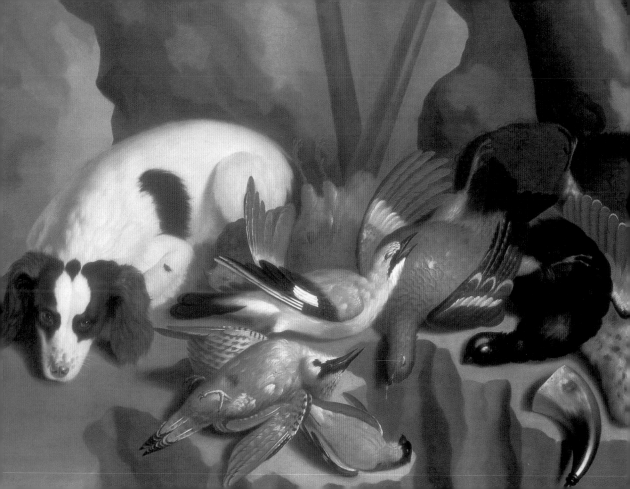

COSTER
DOG WATCHING OVER
DEAD GAME
17th Century

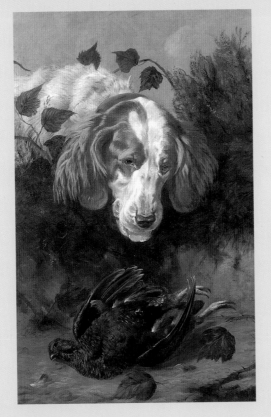

The depiction of dead game was a favorite theme for Dutch and Flemish artists, and it became a logical extension to include the dogs that had assisted in the kill. With remarkable skill, Coster shows the spaniel watching the birds intently, as if they were still alive.

JAN COSTER, 17th Century

" How falsely is the spaniel drawn!
Did man from him first learn to fawn?
A dog proficient in the trade!
He, the chief flatt'rer nature made!
Go, man, the ways of courts discern,
You'll find a spaniel still might learn.
How can the foxe's theft and plunder
Provoke his censure or his wonder? "

JOHN GAY, 1685–1732

GRAEME
"JUST SHOT"—SPANIEL
WITH A DEAD GROUSE
19th Century

Graeme's father was the artist R. H. Roe (1793–1880), and several other members of his family were also painters. So, in order to distinguish himself from them, he omitted his surname when exhibiting his pictures. Graeme specialized in portraying horses, hunting scenes, and sporting dogs.

COLIN GRAEME, 1858–1910

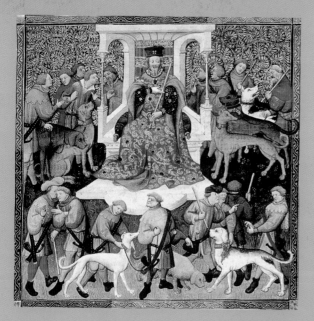

Among the moneyed classes of Georgian England, sporting dogs were not used exclusively for hunting. In this elegant scene they accompany their well-dressed masters as they enjoy a relaxed ride along the banks of a river.

JUDITH LEWIS, fl. 1775–6

FRENCH
HUNTING DOGS
AT COURT
c. 1405

In 1387–8 Gaston III, Count of Foix and Béarn (1331–91) wrote one of the seminal works on the art of hunting. His *Livre de la Chasse (Book of the Hunt)* contained detailed information on existing breeds of dogs, their ailments, and their maintenance. This sumptuous, illuminated version of the treatise was probably produced for John the Fearless, Duke of Burgundy (1371–1419) in a Parisian workshop.

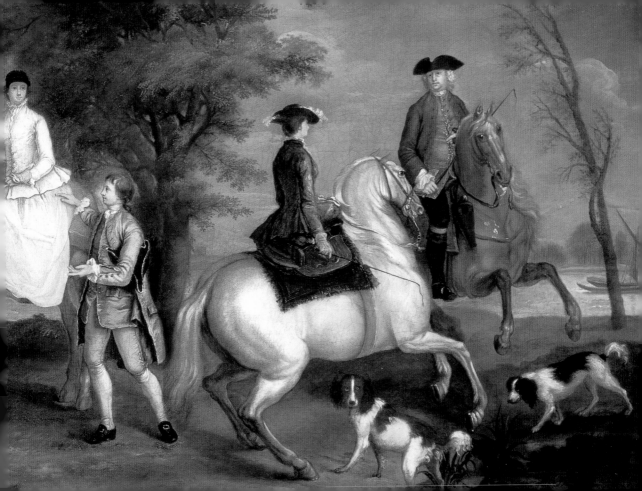

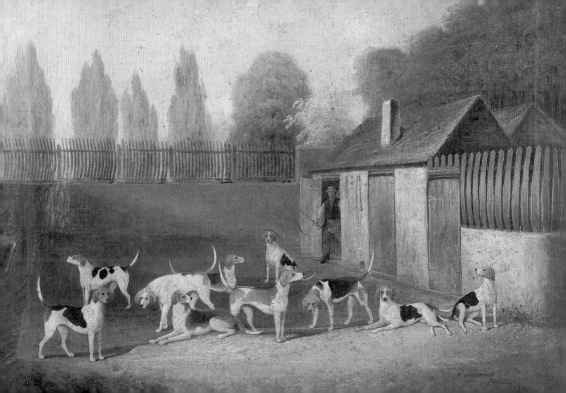

HENWOOD
FOXHOUNDS IN A KENNELYARD
c. 1840

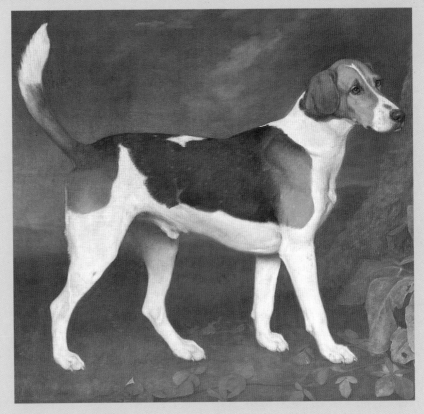

Keeping hunting dogs, like these foxhounds, in kennels helped maintain the pack instinct at a high level. Gundogs, in contrast, had more human contact and training. Their duty was to work with the huntsman, rather than with other dogs.

THOMAS HENWOOD, 19th Century

STUBBS
RINGWOOD, A
BROCKLESBY FOXHOUND
1792

Stubbs had little formal training as an artist, but his intensive study of anatomy helped him to become England's finest animal painter, best known for his pictures of horses. This dog portrait, however, depicting the pride of the Brocklesby pack, is reckoned to be one of his most accomplished efforts.

GEORGE STUBBS, 1724–1806

GIOVANETTI
MEN HUNTING WITH DOGS
1347

If proof were needed that the clergy were as fond of hunting as the laity, it can be found in Giovanetti's frescos. From 1309 until 1377 the Papacy was based at Avignon in southern France and, during this time, imported Italian artists to decorate its new home at the Palais des Papes (Papal Palace). Giovanetti supervised the project and carried out much of the work himself. This damaged fragment comes from the most famous part of the scheme, the hunting scenes in the Chambre du Cerf (Stag Room).

MATTEO GIOVANETTI, C. 1300–68/9

KILBURNE
EXERCISING GREYHOUNDS
1887

The double leash shown in this picture was a standard piece of equipment, designed to accord with the rules of coursing. These stated that no more than two greyhounds were ever to be released against a single hare. The motive, however, was not to give the latter a sporting chance, but rather to prolong the cruel spectacle of the chase.

GEORGE GOODWIN KILBURNE, 1839–1924

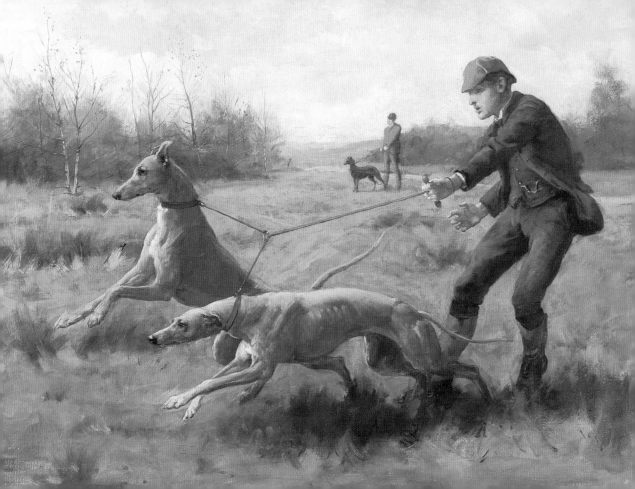

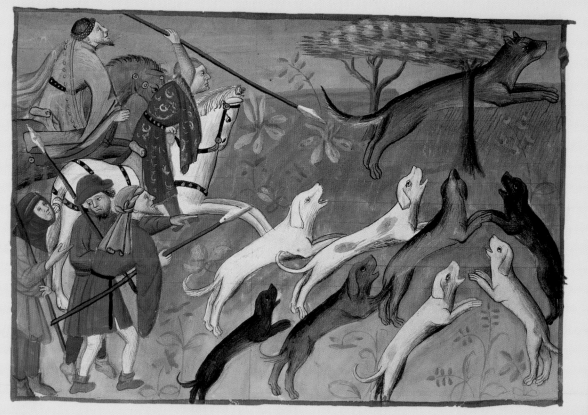

FRENCH

THE WOLF HUNT

C. 1405

This charming miniature, with its incredibly elongated dogs, is an illustration from the celebrated *Book of the Hunt* (1387–8) by Gaston III (who is probably better known as Gaston Phoebus, meaning "the Shining One," owing to his "golden good looks"). Wolf hunting was not a traditional sport, but the animal was a danger to both people and livestock, and every effort was made to exterminate it.

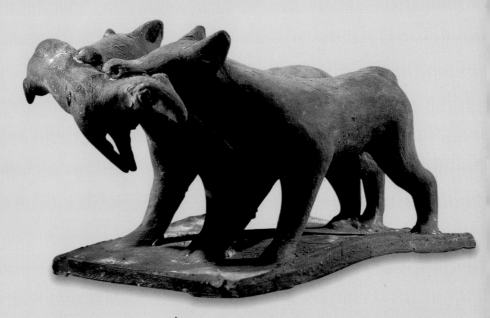

GREEK

TWO WOLVES CARRYING

OFF A RAM

6th Century BC

This is a Tanagra figurine, made out of terra-cotta. The name derives from the town in Boeotia (central Greece) where a large collection of these statuettes was excavated in 1874. Most of the surviving figurines are of people rather than animals, but wolves were an unwelcome part of everyday life. Their disproportionate size gives some idea of the fear they inspired.

39

> " The last dogge oftentimes catcheth the hare, though the fleetest turne him. "
>
> JOHN LYLY, c. 1554–1606

PALIZZI
FOXHUNT
1850

Painting was in the Palizzi family's blood. Filippo and his three brothers all became artists, although he was by far the most successful of the quartet. His skill at depicting animals is self-evident, but he is better known for his landscapes and, through these, he became one of the leading figures in the Italian Realist movement. In his later years he was director of the Naples Academy (1878–80).

FILIPPO PALIZZI, 1818–99

41

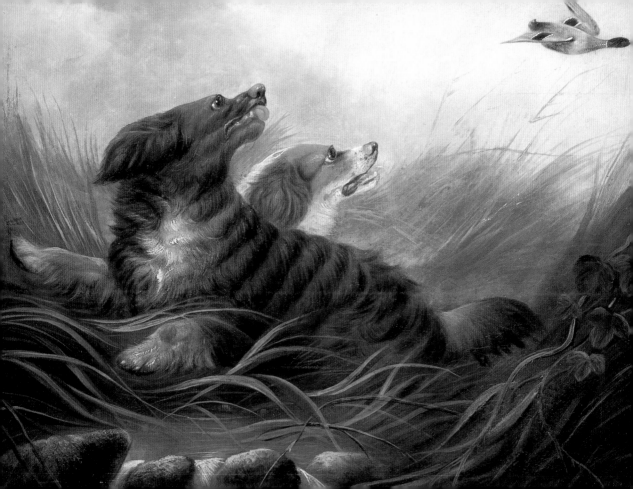

ARMFIELD
SPANIELS THRASHING
19th Century

 Spaniels were widely used in hunting waterbirds, since they had a particular talent for locating this kind of game and then flushing it out. Springer spaniels gained their name from their springing action, while cocker spaniels were supposed to be most effective at finding woodcock. In any event, the birds became an easier target for the huntsman, once they were airborne.

GEORGE ARMFIELD, C. 1820–93

ARMFIELD
THE GAMEKEEPER'S KITCHEN
19th Century

George Armfield Smith is now better known simply as Armfield, although he frequently exhibited under the name of "Smith." He was both a keen sportsman and a prolific painter of dogs, exhibiting thirty-two pictures at the Royal Academy during the 1840s and 1850s. Gamekeepers' cottages were a favorite theme, as they gave him an opportunity to demonstrate his skills as a still-life artist.

GEORGE ARMFIELD,

C. 1820–93

ARMFIELD
TERRIERS AND RABBITS IN A WOOD
19th Century

Terriers (literally "earth dogs") earned their name through their reputation as fierce diggers and burrowers. In organized hunts they were used in the pursuit of foxes or rabbits that had gone to ground. Farmers were also known to have kept them, to help dispose of rats and other vermin.

GEORGE ARMFIELD,

c. 1820–93

HANSEN
RIDER, DOG, AND FISH
1991

Hansen's playful painting is a modern take on the traditional hunting scene. The rider and dog are working together, in hot pursuit of a conventional sporting prize. The classical architecture and the horseman's American Civil War costume underline the timeless nature of the activity.

GAYLEN HANSEN, b. 1921

45

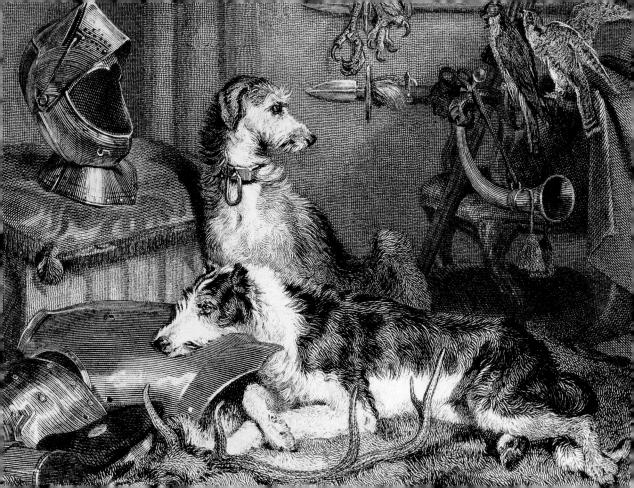

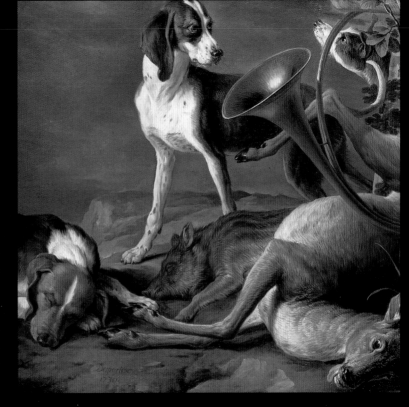

LANDSEER

ABBOTSFORD: HUNTING DOGS
1828

🐺 Abbotsford was the home of Sir Walter Scott (1771–1832), who was always surrounded by a posse of dogs. His favorites were Camp, a black-and-tan terrier, and Maida, a giant deerhound, which used to rest its head on its master's knee while he was writing. Maida is shown here in old age, using a piece of armor as a substitute pillow.

Sir Edwin Landseer, 1802–73

DESPORTES

STILL LIFE OF DEAD
GAME WITH HOUNDS
1730

🐺 Initially a portraitist at the Polish court, Desportes made his name in France as a painter of dogs, game, and hunting emblems, and won the patronage of Louis XIV (1638–1715) and Louis XV (1710–74).

Alexandre-François Desportes, 1661–1743

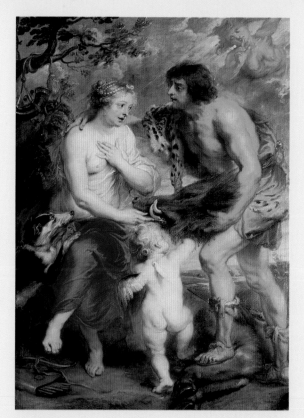

BOUCHER
DAPHNIS AND CHLOE
c. 1747–50

According to ancient legend, Daphnis was the inventor of bucolic poetry. He came from divine origins—he was the offspring of the god Hermes and a water nymph—and he was taught to play the pipes by the woodland deity, Pan. He is shown here as a shepherd, with the panpipes at his waist and his dog at hand, embracing his lover, Chloe.

FRANÇOIS BOUCHER, 1703–70

RUBENS
MELEAGER AND ATALANTA
c. 1635

In a tale from the *Iliad*, the goddess Diana sent a wild boar to ravage the countryside around Calydon, after its king had insulted her. A hunting party was dispatched, headed by Meleager, the king's son, and Atalanta, his beloved. Together, they managed to slay the beast, and the prince offered Atalanta the boar's head and pelt. Here, Cupid looks up approvingly and helps to hand over the curious love-gift.

SIR PETER PAUL RUBENS, 1577–1640

" 'Ah! you should keep dogs—fine animals—sagacious creatures—dog of my own once—pointer—surprising instinct—out shooting one day—entering enclosure—whistled—dog stopped—whistled again—Ponto—no go; stock still—called him—Ponto, Ponto—wouldn't move—dog transfixed—staring at a board—looked up, saw an inscription—"Gamekeeper has orders to shoot all dogs found in this enclosure."—wouldn't pass it—wonderful dog—valuable dog that—very.'

'Singular circumstance that,' said Mr. Pickwick. 'Will you allow me to make a note of it?'

'Certainly, sir, certainly—hundred more anecdotes of the same animal.' "

CHARLES DICKENS, 1812–70

EMMS
STUDY OF HOUNDS
19th Century

The popularity of foxhounds reached a peak in the eighteenth century, when foxes superseded deer as the favorite quarry for huntsmen. Before this, stag hunting had been the preserve of royalty and the aristocracy, although poorer country squires sometimes kept small packs of hounds for chasing foxes and rabbits.

JOHN EMMS, 1843–1912

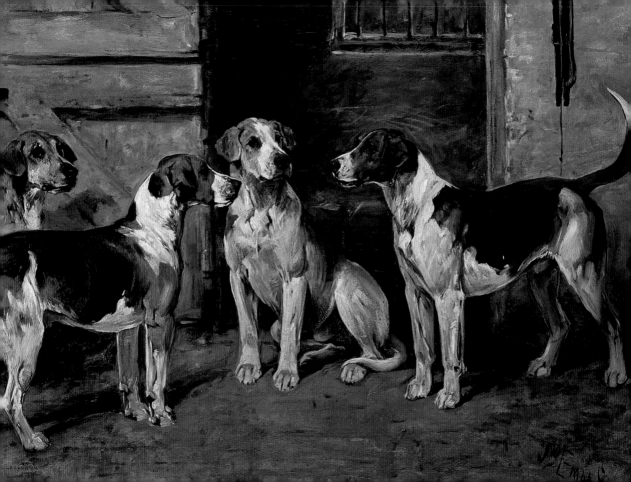

WOODWARD
PORTRAIT OF
FAVORITE FOXHOUNDS
c. 1840S

Before the advent of fox-
hunting, the favorite dog in Britain
was the Talbot hound. The new sport
required a speedier animal, however,
and through selective breeding
the modern foxhound gradually
emerged. Even so, the breed was
not standardized until the nineteenth
century. Before this, as one popular
proverb put it, there were:
So many men, so many minds;
So many hounds, so many kinds.

THOMAS WOODWARD, 1801–52

SARTORIUS
HARRIERS IN A
WOODED LANDSCAPE
1785

The Sartorius family produced three generations of
sporting artists. Little is known about the eldest, John, but
his son Francis was a regular exhibitor at both the Society of
Artists and the Royal Academy. His own son, John Nost Sartorius
(1759–1828), was the most talented of the trio, and is best
remembered for his pictures of the Quorn and Belvoir Hunts.

FRANCIS SARTORIUS, 1734–1804

> " A Greyhoun should be headed like a Snake,
> An necked like a Drake,
> Footed like a Cat,
> Tayled like a Rat,
> Syded like a Team,
> Chyned like a Beam. "

THE BOOK OF ST. ALBANS, 1486

BRITISH
WILD WOLF IN ACTION AT THE
WHITE CITY STADIUM, LONDON
1950

Greyhound races have been staged at White
City in west London, the principal British stadium,
since 1927. This photograph from *Picture Post*
shows Wild Wolf competing in the Greyhound Derby
of 1950. The sport was introduced into Britain by an
American businessman, Charles Munn, and
Brigadier-General A. C. Critchley. Together, they
founded the Greyhound Racing Association.

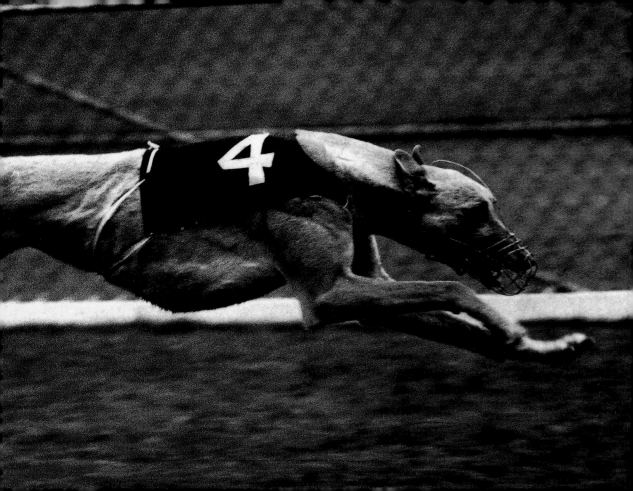

BARKER
A JACK RUSSELL BY A RABBIT HOLE
c. 1890

🐾 This breed was developed by the Reverend John ("Jack") Russell (d. 1883). He began breeding dogs while still an undergraduate at Oxford University, purchasing Trump, the progenitor of his new strain, from a local milkman in 1819. Russell became one of the founding members of the Kennel Club in 1873, and was often called upon to judge at dog shows. After his death in 1883 his favorite portrait of Trump was acquired by the Prince of Wales and displayed in the tack room at Sandringham House.

WRIGHT BARKER, 1864–1941

REINAGLE
THE AFTERNOON SHOOT
c. 1804

🐾 A Scottish painter with Hungarian ancestry, Reinagle studied at the Royal Academy Schools and worked as an assistant to the portrait painter Allan Ramsay (1713–84). He was highly regarded in the world of hunting prints, reserving his best work for the periodical *The Sportsman's Cabinet*. He was also a talented landscape artist and eventually made this his specialist field.

PHILIP REINAGLE, 1749–1833

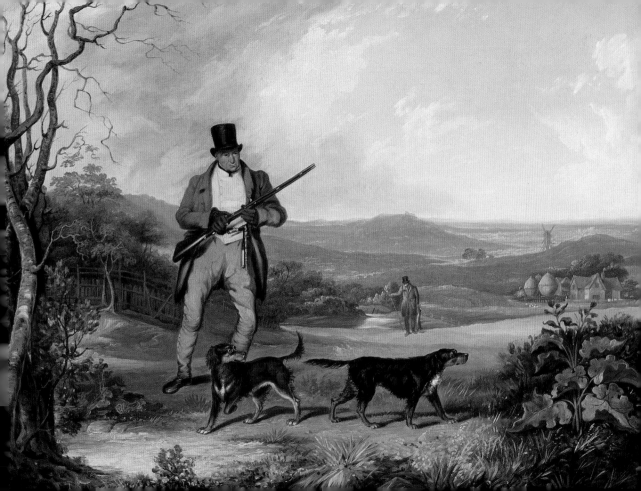

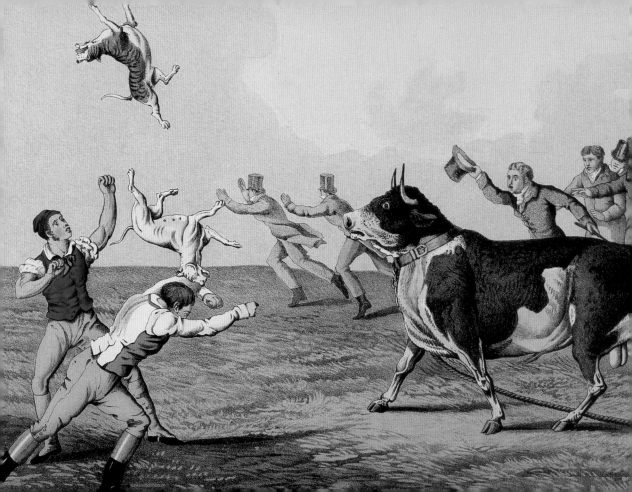

ALKEN
BULLBAITING
1820

 A dog may be man's best friend but, sad to say, humans have not always returned the favor. Bullbaiting was a particularly cruel sport, in which dogs were loosed against a tethered bull, trying to bring it down. Bulldogs were the preferred breed, since they had a powerful bite and their deep-set nostrils enabled them to breathe, while still maintaining their grip.

HENRY ALKEN, 1785–1851

CARDON
DOG IN THE MANGER
20th Century

Cardon's painting provides an alfresco version of the old fable about greed. A saucy dog teases cows, standing guard over a feeding tray and defiantly refusing to let them come near, even though he does not want to eat the food himself.

CLAUDE CARDON, fl. 1892–1915

man's best friend

MARAVILLAS CARRION

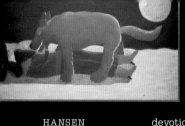

HANSEN
RED DOG

association, back in the mists of time, humans have provided dogs with food and shelter; in exchange, dogs have guarded the human lair, assisted in the hunt, and offered their unqualified affection.

Throughout the centuries examples of this unstinting devotion have been recorded by both writers and artists. In antiquity, the most famous tale of canine loyalty appeared in Homer's *Odyssey*. Near the climax of the narrative Ulysses

STUBBS
SPANISH POINTER
(DETAIL)

reached his homeland again, after being involved for many years in the Trojan War and in numerous other adventures. He arrived wearing the garb of a beggar so

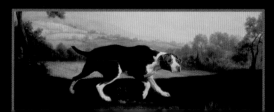

him. The disguise worked all too well, for when he entered his stronghold he was received scornfully by his friends and retainers. Only one living creature recognized him instantly—his faithful hound Argus. Even though it was neglected, lice-ridden, and too decrepit to move, the dog wagged its tail joyfully at the sight of its old master, before expiring from old age.

Stories of this kind are common to most cultures. Often they are highly sentimental, dwelling on the poor treatment that the animals receive, in return for their unswerving affection. They have also offered tempting subjects for many painters, particularly in the nineteenth century, when they were tackled by artists of the caliber of Sir Edwin Landseer (1802–73). In lesser hands, however, such themes could become mawkish and

which a shepherd named John Gray would journey every market day with his Skye terrier, Bobby. In 1858 Gray died and was buried in Greyfriars cemetery. Ever faithful, Bobby

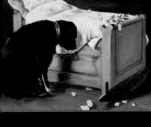

sat by his master's grave and refused to leave it. For the next fourteen years he remained there, only leaving his post at midday, when he was fed at the inn across the road, which he had visited so often with his master.

Over the years Greyfriars Bobby became a celebrated figure in Scotland and, when he eventually died in 1872, a statue was erected in his honor at the gates of the cemetery. There is a similar monument to be seen in Tokyo, honoring the memory of a Japanese Akita called Hachiko, which kept a nine-year vigil for

RCHER
DOG MOURNING
LITTLE MASTER

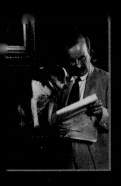

AMERICAN
CHESTER CONKLIN
WITH HIS DOG

In more recent times the most famous image of canine loyalty has derived from, of all things, an advertisement. Toward the end of the nineteenth century an obscure artist called Francis Barraud (1856–1924) agreed to look after his brother's pet, following the brother's premature death. Barraud was enchanted by the dog, an alert little terrier by the name of Nipper, and decided to paint it listening to a recording of his late brother's voice. He sent the completed picture—which was entitled *His Master's Voice*—for exhibition at the Royal Academy, but it was rejected. Undaunted, Barraud patented the image and sold it to the Gramophone Company in 1899.

Since then it has become renowned throughout the world as the advertising logo of HMV. It depicts, on the one hand, the fidelity of the sound quality of the merchandise; on the other, that of a loyal dog, listening to the words of his dead master.

ENGLISH
FAITHFUL FRIENDS

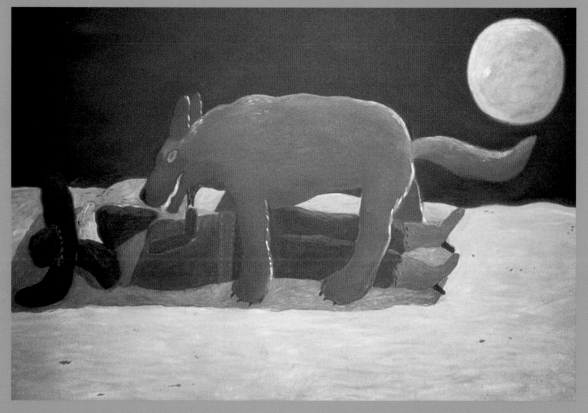

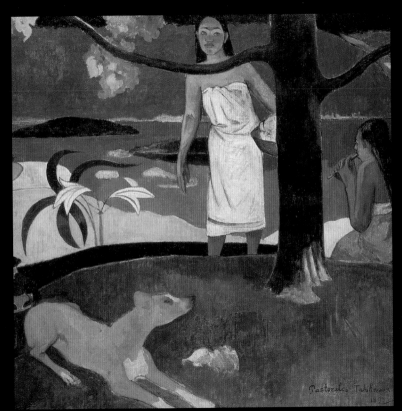

HANSEN
RED DOG
1981

🐺 Drawing his inspiration from
Henri Rousseau's *Sleeping Gipsy*,
Hansen presents a beguiling enigma.
Is the huge canine creature a ferocious
wolf, preparing to attack the bearded
figure, or is it simply a loyal pet, choosing
an inopportune moment to show
its affection?

GAYLEN HANSEN, b. 1921

GAUGUIN
PASTORALES TAHITIENNES (DETAIL)
1893

🐺 In many of his Tahitian pictures
Gauguin tried to create a vision of an
earthly paradise, where men, women, and
animals lived in complete harmony with
their natural surroundings. The dog, as
humanity's closest companion, took pride
of place among the animals in
this Garden of Eden.

PAUL GAUGUIN, 1848–1903

" Giallo! I shall not
see thee dead,
Nor raise a stone
above thy head,
For I shall go some
years before,
Where thou wilt leap at
me no more,
Nor bark, as now,
to make me mind,
Asking me, am I
deaf or blind:
No, Giallo, but I shall
be soon:
And thou wilt scratch
my turf and moan. "

WALTER SAVAGE LANDOR,
1775–1864,
WRITTEN IN OLD AGE

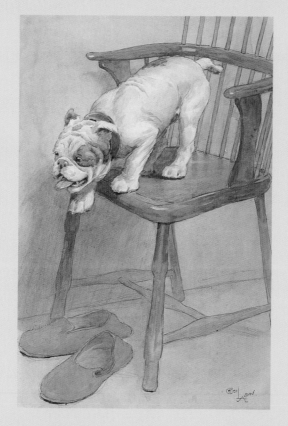

ALDIN
CALCULATING THE JUMP
20th Century

Aldin's interest in dogs came through hunting (he was a Master of Foxhounds), but he is probably best remembered for his humorous illustrations. In these he usually placed a very human slant on canine actions. Here, the comic effect is heightened by the worn slippers and the pup's facial marking, which resembles a black eye.

CECIL ALDIN, 1870–1935

CALLIS
UNTITLED
1998

Callis's splendid painting captures a dog in a very familiar pose—with its tongue hanging out and dribbling saliva onto the carpet. Dogs have to act in this way, because their only efficient sweat glands are in their feet. In order to keep the rest of their bodies cool, they need to open their mouths and pant.

JO ANN CALLIS, b. 1940

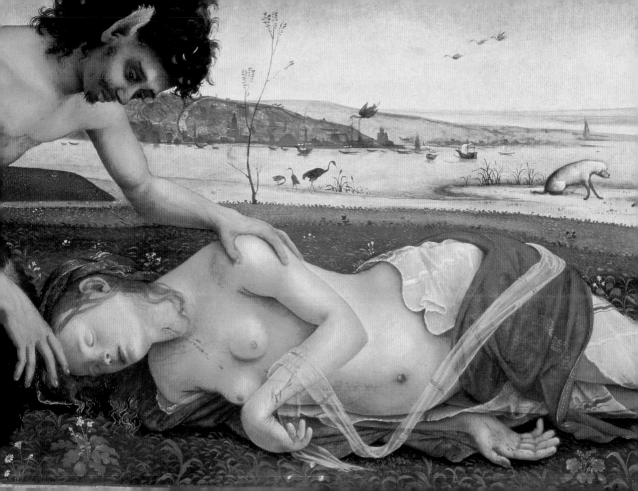

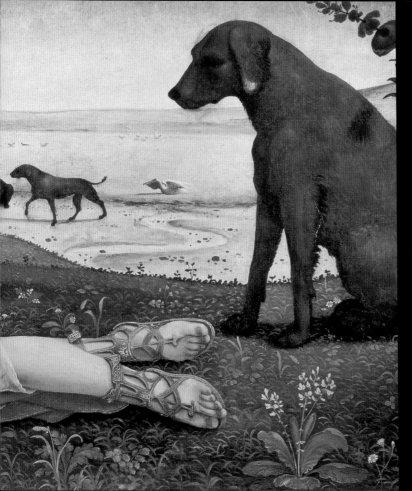

PIERO DI COSIMO
CEPHALUS AND PROCRIS
C. 1510

Cephalus, a satyr, was the lover of a nymph called Procris. They were blissfully happy, until the goddess Diana spied the satyr and wanted him for herself. He spurned her advances, however, sending the goddess into a jealous rage. As a result she engineered a terrible accident, in which Cephalus killed the nymph by mistake. Here, he mourns for his beloved. A sympathetic dog looks on, emphasizing that the animal side of the satyr's nature can grieve as deeply as his human side.

PIERO DI COSIMO, C. 1462–1521

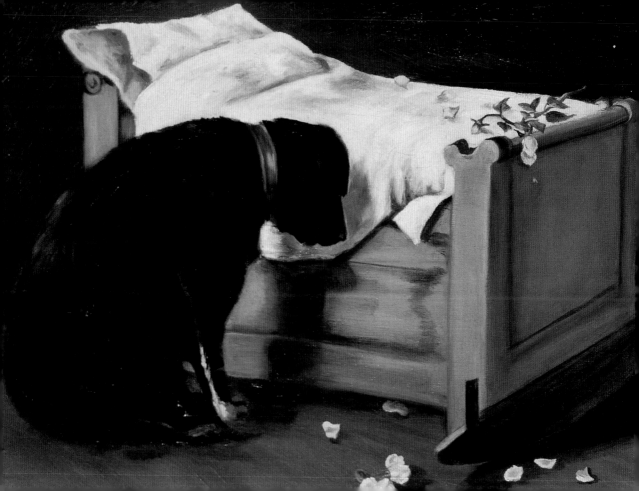

ARCHER

A DOG MOURNING ITS LITTLE MASTER
1896

 Landseer's work (*see right*)
spawned a host of inferior imitators.
In this case, a Labrador retriever bows
its head before an empty cradle. The
scattered blossoms emphasize that the
victim died before reaching maturity.

A. ARCHER, fl. 1860–96

LANDSEER

THE OLD SHEPHERD'S CHIEF MOURNER

c. 1837

In one of his most celebrated paintings
Landseer illustrates the closeness of the bond
that can exist between a man and his dog.
The other mourners have gone home, but the
dog remains behind, unwilling to be separated
from his master. A shepherd's life could be a
lonely one, as the spartan background implies,
and his closest companion might often be
the dog that helped him tend his flock.

SIR EDWIN LANDSEER, 1802–73

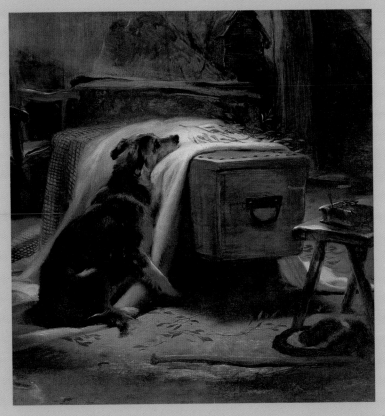

ANGUISCIOLA
BOY WITH DOG
16th Century

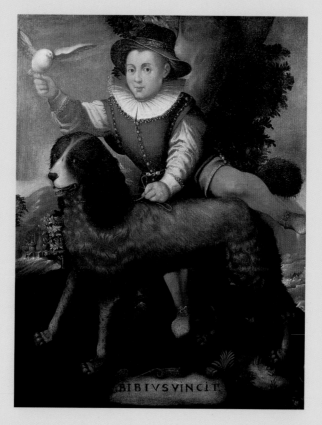

Dogs placed in the nurseries of well-born children had to display considerable forbearance. This patient creature manages a kind of smile, as his young master attempts to climb on his back. The breed is extraordinary: the head is reminiscent of an oversized spaniel, while the clipped tail is more akin to that of a poodle.

SOFONISBA ANGUISCIOLA, 1527–1625

VAN DYCK
THE CHILDREN OF CHARLES I
1637

The child in the center, with his hand resting on the huge mastiff, is the future Charles II (1630–85). He was so fond of dogs that a breed of spaniel—the King Charles—was named after him. Some of his subjects disapproved. Samuel Pepys used to complain in his diary that the king preferred his dogs to his royal duties.

Studio of SIR ANTHONY VAN DYCK, 1599–1641

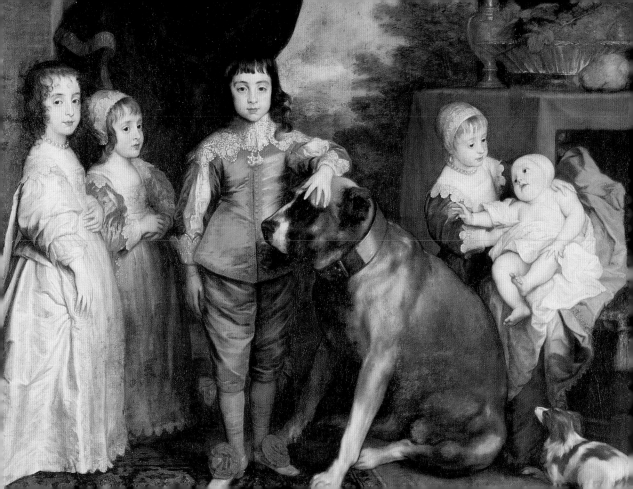

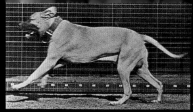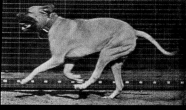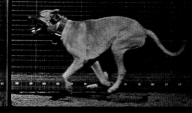

MUYBRIDGE

RUNNING DOG
1887

These [o] photographs come from *Animal Locomotion*, Muybridge's pioneering study of the way that creatures move. His interest in the subject dated back to 1872, when the governor of California asked him to help settle a wager, by providing photographic evidence as to whether or not a racehorse ever had all four legs off the ground at the same time. This was a question that had taxed the minds of many sporting artists, and Muybridge proved in 1877 that such was actually the case.

EADWEARD MUYBRIDGE, 1830–1904

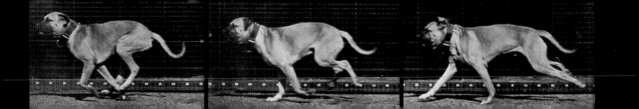

TRÜBNER

DOG AND SAUSAGE

(CAESAR AT THE RUBICON)

1878

Temptation is at hand. A large pet dog has spied a tasty treat and, as the subtitle suggests, the moment of decision has arrived. It will only take a simple lunge to reach the sausage, but is it worth arousing the displeasure of his owners?

WILHELM TRÜBNER, 1851–1917

HANSEN

DOG WITH A BONE

1985

In the wild, dogs or wolves will bury bones if they have a surplus of food. The act of burying is designed to conceal the food from other scavengers or, in hot climates, to prevent it from attracting flies. This particular bone resembles a human skull, adding another dimension to the painting.

GAYLEN HANSEN, b. 1921

" But he answered and said, It is not meet to take the children's bread, and to cast it to dogs. And she said, Truth, Lord: yet the dogs eat of the crumbs which fall from their masters' table. "

MATTHEW 15: 26–7

79

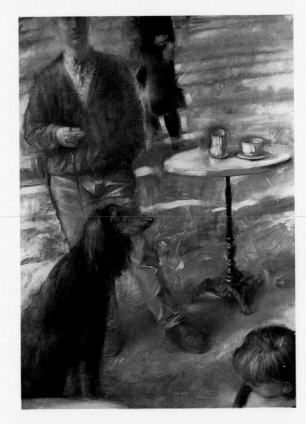

STERN

TRUE LOVE

1989

Stern's dog gazes back at his mistress with unconditional love, silently assuring her that he will remain by her side through all the ups and downs of life. The mood of devotion is reinforced by a series of heart-shapes, scattered across the rich blue background.

PIA STERN, b. 1952

CHADWICK

LA VIE SILENCIEUSE

1996

A keen traveler, Chadwick enjoys soaking up the atmosphere in foreign parts. Here, he portrays a young man and his dog, enjoying a few relaxing moments at a pavement café on a Parisian boulevard.

GREGG CHADWICK, b. 1959

81

> " The rich man's guardian
> and the poor man's friend,
> The only creature faithful
> to the end. "
>
> GEORGE CRABBE, 1755–1832

HERBERG
OH VINCENT OH
1997

The Vincent in question is, of course, Vincent van Gogh (1853–90). The background is a pastiche of *Starry Night* (1889), one of the Dutchman's most famous canvases. The flamelike foliage of the cypress also appeared in that work, as well as in a number of van Gogh's other paintings.

MAYDE MEIERS HERBERG, b. 1946

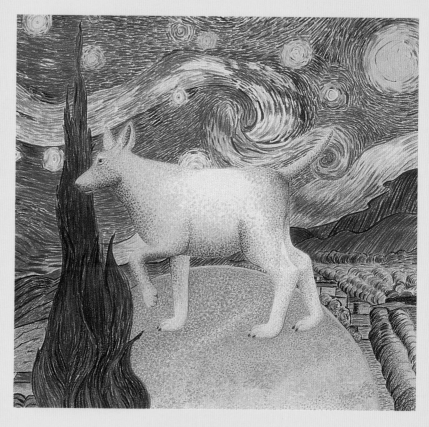

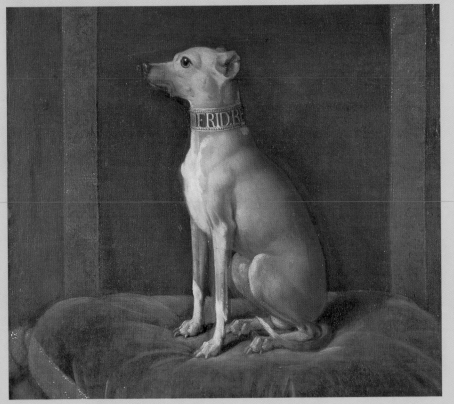

GERMAN
GREYHOUND BELONGING TO
FREDERICK THE GREAT
18th Century

Italian greyhounds were extremely popular in royal circles. Queen Victoria, Charles I, Catherine the Great, Mary, Queen of Scots, and Anne of Denmark are all known to have owned them. This fine specimen belonged to Frederick the Great (1712–86). With a suitably regal air, he poses for his portrait on a plush velvet cushion, wearing an ornate collar with his master's name.

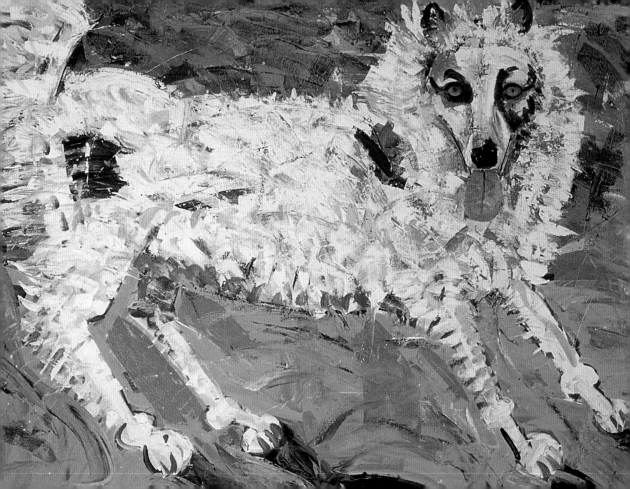

ROMERO
TOTO
1984

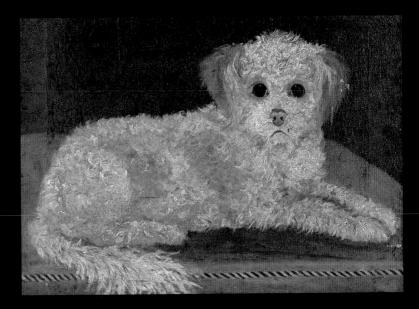

The advent of photography all but destroyed the market for canine portraits. Clearly, the camera will always provide the most accurate visual reminder of a favorite pet. Instead, some modern painters have sought inspiration in naïve or provincial art (*see right*), hoping to capture its air of simplicity and freshness.

FRANK ROMERO, b. 1941

" When the old dog barks
it is time to look out. "

LATIN PROVERB

ENGLISH
A TERRIER ON
A CUSHION
19th Century

While the upper end of the portraiture market belonged to specialists such as Stubbs or Landseer, most canine pictures were produced by journeymen artists, who made their living painting inn signs or coaches. Their work may have little artistic merit, but it provides intriguing evidence of the kind of dogs kept by less prosperous members of society.

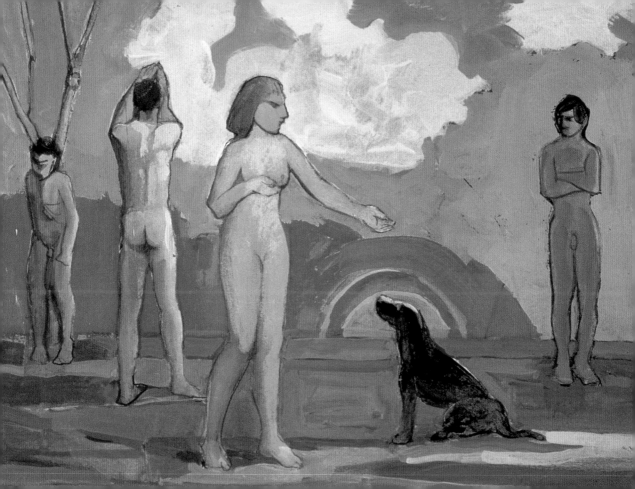

BROWN
FOUR FIGURES AND DOG AT SUNSET
1993

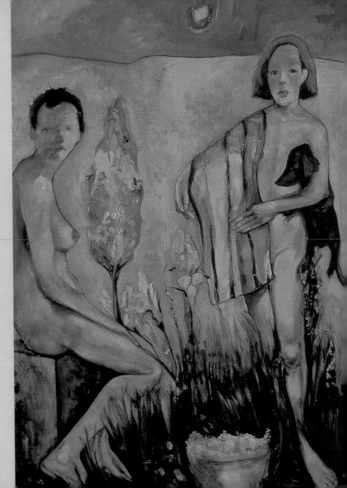 Brown lives in San Francisco, and idyllic scenes of the Pacific shoreline feature prominently in his work. Here, the setting sun creates a halolike effect around the dog's head, and at least one of the bathers appears to be able to walk on water.

THEOPHILUS BROWN, b. 1919

CARRION
DORLI'S BATH
1999

Pets love to share almost everything with their owners, although they may draw the line at a bath. In Carrion's picture, a woman is clumsily holding her dachshund—an object lesson in how not to lift an animal—prior to dipping it in the tub.

MARAVILLAS CARRION, b. 1968

JAMES
AFTER L.A. NO.11
1989

After a successful exhibition in Los Angeles, James did a series of paintings chronicling his dog's favored niches—here, draped over the back of a chair. The ears of another dog, sitting at the woman's feet, are just visible.

CHRISTOPHER JAMES, b. 1947

next pages ▶
STUBBS
SPANISH POINTER
(DETAIL)
18th Century

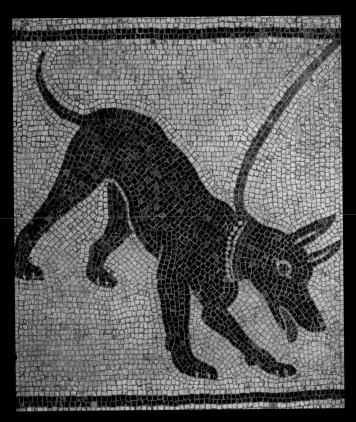

🐾 The Spanish pointer is heavier and less agile than its English counterpart. Its name comes from its extraordinary hunting stance. Once the dog has detected the presence of game, it lowers its head and stands absolutely motionless. Its entire body—head, torso, and tail—forms a straight line, "pointing" at the prey. If necessary, it can remain frozen in this pose for some considerable time.

GEORGE STUBBS,
1724–1806

ROMAN
CAVE CANEM
1st Century AD

🐾 As well as offering companionship, dogs showed their good will toward humans by guarding their homes. This practice dates back to ancient times. Among the ruins at Pompeii, archaeologists uncovered a series of striking mosaics, set into the floors of various entrance halls. Each of these portrays a yapping dog and bears the warning, *Cave Canem* (Beware of the Dog).

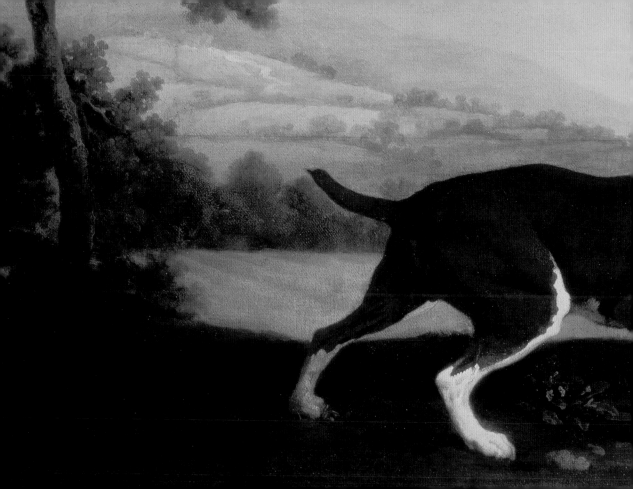

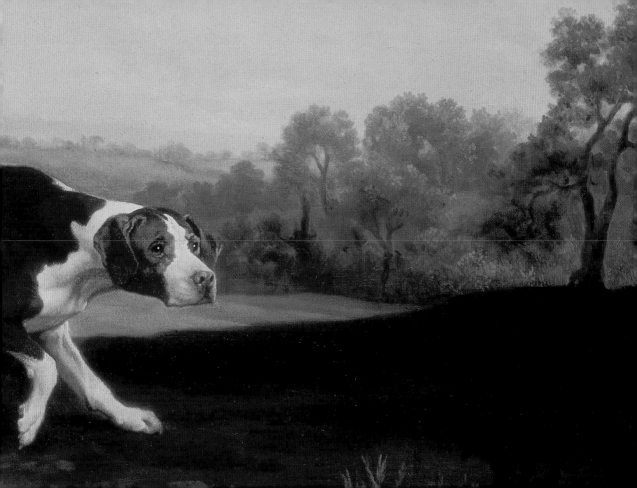

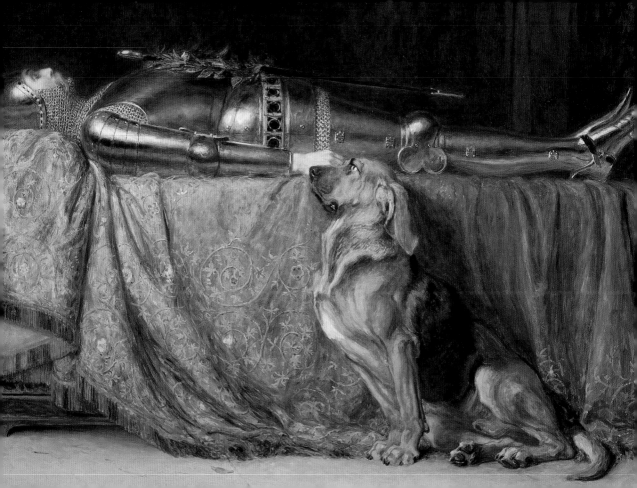

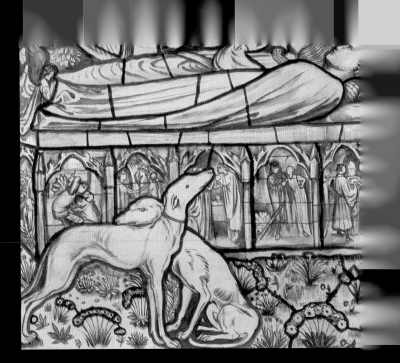

RIVIÈRE
REQUIESCAT
1889

Dogs often featured in medieval tomb effigies, curled up by the feet of their master. Rivière's variation on this theme reflects both the revival of interest in the Middle Ages and the Victorian public's fascination with tales of canine devotion. A faithful bloodhound sits by his master's corpse, intoning a silent prayer (a requiescat is a prayer for the soul of the departed).

BRITON RIVIÈRE, 1840–1920

> ❝ Ye who perchance behold
> this simple urn
> Pass on—it honors none
> you wish to mourn
> To mark a friend's remains
> these stones arise
> I never knew but one—
> and here he lies. ❞

LORD BYRON, 1788–1824,
EPITAPH FOR HIS DOG, BOATSWAIN

BURNE-JONES
THE TOMB OF
TRISTRAM AND ISEULT
(DETAIL)
1862

Dogs figure prominently in the Arthurian legend of the doomed lovers Tristram and Iseult. Tristram gave Iseult a dog as a love-gift, and the creature recognized him, when he later returned in disguise.

SIR EDWARD BURNE-JONES, 1833–98

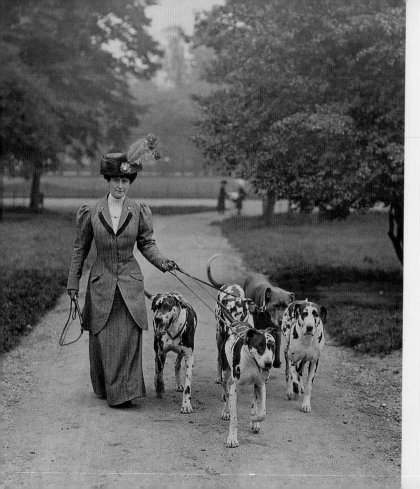

ENGLISH

MRS. FIELDER WALKING HER
DOGS IN BROCKWELL PARK
c. 1915

The keeping of pets imposes certain obligations on an owner. Dogs have to be walked regularly, to gain the exercise they would otherwise have had from their working or sporting activities. This stylish woman has dressed up for the occasion. Her dogs appear very well trained, remaining close to other members of the pack.

FLAMENG

ELEGANT WOMAN BY THE SEA
1920S

At certain times, some dogs have been more fashionable than others. The Art Deco period, with its emphasis on streamlining, witnessed a positive vogue for dogs with sleek lines. Any woman who wished to look chic could only be seen with a borzoi, a saluki, or a greyhound.

FRANÇOIS FLAMENG, 1856–1923

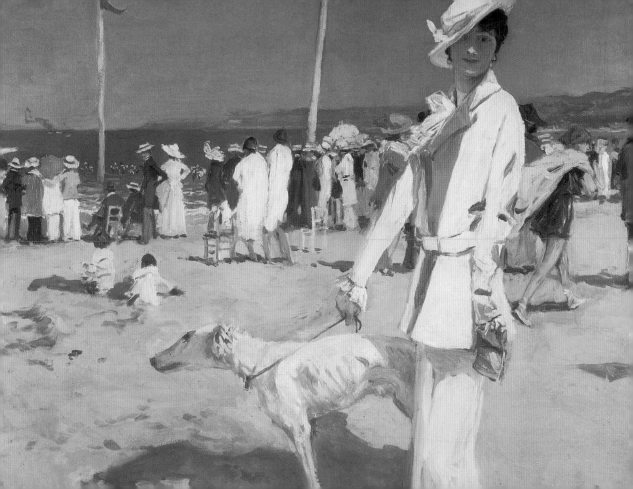

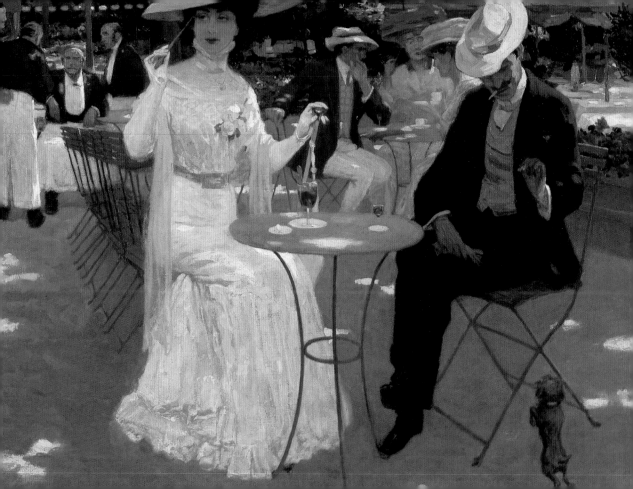

STEVENS
CAFÉ SCENE
C. 1910

Some owners like their dogs to sit up and beg or perform other tricks for them. The key to this kind of foolery is the reward system. In return for a tiny tidbit, this ridiculously small creature has consented to balance on its hind legs.

GUSTAV MAX STEVENS, 1871–1946

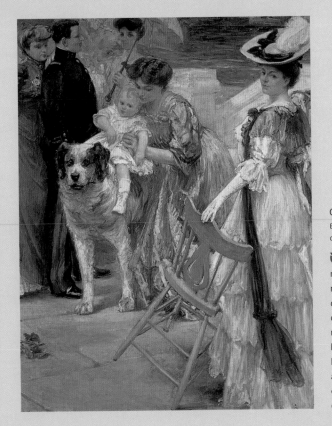

GRAU
EN FAMILLE
C. 1900

By the late nineteenth century the modern notion of the pet dog had taken root. Instead of being consigned to the nursery or used solely for hunting, dogs had now become part of the family, a natural participant at each of its gatherings.

GUSTAVE-ADOLPH GRAU, 1873–1919

97

98

JOY
OFF TO SCHOOL
1860

A smartly dressed
child heads off to school,
accompanied by her cairn
terrier. The breed originated
in Scotland, and is related
to the Skye and West
Highland white terriers.
It was once used for
hunting foxes, badgers, and
otters, but is now firmly
established as a lively little
pet. As the schoolgirl has
discovered, though, it
hates being left at home.

THOMAS MUSGRAVE JOY, 1812–66

VASNETSOV
MOVING DAY
1876

At the other end of
the scale, dogs also befriend
the most wretched members
of society. The ironic title
refers to a vagrant couple,
for whom every day is
"moving day." Their entire
belongings are contained
in a threadbare sack
but, even so, their dog
will not desert them.

VICTOR VASNETSOV,
1848–1926

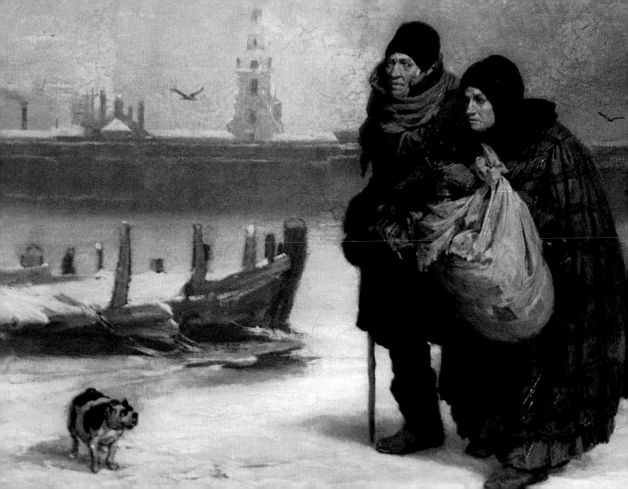

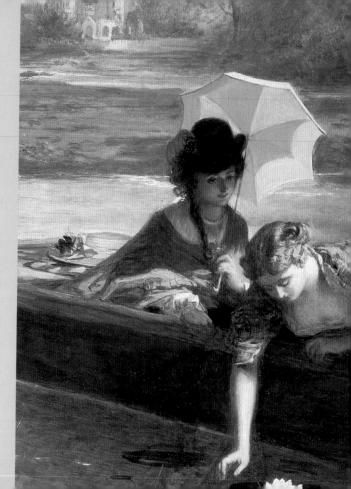

" To look at Montmorency you would imagine that he was an angel sent upon earth, for some reason withheld from mankind, in the shape of a small fox-terrier. There is a sort of Oh-what-a-wicked-world-this-is-and-how-I-wish-I-could-do-something-to-make-it-better-and-nobler expression about Montmorency that has been known to bring tears into the eyes of pious ladies and gentlemen. "

JEROME K. JEROME, 1859–1927

STONE
A PLEASANT SPOT ON THE THAMES
1863

Boating was one of the most popular middle-class pastimes in Victorian England. In this idyllic scene, a group of young people is punting along the river near Oxford. The flat platform at the end of the punt provides an ideal vantage point for the dog. The notion of taking a pet on the river gained popularity after the publication of Jerome K. Jerome's *Three Men in a Boat* (1889), which included the nautical adventures of a dog called Montmorency.

MARCUS STONE, 1840–1921

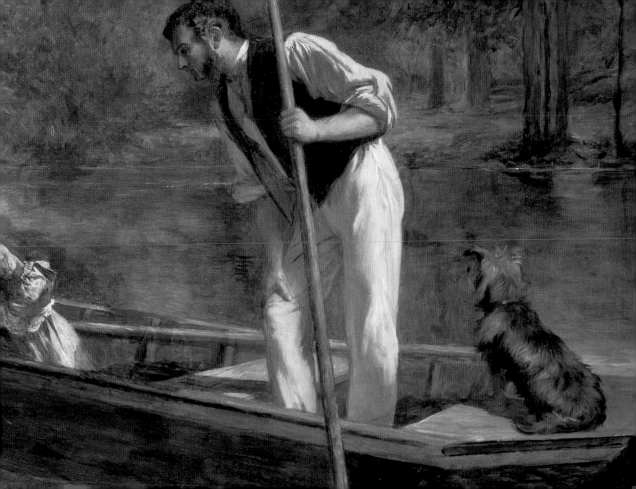

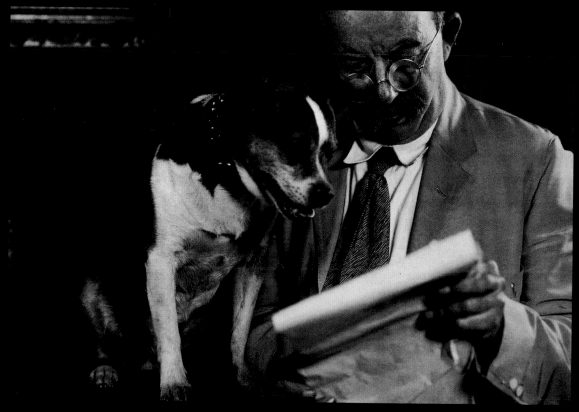

" I have sometimes thought of the final cause of dogs having such short lives, and I am quite satisfied it is in compassion to the human race; for if we suffer so much in losing a dog after an acquaintance of ten or twelve years, what would it be if they were to live double that time? "

SIR WALTER SCOTT, 1771–1832

AMERICAN
CHESTER CONKLIN
WITH HIS DOG
c. 1935

Chester Conklin (1888–1971) was a veteran of Hollywood's silent slapstick comedies, featuring prominently in Mack Sennett's output at the Keystone Studios. In this publicity shot his dog helps him check over the script for a new film with W. C. Fields (1880–1946).

LANDSEER
AN OLD MAN AND HIS DOG
SEATED BY THE ROADSIDE
19th Century

Landseer's paintings depict dogs from all walks of life. Their masters range from royalty to the occupants of the humblest shed. In most cases the artist showed how closely dogs were attuned to the lifestyle of their owners. Here, the animal appears to echo the reflective mood of his master.

SIR EDWIN LANDSEER, 1802–73

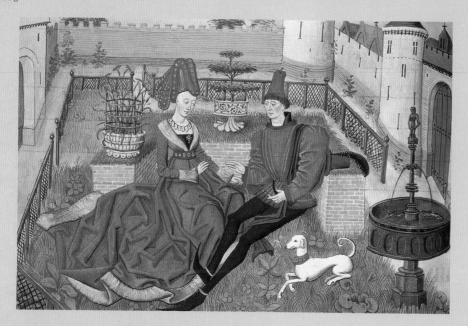

LIÉDET
THE GARDEN OF LOVE
c. 1460

In some cases, symbol and reality overlap. In the fifteenth century greyhounds were highly favored, both as hunting dogs and as companions for noble ladies, so the presence of this elegant white dog appears perfectly natural. In all probability, however, it was included as a symbol of fidelity, indicating that the young couple will remain true to each other.

LOYSET LIÉDET, active 1460–78

**THE MASTER
OF MOULINS**
THE NATIVITY
c. 1480

During the Renaissance, when a patron commissioned a painting for a local church, he would often add emphasis to his piety by instructing the artist to include his portrait in the holy scene. Here, for example, the donor—Cardinal Rolin—is placed fairly close to the crib, nearer in fact than the shepherds mentioned in the Bible. His dog is also included, sitting on the hem of his robe.

THE MASTER OF MOULINS,
active c. 1480–1500

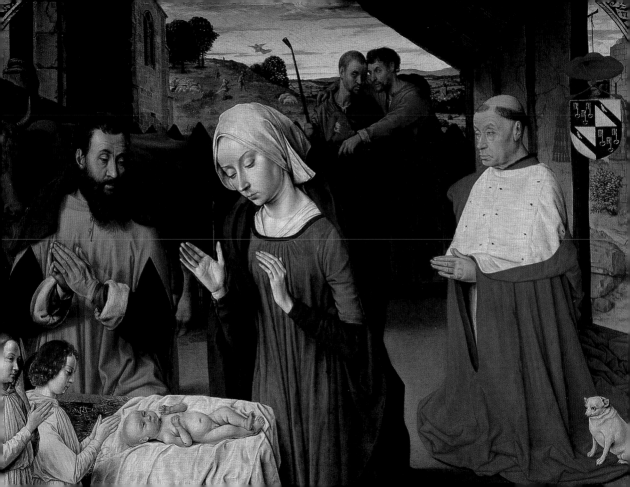

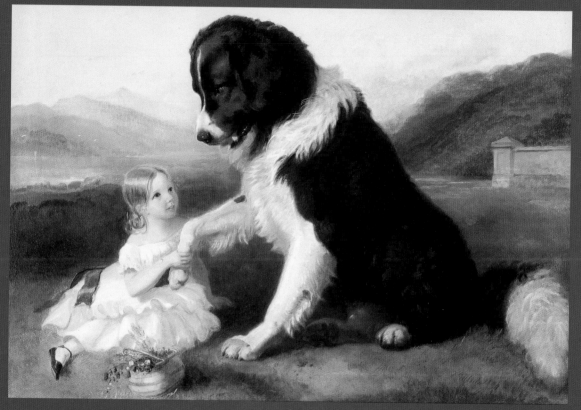

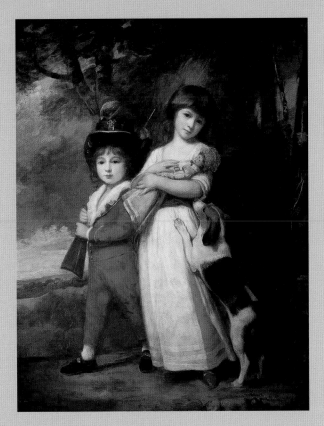

ENGLISH
FAITHFUL FRIENDS
19th Century

 Victorians were hugely sentimental about dogs and children, and themes linking the two were common in both art and literature. Sometimes the role of the dog underwent a subtle change—instead of being represented as man's best friend, it was shown as a substitute parent. Here, the giant dog adopts a distinctly fatherly air toward the young child.

ROMNEY
PORTRAIT OF THE
VERNON CHILDREN
18th Century

 Children were frequently portrayed with their dogs, and it was often quite a challenge for artists to find novel ways of presenting them. In this case, the serious-looking youngsters have adopted adult roles: the boy pretends to be a soldier, while his sister acts like a mother. In a supremely naturalistic gesture, the dog climbs up and nudges the girl, trying to persuade her to pay attention to him instead.

GEORGE ROMNEY, 1734–1802

107

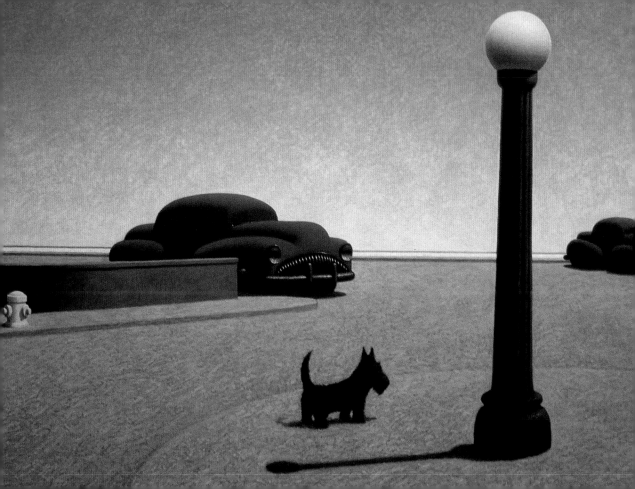

> **" Asking a working writer what he thinks about critics is like asking a lamppost how it feels about dogs. "**

CHRISTOPHER HAMPTON, b. 1946

CHAPMAN
THE SPIRITED LIFE
1991

Chapman's colorful picture presents a dog's-eye view of the world. There are no people or buildings in sight; instead, there are cars to chase, sidewalks to examine, fire hydrants to sniff, and most inviting of all, an enormous lamppost.

MICHAEL CHAPMAN, b. 1957

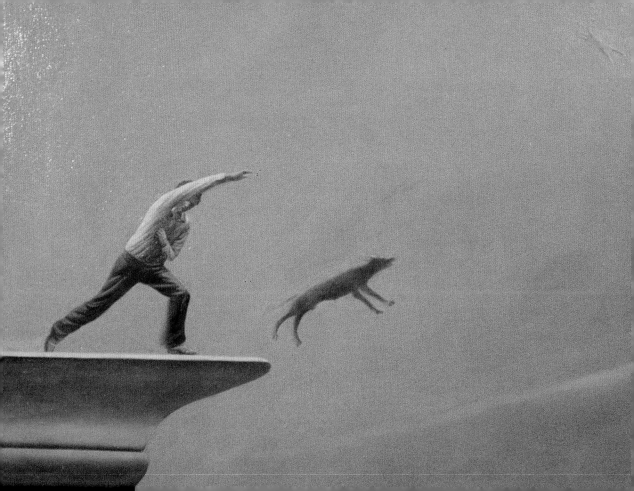

PURDY

FETCH
1985

 Purdy's penchant for black humor is firmly in evidence here. A man tests the loyalty of his dog to the full, by hurling an object off a rooftop and sending the unfortunate creature to fetch it.

GERALD PURDY, b. 1930

WARNER

RETRIEVER
1993

 Warner hails from the wide open spaces of Montana, using them as the setting for many of his animal pictures. Here, his faithful dog poses patiently, trying to convey to his master that throwing sticks is a far more useful activity than painting.

CHRISTOPHER WARNER, b. 1953

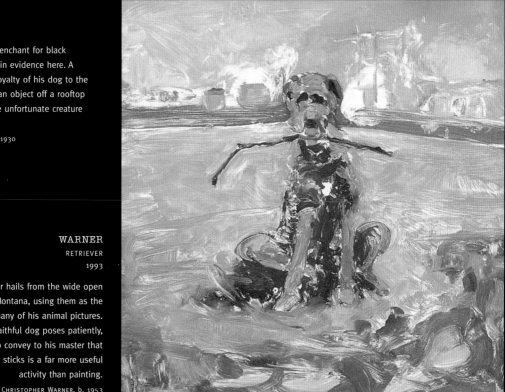

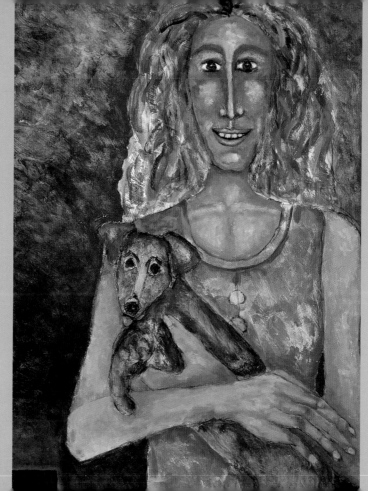

HAGER
GIRL WITH DOG
1998

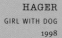 Many artists find it hard to resist the idea of painting a dog that looks like its owner. Here, the girl's long, bony nose mirrors the dachshund's snout and her tall, slender frame echoes the animal's elegant torso. The dog's paws, however, cannot compete with his mistress's incredibly long fingers.

THOMAS HAGER, b. 1965

ONG
WOMAN WITH A DOG
1997

Ong's colorful drawing shows a pet in a different light. While Hager's dog is perky and attentive, Ong's dachshund sits quietly in her owner's lap. The pose is a highly protective one. The composition is reminiscent of traditional images of maternity, most notably that of the Virgin and Child.

DIANA ONG, b. 1940

113

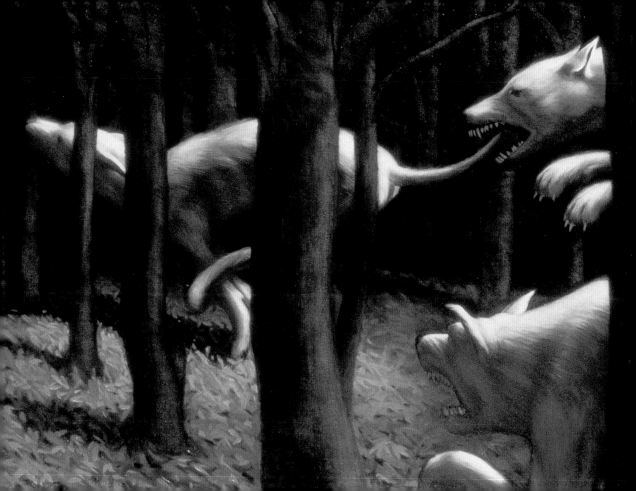

CHAPTER THREE

wild dogs

LEONARD KOSCIANSKI

CAUGHT IN THE FOREST

Only the narrowest of dividing lines separates the domesticated dog from its savage cousins, for the four main branches of the dog family (Canidae)—wolves, foxes, jackals, and dogs—have much in common. The formation of their teeth and claws, their carnivorous diet, their packlike habits, and the gestation period of their females are all very similar. Wolves and dogs, in particular, are extremely alike. They can be crossbred with great ease, while matings between dogs and jackals or foxes (although technically feasible) are far less common.

KOSCIANSKI
JUGULAR

BALOG
COYOTE

In addition to these four main categories, the Canidae also encompasses a number of intermediate breeds, known as pariah dogs. These include the Australian dingo, the coyote or prairie wolf, the Asian dhole, and the Cape hunting dog. Many of

sometimes feeding off their garbage, and they have been known to cooperate in people's hunting activities. Some authorities, for example, have claimed that the Cape hunting dog is identical to the hyena dog, which was used by the Ancient Egyptians and Assyrians. Despite these close links, however, pariah dogs never became truly domesticated. Dingos, for instance, may live and hunt alongside Aborigine tribesmen, but they still return to the wild as soon as the mating season begins.

When prompted by their human owners, domestic dogs still know how to display the same ferocity as their ancestors. Over the centuries, for example, they have been deployed in many bitter military contests. Herodotus (c. 430 c. 425 BC) mentions their presence in a battle

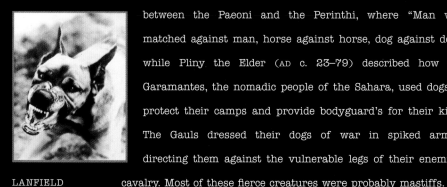

LANFIELD
THE HOUND OF
THE BASKERVILLES

between the Paeoni and the Perinthi, where "Man was matched against man, horse against horse, dog against dog," while Pliny the Elder (AD c. 23–79) described how the Garamantes, the nomadic people of the Sahara, used dogs to protect their camps and provide bodyguard's for their king. The Gauls dressed their dogs of war in spiked armor, directing them against the vulnerable legs of their enemies' cavalry. Most of these fierce creatures were probably mastiffs.

Perhaps the most famous of the warrior dogs was Boye, the white poodle of Prince Rupert (1619–82), which accompanied him throughout his campaigns in the English Civil War. Boye became such a tangible symbol of Royalist resistance that Roundhead pamphleteers supporting Oliver Cromwell likened him to a demon ("no better than a witch in the shape of a white dogge") and rejoiced when he was killed at the battle of Marston Moor on July 2, 1644.

In times of peace, a different kind of wild dog struck fear into people's hearts—the rabid dog. The symptoms of this disease were both terrifying and baffling, and they attracted a host of explanatory myths. The Ancient Greeks believed that mad dogs were possessed by unquiet ghosts, while early Christians regarded them as a mark of the Devil. Others ascribed the problem to the weather.

The Romans named the height of their summer *dies caniculares* (dog days: July 3–August 11), believing that the heat of the sun was intensified by Sirius, the Dog Star. For many, it was this heat that was responsible for driving dogs wild. In Britain, for example, Victorian legislation barred dog owners from letting their animals run free during this period each year.

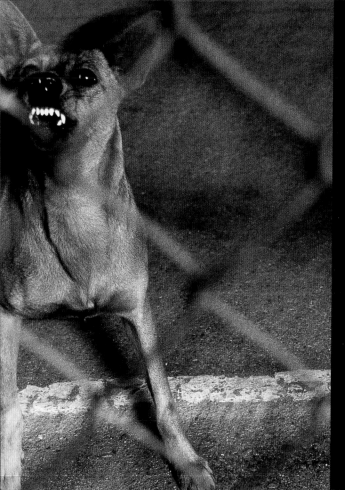

HUSH

SNARLING DOG
BEHIND CHAIN FENCE
20th Century

Every noise made by a dog signals a different level of aggression. A barking dog is calling for support and is unlikely to attack; a growler is still unsure of his ground, but caution should be exercised; a snarling dog spells danger and should be avoided; an all-out attack usually takes place in silence.

GARY HUSH, 20th Century

HANSEN

ENCOUNTER
1979

Hansen's moonlit scene is a blend of humor and ambiguity. A huge dog, barely restrained by its owner, is about to leap on a bearded stranger. Is this a joyful greeting, welcomed enthusiastically by both parties, or is the man throwing up his arms in horror, at the prospect of a ferocious attack?

GAYLEN HANSEN, b. 1921

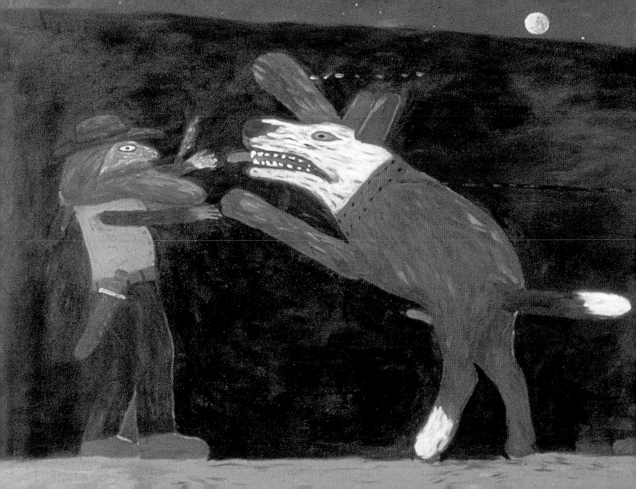

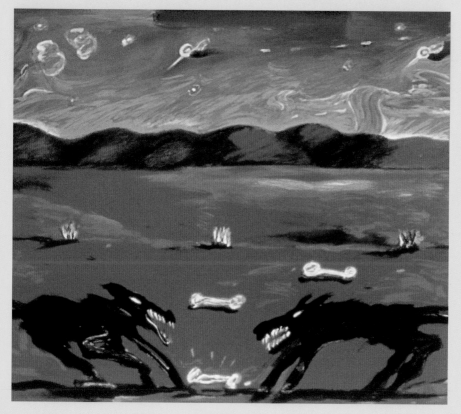

ALMARAZ
GREED
1985

In his colorful Hispanic manner, Almaraz uses two dogs to illustrate the sin of Greed. With teeth bared and tails erect, the animals confront each other over a single bone, even though the landscape behind is peppered with other bones, which are there for the taking.

CARLOS ALMARAZ, 1941–89

ROMAN
BAYING HOUND
Ist–3rd Century AD

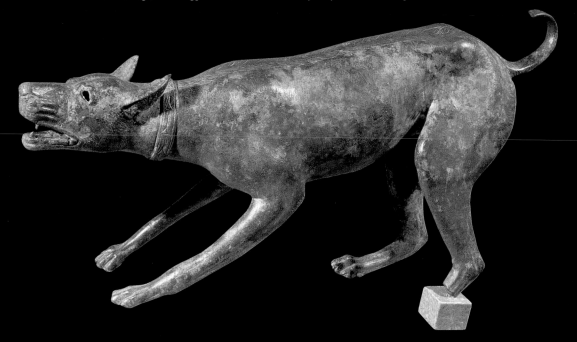 The Romans kept dogs to guard their property, so barking was encouraged. The bark itself is an alarm call, designed to attract other members of the pack, whether human or canine. Interestingly, the bark of domesticated dogs is much louder and more impressive than the sounds made by wolves or wild dogs, which suggests that it has been developed by selective breeding over the centuries.

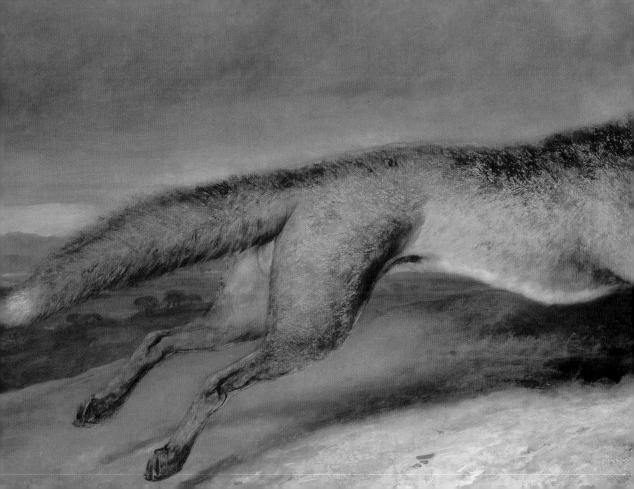

" **When the fox preaches,
look to your geese.** "

GERMAN PROVERB

HANCOCK
FOX MAKING OFF WITH A RABBIT
1841

It was once believed that foxes lived
almost exclusively on rabbits and birds, but
in fact the animal's diet is extremely varied.
Analysis of its droppings has shown that it
consumes a variety of small mammals (mice,
voles, hedgehogs), insects, and earthworms.
Fruit, especially apples and plums, is also
popular. Additionally, in urban situations,
foxes will scavenge food from garbage bags,
bird feeders, and refuse dumps.

CHARLES HANCOCK, 1802–77

125

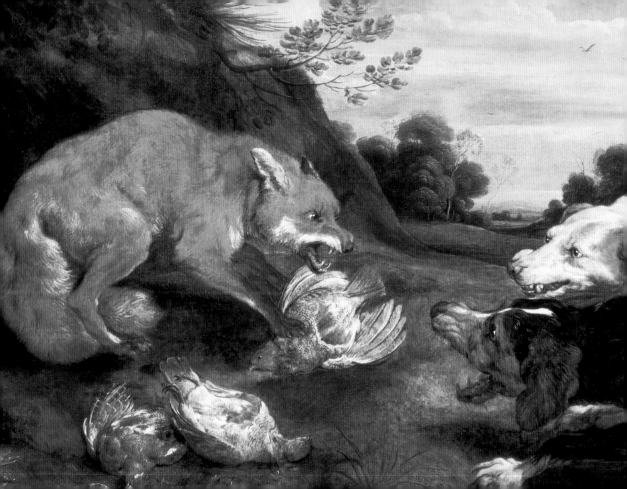

DE VOS
FOX AND HOUNDS
WITH PARTRIDGES
17th Century

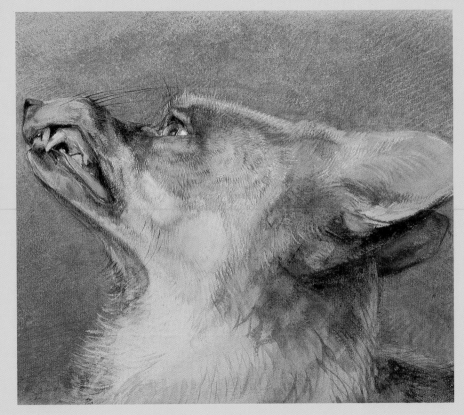

As a specialist in hunting scenes and still lifes, this picture enabled de Vos to demonstrate the full range of his talents. It also portrayed the fox as a wanton destroyer of game birds and domestic fowl.

PAUL DE VOS,

c. 1596–1678

LEWIS
STUDY OF A FOX
19th Century

Lewis's fine painting provides an accurate depiction of a typical fox's markings. Parts of the ears are black, while the undercarriage is white. The bared teeth indicate the animal's biting power.

JOHN FREDERICK LEWIS, 1805–76

KLIMT
FABLE
1883

This enigmatic painting dates from the start of Klimt's career. The composition stemmed from a series of illustrations, commissioned by the publisher Martin Gerlach for a book called *Allegories and Emblems*. The various animals are allusions to the fables of Aesop (6th Century BC) and Jean de La Fontaine (1621–95).

GUSTAV KLIMT, 1862–1918

COOPER
A FOX
1817

Foxes normally sleep curled up in this fashion, though they often prefer to lie with their tail across their nose, since this provides extra warmth. They may choose to sleep above ground, but their typical resting spot is a burrow, called an earth or den. They have also been known to share a badger's set.

ABRAHAM COOPER, 1787–1868

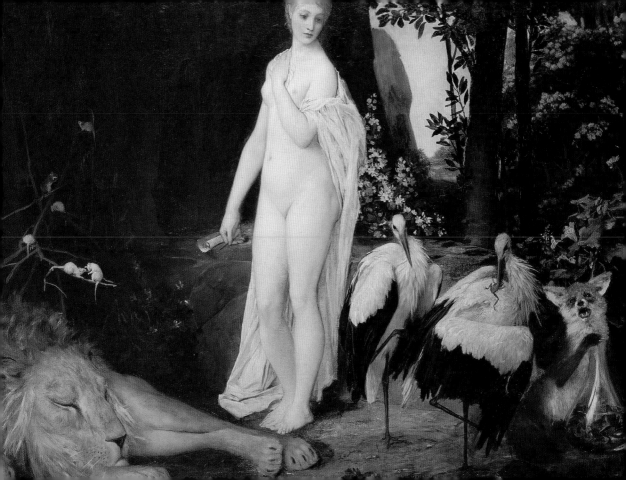

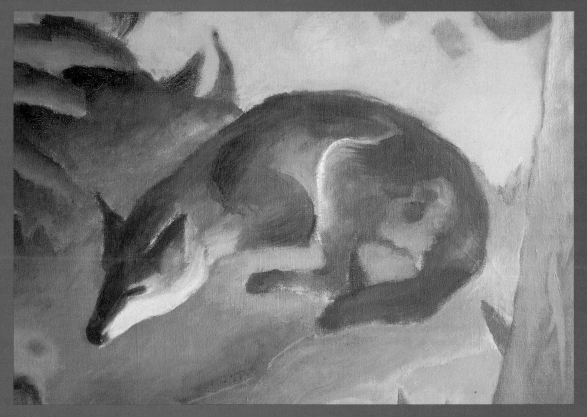

CONDÉ
DJANGO
1982

 Many of Condé's paintings feature a vagabond traveling through the Spanish countryside. Here, the drifter encounters some wild dogs in a hilly landscape. These were modeled on his own pet dog, which answers to the name of Django.

MIGUEL CONDÉ, b. 1939

MARC
PURPLE FOX
1911

 Marc regarded animals as more innocent and spiritual than mankind, "the most bungled of all beasts, the one that has strayed most dangerously from its instincts." He aimed at an "animalization of art," in which he hoped to capture the way that animals sensed their own existence. In this charming scene, a fox—so often a byword for cunning and cruelty—is portrayed as the gentlest and most docile of creatures.

FRANZ MARC, 1880–1916

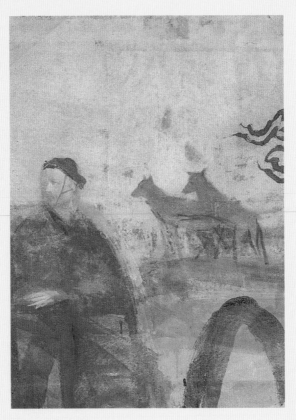

next pages ▶
HERRING
FOX ON THE RUN
(DETAIL) 1830
 A hunted fox knows that its scent is carried on its feet and will try to mask the smell. It will run through a plowed field rather than grassland, because clinging particles of soil diminish the scent. Running along a wall, a hard track, or through a stream is even more effective. When possible the fox may also run through a flock of sheep, in order to throw the hounds off the scent.

JOHN FREDERICK
HERRING Senior,
1795–1865

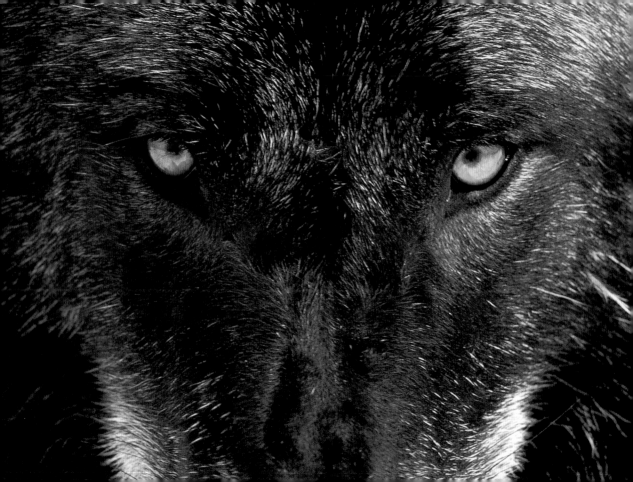

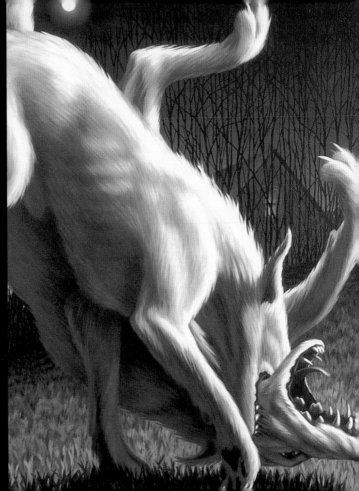

WARDEN
GRAY WOLF
20th Century

Perhaps the most impressive feature of the wolf is its cold, penetrating gaze. Not surprisingly, this has been the focus of many of the legends about werewolves. Traditionally the eyes were the only parts of these monsters that did not change during their transformation, so men with wolfish eyes were often regarded with suspicion. Close-knit eyebrows were deemed to be another warning sign.

JOHN WARDEN, 20th Century

KOSCIANSKI
JUGULAR
1984

Few artists have managed to capture the essence of animal savagery as explicitly as Koscianski. In a sinister moonlight, which transforms the creatures into silvery phantoms, one of the beasts goes for the death-blow, the severing of the jugular vein. The house in the background offers an uncomfortable reminder that only the thinnest veneer of civilized behavior separates humanity from this kind of brutality

LEONARD KOSCIANSKI, b. 1952

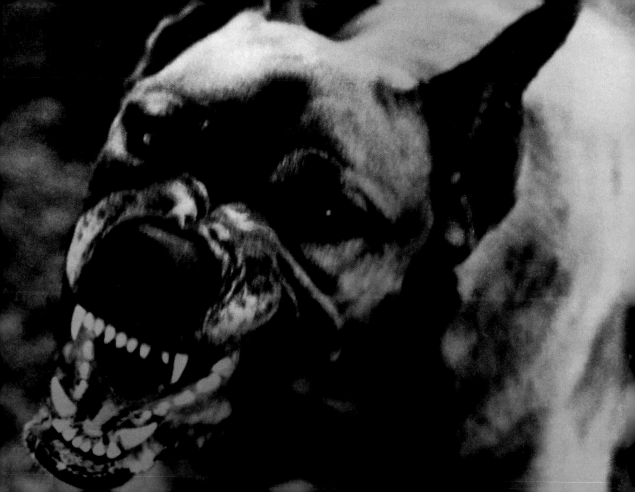

LANFIELD
THE HOUND OF THE BASKERVILLES
1939

 The hound is perhaps the most famous wild dog of all. Conan Doyle (1859–1930) admitted that he based his *Hound of the Baskervilles*—a "huge creature, luminous, ghastly, and spectral"—on an old West-Country legend. Without doubt, this was a variant of the ghostly Black Dog, a familiar omen of death, which features prominently in English folklore.

SIDNEY LANFIELD, 1900–72

ETRUSCAN
THE CAPITOLINE WOLF
C. 500 BC

 This is the most famous version of the *Lupa*, the she-wolf who suckled Romulus and Remus. It is the head of the statue, which inspired—among other things—the poster of the Rome Olympics (*see page 317*). It owes its present name to the Capitoline Museum in Rome, where it is on permanent display.

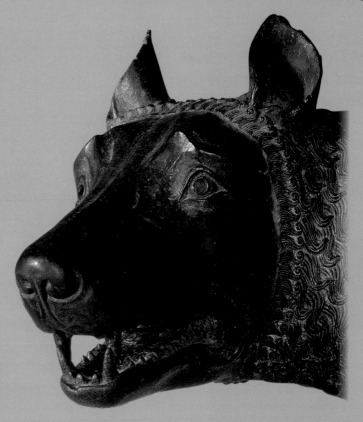

137

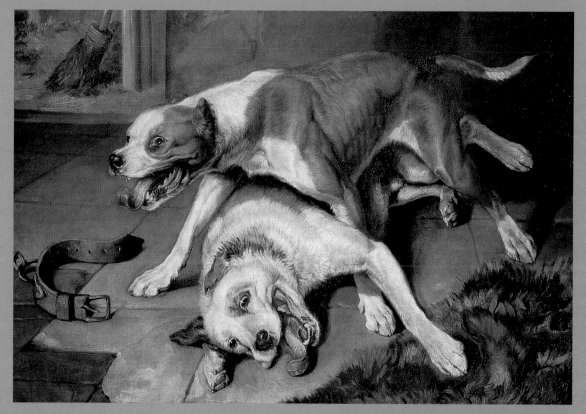

LANDSEER
FIGHTING DOGS
c. 1818

Landseer is chiefly associated
with sentimental scenes, but he also
portrayed nature in the raw. Here,
one dog has slipped its collar to
attack an intruder. After a fierce fight,
the dogs are catching their wind;
their eyes are rolling and they are
panting. The picture was exhibited
when Landseer was just sixteen.

Sir Edwin Landseer, 1802–73

GREEK
THE DEATH OF ACTAEON
c. 460 BC

Actaeon was a huntsman who
accidentally came upon Artemis and
her nymphs, bathing in a secluded
pool. Furious at the intrusion,
Artemis transformed the unfortunate
mortal into a stag, and he was
pursued and killed by his own
hounds. Here he is shown (still in
human form) fighting off the dogs.

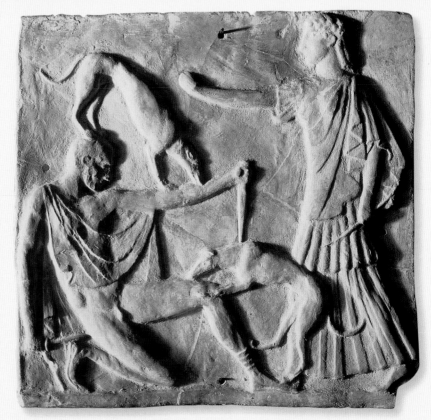

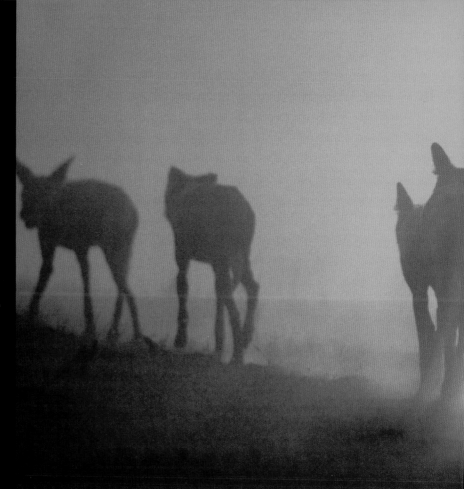

BALFOUR
PACK OF WILD
DOGS AT SUNSET
20th Century

An ominous sight for many animals. When hunting, packs of wild dogs or wolves make no attempt to conceal their approach. The key to their success is stamina and teamwork. Once they have encircled a victim, they share the workload of chasing it. As one pursuer tires, another takes over and the first one rests. This process is repeated until the prey is exhausted, when the pack moves in for the kill.

DARYL BALFOUR, 20th Century

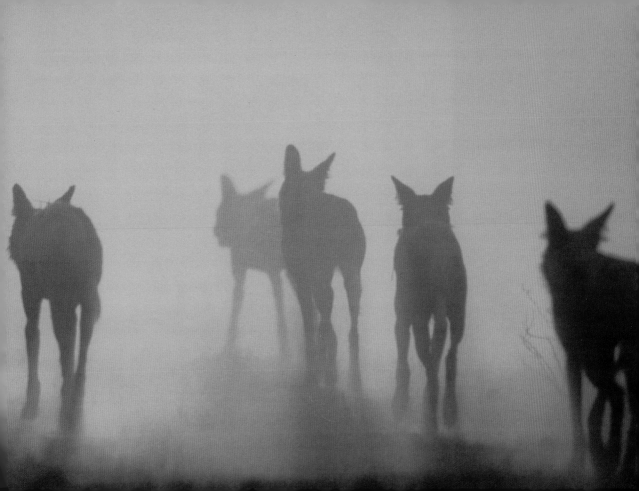

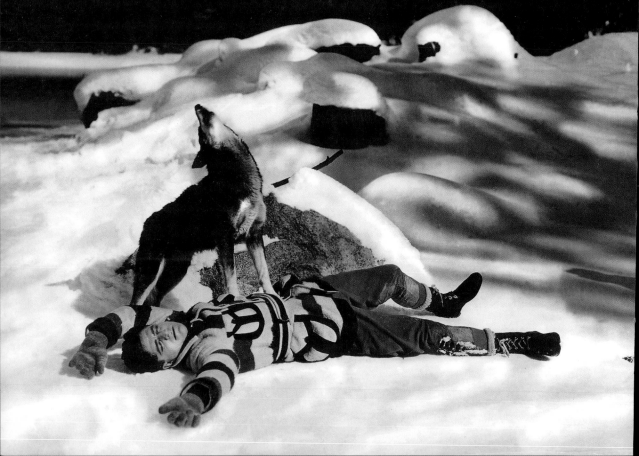

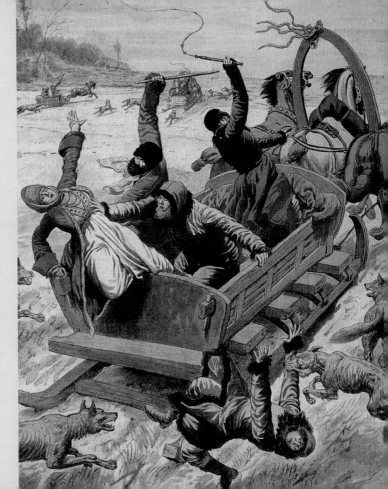

GERMAN

UNDER THE ALASKAN WOLF
1930

Wolves are indigenous to many parts of the northern hemisphere, although they are perhaps at their most dangerous in Arctic regions, where food is scarce. The novels of Jack London (1876–1916) created a vogue for adventure movies set in the frozen north, where packs of famished wolves preyed upon unwary settlers. This still comes from a German movie.

FRENCH

A RUSSIAN WEDDING PARTY ATTACKED BY WOLVES
1911

This highly melodramatic view of Russian life was published in a French magazine, *Le Petit Journal*. Wolves do hunt in packs, but they tend to isolate an individual victim at an early stage. Once this target has been selected, they then take it in turns to give chase, until the victim is exhausted and succumbs.

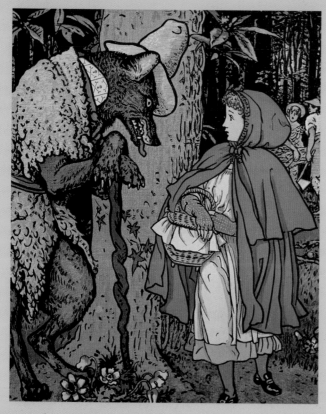

CRANE
LITTLE RED RIDING HOOD
19th/20th Century

The earliest version of this familiar tale was by Charles Perrault (1628–1703), although he based it on older folk traditions. Perrault's account ended very abruptly, with the little girl being gobbled up. In French lore, the wolf was originally a *bzou* (a type of werewolf). Crane's illustration also incorporates the proverb about the "wolf in sheep's clothing."

WALTER CRANE, 1845–1915

SPECHT
WOLF
1890

The wolf is the most savage member of the dog family. In a recent survey it was found that the average wolf breaks 29 percent of its teeth, because it spends so much of its time cracking bones. The creature is particularly dangerous during the mating season, when fights over she-wolves are commonplace.

FRIEDRICH SPECHT, 1839–1909

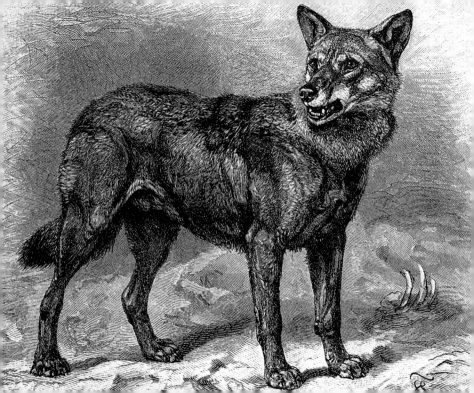

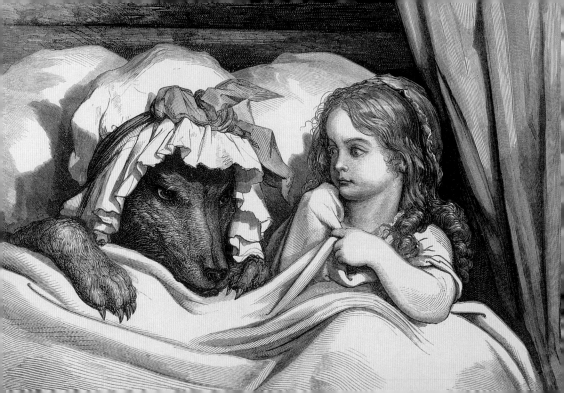

DORÉ

LITTLE RED RIDING
HOOD AND THE WOLF
1862

The symbolic meaning of this famous tale has been the subject of much speculation. Among psychoanalysts, the most common view is that the wolf represents the male seducer, while the true danger facing the little girl is her budding sexuality. Others interpret the tale in Oedipal terms: the girl wants to be seduced by her father (the wolf), but can accept this only when her mother (grandmother) is no longer around.

GUSTAVE DORÉ, 1832–83

HANSEN

FENCE, ROSES, AND DOGS
1993

As so often in his work, Hansen stresses the contrast between human and canine viewpoints. Smells are immensely important to dogs. In this picture Hansen emphasizes the anal region of the creature, and includes a fence—a favorite target for urinating dogs. To humans, these odors are distasteful but, to a dog, they are as welcome as the fragrance of roses.

GAYLEN HANSEN, b. 1921

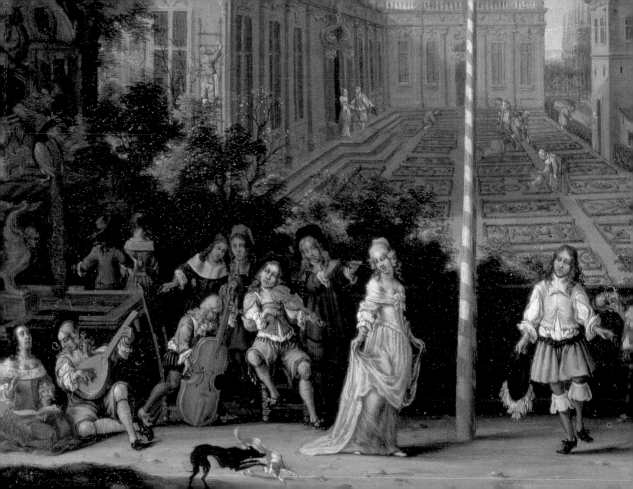

GYSELS
AROUND THE MAYPOLE
17th Century

Gysels's elegant composition combines two
well-worn themes. In part, it is a calendar scene,
illustrating the various working activities that take
place in the month of May. In addition, it portrays
a Garden of Love, where young couples disport
themselves in idyllic surroundings. The squabbling
dogs inject a note of realism, while also hinting that
the course of true love does not run smoothly.

PIETER GYSELS, C. 1621–90

149

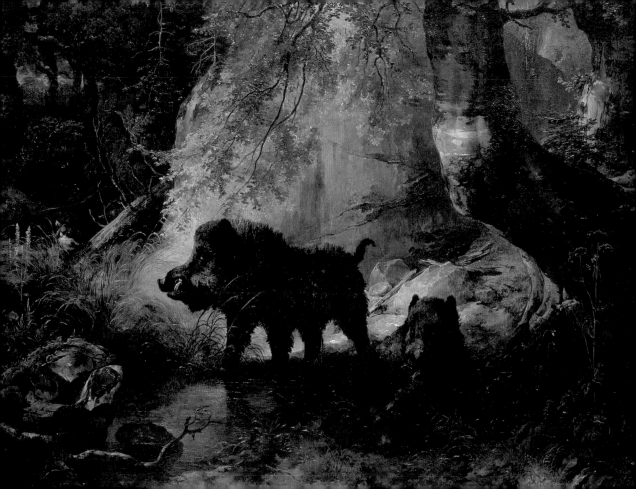

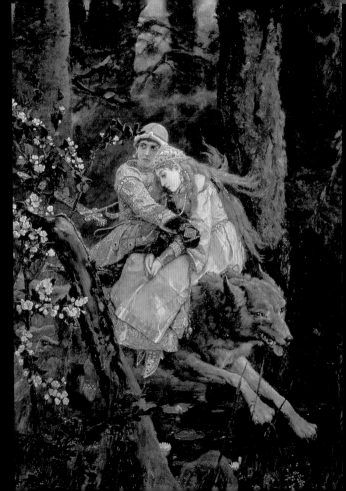

> **"** No matter how much you feed a wolf,
> he will always return to the forest. **"**

RUSSIAN PROVERB

GAUERMANN
WILD BOAR AND WOLF
1835

Wolves are versatile hunters, operating equally effectively in open plains or in heavily wooded regions. They usually hunt in packs, but an animal that has lost its mate will often abandon the group and become a genuine lone wolf. In this scene, a boar has scented trouble from one of these mavericks and has raised its bristles, to make itself appear larger.

FRIEDRICH GAUERMANN, 1807–62

VASNETSOV
IVAN AND THE GRAY WOLF
1889

In this famous Russian legend, Prince Ivan went in search of a mystical firebird, which had been stealing the king's magic apples. On the way he befriended a gray wolf, which helped him in his quest. Here, the beast carries Ivan and Yelena, his future bride, through a dangerous forest.

VICTOR VASNETSOV, 1848–1926

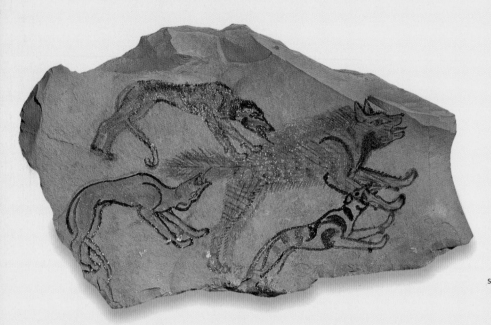

EGYPTIAN

DOGS CHASING A HYENA
New Kingdom period,
1555–1080 BC

The dogs depicted on this limestone ostracon (potsherd) would appear to be greyhounds. Normally the Egyptians used the hyena dog or Cape hunting dog when pursuing hyena, though they eventually exchanged this for an animal resembling the modern fox terrier.

BUSBY

MAD DOG
1826

Dogs suffering from rabies or hydrophobia might well cause panic in the streets. Once infected with this terrible disease, a normally docile animal would suddenly turn vicious, before developing paralysis and dying. The term "hydrophobia" was widely used, in the mistaken belief that rabid dogs were afraid of water. In fact, this only affected human victims, who would suffer painful throat spasms if they attempted to drink.

THOMAS BUSBY, fl. 1804–37

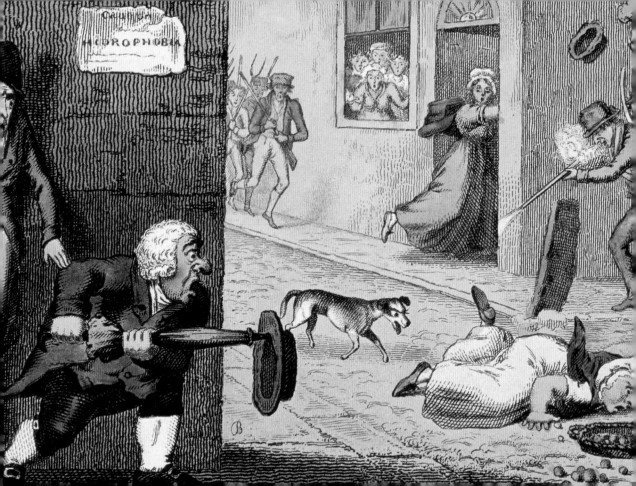

next pages ▶

next pages ▶

" Dogges bark at
the moone without
any cause. "

THOMAS CRANMER, 1489–1556

BILIBIN
PRINCE IVAN AND
THE GRAY WOLF
1899

🐺 The wolf in the
firebird legend could
hardly be more different
from his counterpart in
Little Red Riding Hood.
Here, the young prince
lies slain and some crows
are circling above him. The
gray wolf will resuscitate
Ivan, however, and help
him take revenge on his
evil brothers.

IVAN JAKOWLEWITSCH BILIBIN,
1876–1942

BALOG
COYOTE
20th Century

🐺 There are about a dozen
varieties of the coyote or prairie
wolf, which is native to North
America and Mexico. It hunts in
packs and, although is now officially
a protected species, is still feared for
its occasional attacks on livestock.

JAMES BALOG, 20th Century

after GRIMM
LITTLE RED CAP
C. 1905

🐺 In the version by the Brothers
Grimm, published in 1812, Little
Red Riding Hood's headgear was
changed to a cap. This may be a
reference to the Liberty Cap (symbol
of the French Revolution of 1789),
reflecting anti-French sentiments
in Germany at the time.

after JACOB GRIMM, 1785–1863, and
WILHELM GRIMM, 1786–1859

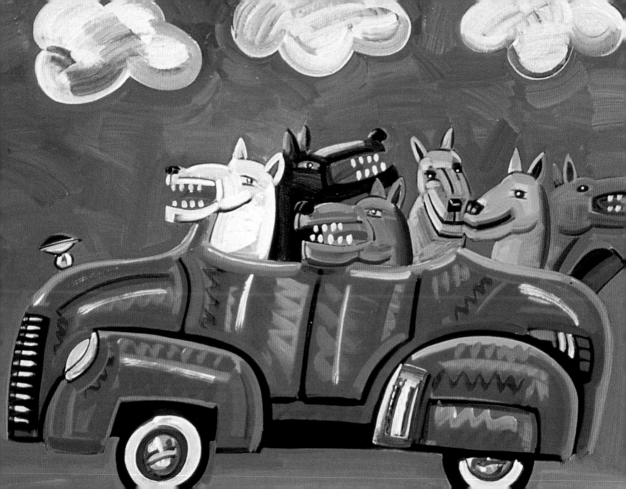

it's a dog's life

FRANK ROMERO
LOS 6 LOBOS

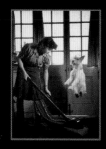

HUTTON
SPRING-CLEANING

Dogs have become such an integral part of the human way of life that it is easy to regard them as entirely domesticated animals. Many of their behavior patterns, however, hark back to their primeval origins, when they roamed free in the wild.

Above all else, dogs are social animals. They are designed to operate in packs, and many of their actions are geared toward communal activity. Howling, for example, is a signal from animals that have become separated from the main body of the pack. In wolves, this is most common in the early morning or evening, summoning other pack members for a group hunt. Although this might not seem to apply to domestic dogs, they may still howl if they are left alone for long periods. In doing so, they are effectively calling out to members of their human pack to come and join them. Some dogs have also been known to "sing along" when

LESTER
THE AUDITION

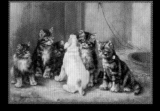

they hear a musician or vocalist performing. In such cases they are simply misreading the singer's efforts as a primitive tribal call and are responding accordingly.

after BONER
THE DOG AND
THE WOLF

In addition to sound, dogs also communicate through smell. All of them have powerful scent glands, which are located beneath their tails. The emitted odors offer detailed, personal information about the bearer, which is of immense interest to every other dog. This is why, when two dogs meet, their initial reaction is to sniff each other's rumps. Confident or dominant dogs raise their tails, so that their superiority can readily be detected; weaker animals place their tails between their legs, in an attempt to cover their scent glands and mask their insecurity. Dogs

TENRÉ
INTRODUCTIONS

... g a leg and lowering a drink indirectly as high above ground level as possible.

In common with their human owners, dogs continue to indulge in playful behavior throughout their lives. When dogs are playing among themselves, their games usually consist of pretend versions of their normal activities— fighting and chasing. Although to an outsider these can appear worryingly real, the dogs learn at a very early age to use "soft" bites, so that they do not hurt each other. To make the situation doubly clear, play is often preceded by a gesture of invitation, in which the dog performs a type of bow, lowering its front half to the ground, while keeping its rump in the air.

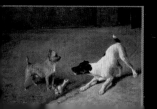

Pack leaders are essential. Without them, for instance, the half-wild husky sledge teams would not be able to operate, because the dogs would fight among themselves. Similarly, every hunt would end in mayhem, with the hounds squabbling over their quarry.

In human households, pet dogs readily acknowledge their owner as the pack leader. Indeed, problems with a badly behaved dog usually occur only when, through poor training, the animal is allowed to gain the impression that it—rather than its owner—is the boss. There is, however, one crucial caveat. Throughout the dog family, the ownership of food overrides all other social relations. So, owners beware! The most submissive of dogs may react savagely if someone—even in play—tries to snatch away a tasty tidbit or a prized possession.

ALDIN
MISCHIEVOUS PUPPY

HARDY
BOB A JOB

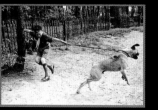

HANSEN
DOG
1989

 Hansen's dogs are rarely very attractive creatures. With its hairless patch around the rump and its golf-ball eyes, this one looks decidedly fleabitten and mangy. It clearly has a playful personality, however, for here it is toying contentedly with a flower.

GAYLEN HANSEN, b. 1921

PIERRE
HOUND DOG II
20th Century

 A hound dog is slang for a scrawny mutt, a term that derives from an old Elvis Presley song. Give him a bone, however, and even the scruffiest mongrel will be happy.

CHRISTIAN PIERRE, b. 1962

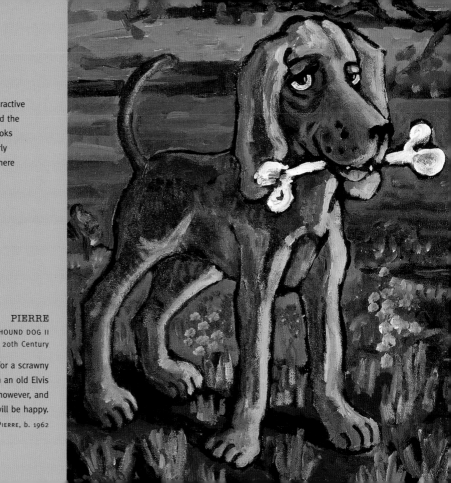

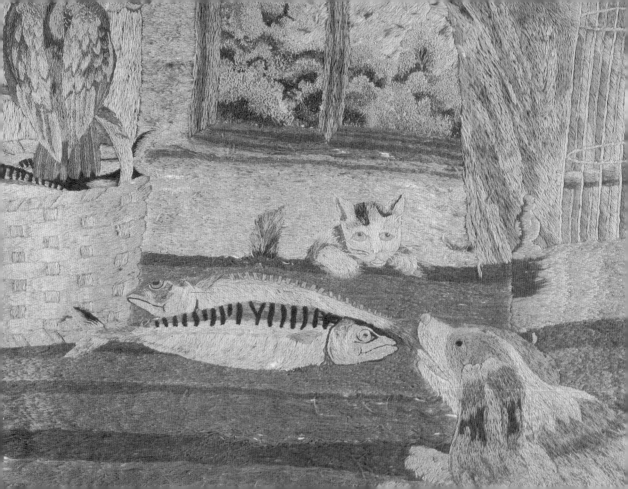

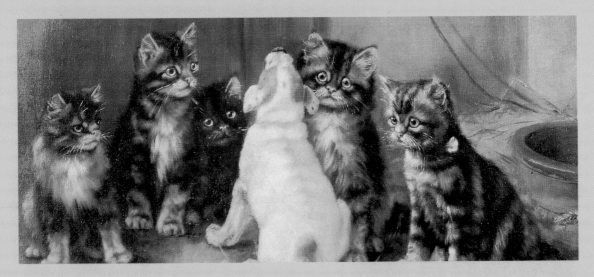

ENGLISH
CONFRONTATION ACROSS A TABLE
19th Century

Contrary to popular belief, most dogs are very partial to fish. This amusing woolwork scene depicts a three-way conflict of interest, as a spaniel, a cat, and a parrot all cast a greedy eye on some fish, which has unwisely been left on the table.

LESTER
THE AUDITION
c. 1885

Dogs react to a wide variety of noises. They may start to howl or whine if they hear any sound that might be interpreted as another pack member, even if it is only a song on television or a ringing telephone. It is not clear what has set off this particular pup but, in these wide-eyed kittens, he has clearly met with an unappreciative audience.

ADRIENNE LESTER, 19th Century

167

ALMASY
PATIENCE
1946

Most dogs are curious rather than hostile, where cats are concerned. They will normally only give chase if the cat starts running, thus triggering off their natural hunting instincts. Here, a pair of alert hounds reserve judgement, waiting for the kitten to make the first move.

PAUL ALMASY, b. 1906

FOUJITA
CATS AND DOGS
1924

Foujita, a Japanese artist who worked mainly in France, was better known for his pictures of cats than for his dogs. Nevertheless, these elegant Pekingese underline the importance of the breed in the East. In China they were revered, because of their resemblance to the sacred lions of Buddha. Their sale was prohibited and examples reached the West only in 1860, after British troops had looted the Imperial Palace.

TSUGOUHARU (or LÉONARD) FOUJITA, 1886–1968

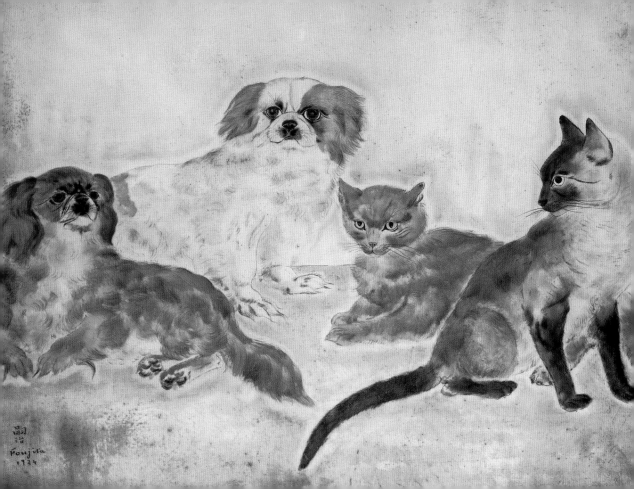

Edmund Lunde

LYNDE
MOTHER'S PRIDE
19th Century

 Bitches usually stay close to their litters, ready to warn off any strangers with aggressive growling. In the nineteenth century it was common practice to keep puppies in an outhouse, but the current view is that they are better off indoors, where they can learn about domestic life as early as possible.

RAYMOND LYNDE, 19th Century

ENGLISH
STABLE FRIENDS
19th Century

 Cats and dogs do not make natural bedfellows. On the most basic level, dogs are social animals, while cats are loners. Nevertheless, some cats may be treated as honorary dogs, if they are introduced at an early age and encouraged to play together.

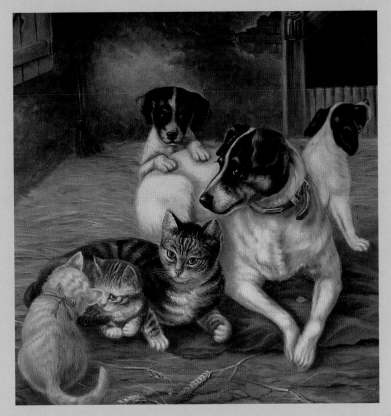

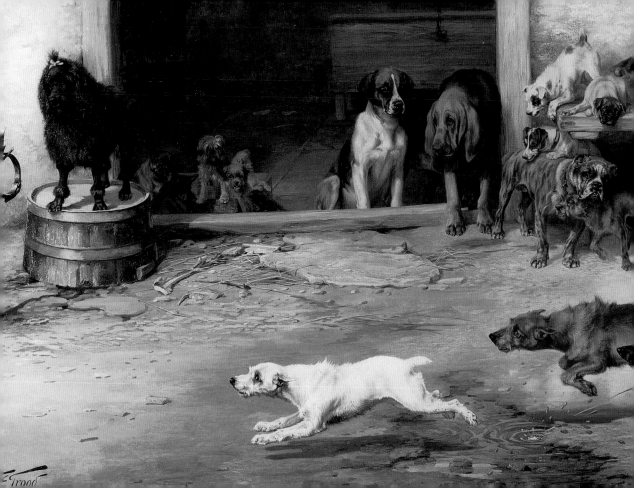

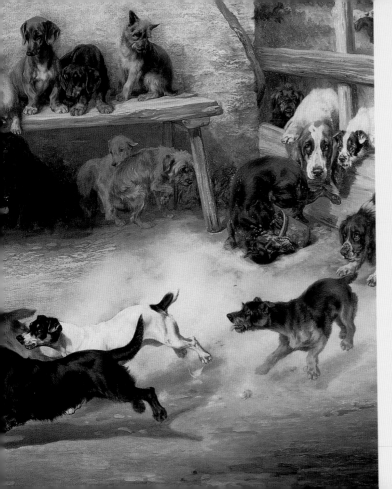

" This business is dog
eat dog and nobody
is gonna eat me. "

SAMUEL GOLDWYN, 1882–1974

TROOD
HOT PURSUIT
1894

The bulk of Trood's work came from portrait commissions, but he occasionally produced bustling group scenes, in which a wide range of breeds were exhibited together in a single picture. The theme here is improbable, though the depiction of the different breeds is meticulously accurate. There are also some humorous touches, most notably in the shape of the large poodle on the makeshift podium, which is waiting to award a brand-new collar to the winner of the race.

WILLIAM HENRY HAMILTON TROOD, 1860–99

173

ARMFIELD
THE BONE OF CONTENTION
1859

In most dealings between themselves, dogs observe a rigid social hierarchy. Usually the dominant animal will make its position clear, through an established set of signals. This system can break down when food is involved. Possession, in this instance, is the full ten-tenths of the law, and a normally submissive dog will readily defy a pack leader, if its bone is threatened.

GEORGE ARMFIELD, C. 1820–93

ALDIN
MISCHIEVOUS PUPPY
20th Century

" Let dogs delight to
bark and bite,
For God hath made
them so;
Let bears and lions
growl and fight,
For 'tis their nature too. "

ISAAC WATTS, 1674–1748

Many dog owners will be all too familiar with a sight like this. Often it may be caused by separation anxiety. A dog, left alone at home, will become agitated and take out his frustration on domestic objects. If the perpetrator can manage such a charmingly submissive pose, however, he may succeed in defusing his owner's anger.

CECIL ALDIN, 1870–1935

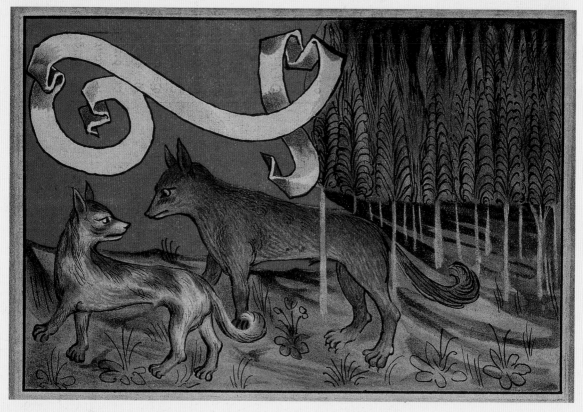

after BONER

THE DOG AND THE WOLF

14th Century

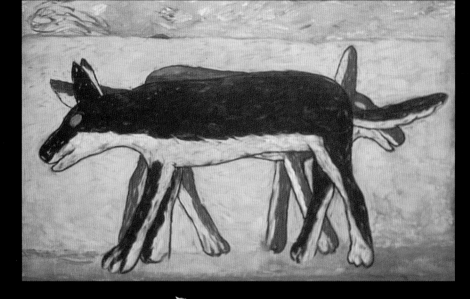

This miniature comes from a fifteenth-century manuscript version of *Der Edelstein* *(The Precious Stone)*, a popular German anthology of fables. The stories had been translated from the Latin during the previous century by a Dominican monk named Boner. Traditionally wolves were portrayed in fables as vicious, predatory creatures, but the dog's role was more varied. It could represent tenacity, loyalty, or foolishness.

after ULRICH BONER, 1300–49

HANSEN

TWO DOGS

1991

The scent glands beneath a dog's tail contain vital information about its strength and status. For all dogs, these olfactory signals are far more revealing than any visual details. So it is both polite and necessary for dogs to make their introductions through a mutual sniffing process.

GAYLEN HANSEN, b. 1921

177

EMMS
TWO DOGS WITH A BONE
1896

The dog on the right is performing the characteristic canine "bow," indicating to its companion that it wants to play. The smaller dog has not yet made up its mind. Its erect ears and tail are hostile signals, suggesting a certain reluctance to give up ownership of the bone.

JOHN EMMS, 1843–1912

BOGDANY
TWO DOGS IN A LANDSCAPE (DETAIL)
17th Century

Even though the birds and the dogs are very much alive, this painting is rooted in the Dutch still-life tradition. It brings together a fine array of nature's riches and afforded the artist an opportunity to demonstrate his remarkable versatility.

JAKOB BOGDANY, 1660–1724

next pages ▶

TROOD
UNCORKING THE
BOTTLE AND A
SURPRISING RESULT
1887

Trood's dog paintings usually displayed a typically Victorian blend of realism and sentimentality. This whimsical excursion, however, was a foretaste of things to come. The spectacle of two little dogs bowled over by a popping cork anticipated the comic antics of twentieth-century animated cartoons.

WILLIAM HENRY HAMILTON
TROOD, 1860–99

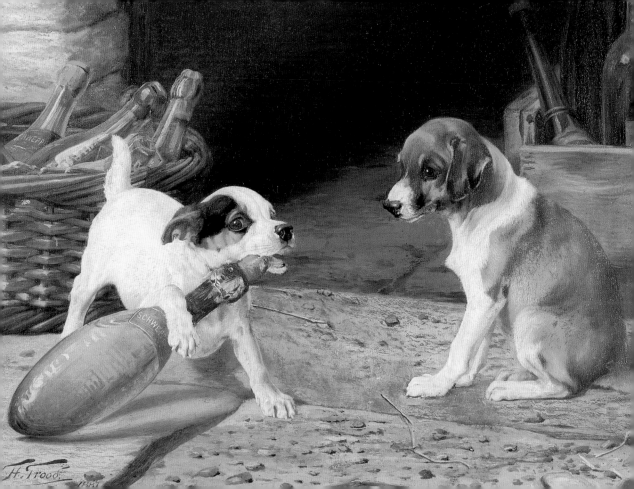

H. Frood
1889

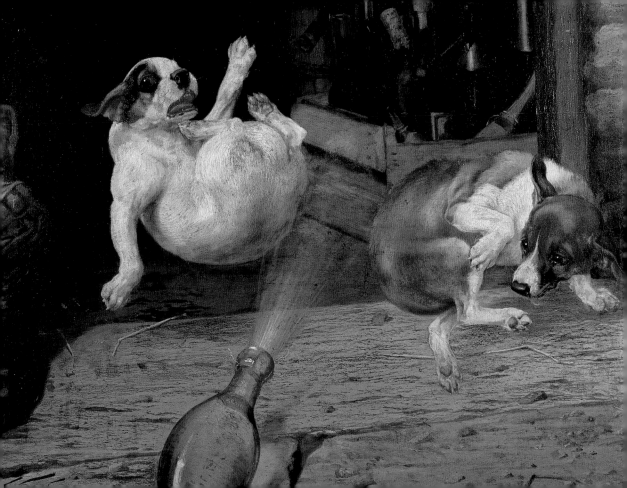

after LANDSEER
DIGNITY AND IMPUDENCE
c. 1839

This is a copy of one of Landseer's most popular canine portraits. The subjects were a bloodhound named Grafton and a Scotch terrier called Scratch, both of which belonged to Jacob Bell, a research chemist. Grafton had a reputation for fighting with other dogs, but here he permits his impish little companion to share his kennel.

after Sir Edwin Landseer, 1802–73

MARSHALL
THREE DOGS
19th Century

Butter wouldn't melt in their mouths, but the telltale signs of a shredded letter confirm that this trio have been up to mischief. Some dogs will attack any mail that comes through the mailslot, regarding it as an invasion of their territory. They bark, in order to chase away the mailman, and react with even greater fervor when the impudent fellow returns the following day to repeat the offence.

William Elstob Marshall, fl. 1859–81

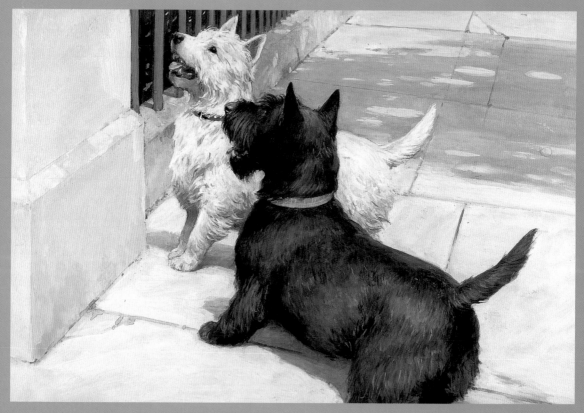

SCOTT
BLACK AND WHITE
20th Century

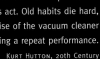 Up until the nineteenth century there was considerable confusion over many of the smaller breeds of terrier. Skyes, Dandie Dinmonts, West Highland whites, and cairns were often grouped together under the blanket term of Scotch terrier. Gradually separate clubs were founded for each of the different breeds, and Scotch was changed to Scottish (1887). The picturesque contrast between a black Scottie and a West Highland white has proved irresistible for many artists.

SEPTIMUS SCOTT, 1879–C. 1932

HUTTON
SPRING-CLEANING
1949

No, it's not a trick photograph. This little terrier learned to make dramatic leaps when it belonged to a circus act. Old habits die hard, however, and the noise of the vacuum cleaner has prompted it into giving a repeat performance.

KURT HUTTON, 20th Century

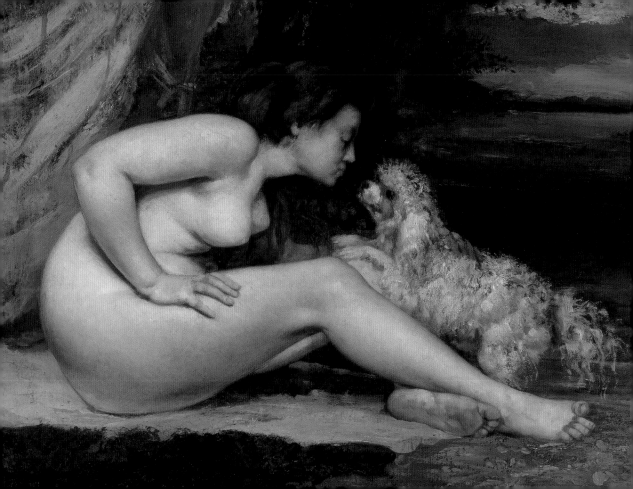

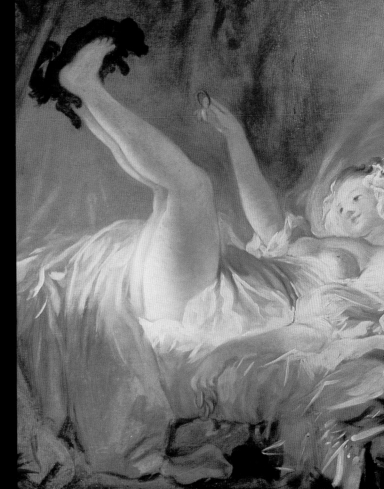

COURBET
FEMALE NUDE WITH DOG
1861–2

Courbet was extremely
fond of dogs. He included one
in a self-portrait and featured
others in a number of brutally
realistic hunting scenes. Here,
he is attempting to appeal to
a more popular market—the
restrained, nineteenth-century
equivalent of the rococo
boudoir picture.

GUSTAVE COURBET, 1819–77

FRAGONARD
LA GIMBLETTE
1760S

Erotic boudoir scenes were a staple
feature of rococo art. Fragonard painted
several pictures on this theme, using
the puppy to preserve a semblance
of decency. The *gimblette* mentioned in
the title is the ring-biscuit, which the girl
is offering the dog.

JEAN-HONORÉ FRAGONARD, 1732–1806

' At one of the last dog shows in which she was entered with two or three of her best male pups, she was reluctant to get up on the bench assigned to her and her family, and so I got up on it myself, on all fours, to entice her to follow. She was surprised and amused, but not interested, and this was also true of my wife, who kept walking past the bench, saying out of the corner of her mouth, 'Get off that bench, for the love of heaven!' **"**

JAMES THURBER, 1895–1961

ENGLISH
WAITING FOR THE JUDGES
1967

No wonder toy dogs always appear so craven. This candid snapshot demonstrates just how terrifying it is to live in a world of giants. The scene is Cruft's, Britain's most important dog show, which is now staged annually in Birmingham.

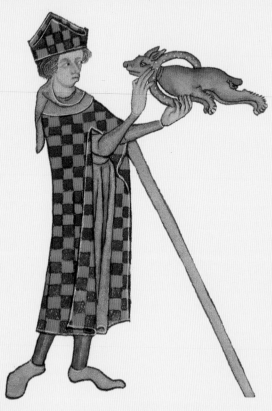

TOULOUSE-LAUTREC

IN THE CIRCUS
1899

The Impressionists loved portraying modern, popular entertainments in their pictures. Performing dogs were a common sight in circuses of the day. In Toulouse-Lautrec's vivid drawing, a clown called Footit advances rather menacingly on a terrified poodle.

HENRI DE TOULOUSE-LAUTREC,
1864–1901

LUTTRELL PSALTER

PERFORMING DOG
14th Century

Medieval illuminators liked to decorate the margins of their manuscripts with amusing, miniature scenes. Even when the texts were religious (psalters were versions of the Book of Psalms), these scenes would frequently be humorous or satirical. Here, a man wearing a bishop's miter holds up a hoop for an acrobatic dog.

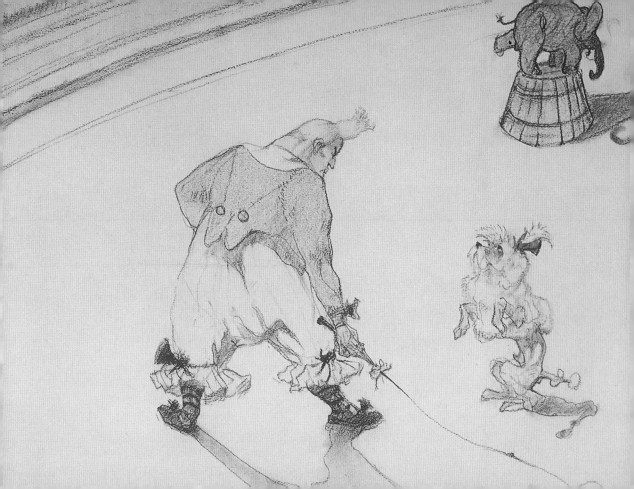

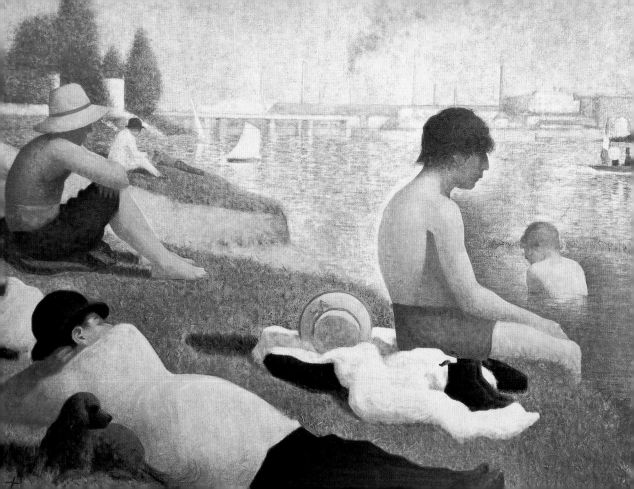

SEURAT
BATHING AT ASNIÈRES
1883–4

Seurat borrowed the subject matter of the Impressionists, but tried to give it a timeless, permanent feel. The dog was a late addition to the composition and its head, like several others in the picture, is shown in strict profile, gazing to the right. Asnières was a popular bathing spot on the Seine, where workers could enjoy a brief respite from their jobs in the factories, which are faintly visible in the distance.

GEORGES SEURAT, 1859–91

TUKE
BOYS BATHING
1912

Tuke was an English Impressionist, who specialized in painting bathing scenes in his beloved Cornwall. His preference for depicting nude boys was controversial at the time but, in retrospect, his idyllic compositions provide a poignant reminder of the generation of young men who were slaughtered in the Great War.

HENRY SCOTT TUKE, 1858–1929

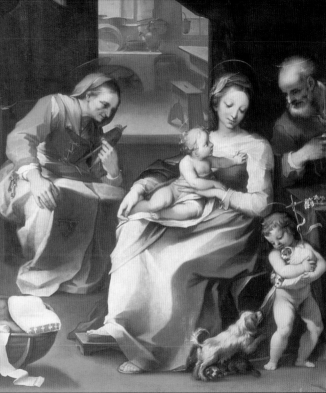

" The greater love is a mother's; then comes a dog's; then a sweetheart's. "

POLISH PROVERB

SALIMBENI
HOLY FAMILY
16th Century

Mannerist painters looked for new and unusual ways of portraying familiar themes. In this instance, Christ and his parents are depicted in a contemporary domestic setting, complete with a kitchen in the background. To add to the air of informality, a mischievous puppy tugs at a dangling piece of cloth, held by the infant John the Baptist.

VENTURA DI ARCANGELO SALIMBENI, 1568–1613

BONFIGLI
THE ANGEL GABRIEL
15th Century

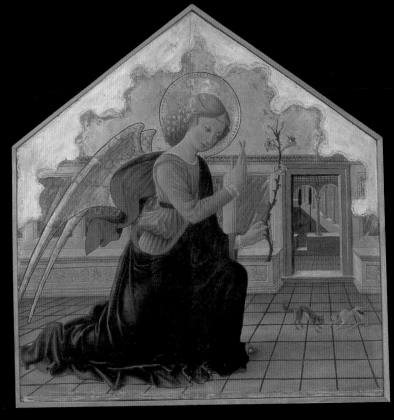 This is the left-hand panel of an Annunciation. Gabriel holds a lily, symbolizing purity, and informs the Virgin Mary (in the unseen right-hand panel) that she will bear a child. The scene is set in the living quarters at the Temple of Jerusalem, and the artist has tried to create a convincing, domestic atmosphere by showing a cat and a dog approaching each other with suspicion.

BENEDETTO BONFIGLI, 1420–96

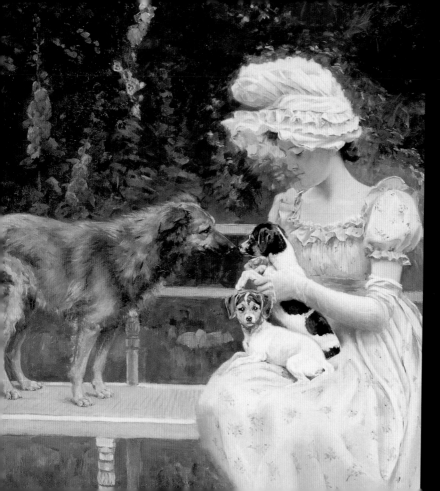

TENRÉ
INTRODUCTIONS
19th Century

Puppies need to be familiarized at an early stage with all members of the household, whether these are humans or other dogs. Here, one puppy is being introduced to a different breed of dog, while his companion appears more interested in the artist.

CHARLES HENRY TENRÉ, 1864–1926

HORLOR
WAITING FOR FATHER'S RETURN
19th Century

As were many Victorian animal painters, Horlor was greatly influenced by Sir Edwin Landseer. Typically his pictures were of cluttered interiors, inhabited by an array of dogs and other domestic creatures. The setting was usually a gamekeeper's or farmer's cottage, where the emphasis was firmly on the virtues of hearth and home.

GEORGE W. HORLOR, fl. 1849–91

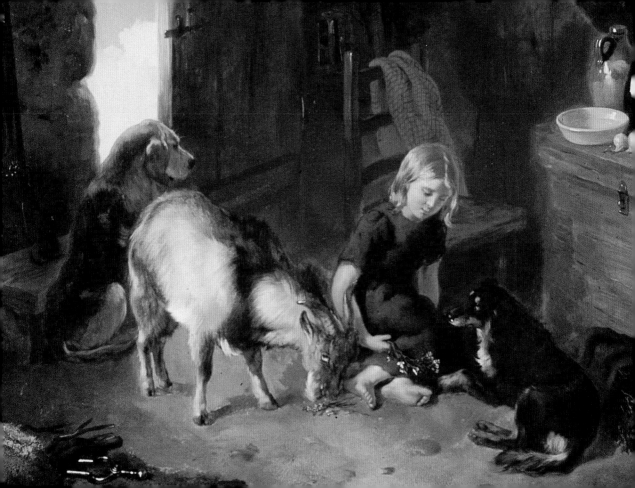

WALLER
YORKSHIRE DANDIES
1889

 Dandie Dinmonts take their name from a character in *Guy Mannering* (1815) by Sir Walter Scott (1771–1832). In the novel Dandie was a Lowland farmer and a keen huntsman. He kept a pack of these terriers, giving them such names as Auld Mustard, Young Pepper, and Little Mustard. Such was the popularity of the book that, for a time, the breed was known as the Pepper and Mustard. The first official Dandie Dinmont club was founded in 1876.

LUCY WALLER, fl. 1882–1906

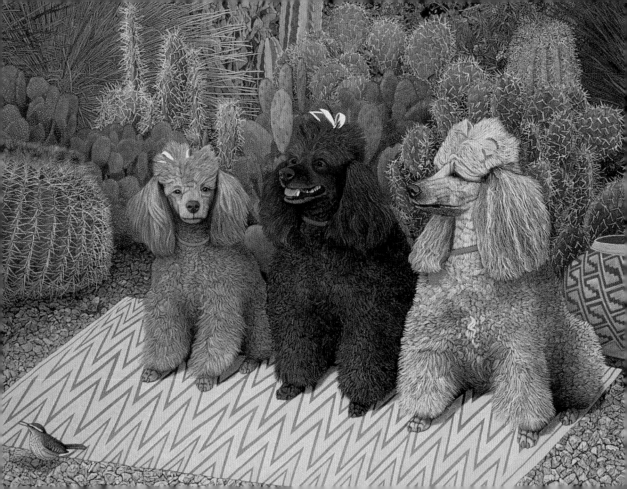

WINSRYG
THREE POODLES IN PHOENIX
1996

 The practice of clipping a poodle's coat is very old. The intention may have been to make the dog more mobile when hunting, though some believe that it was done for purely decorative reasons, to give it the appearance of a lion cub. Frequent trips to the groomers encourage the addition of bows and elegant collars, as in this portrait of pampered Arizonian poodles in a cactus garden.

MARIAN WINSRYG, b. 1941

CHAPMAN
WHITE POODLES WITH A BIRD
1858

Initially, poodles were mainly imported into Britain from Germany (where they probably originated), and were used extensively for hunting waterfowl. Indeed, the name is thought to have derived from the German word *pudeln* (to paddle about). Subsequently, lighter versions of the breed were brought across from France and Belgium. Some of these—like the pair depicted here— were closely allied to the bichon frise.

JOHN WATKINS CHAPMAN, fl. 1853–1903

REINAGLE
THE GREENHALGH CHILDREN
1803

Most dogs love to chase and retrieve balls or sticks. The game works well, because it activates a dog's natural hunting instincts. Here, the children have decided to throw pebbles, which is not recommended.

RICHARD RAMSAY REINAGLE, 1775–1862

HARDY
BOB A JOB
1949

In a more innocent age, boy scouts used to raise funds by performing minor domestic chores for a bob (a shilling or, in decimal coinage, five pence). Clearly, given the boisterous temperament of the dog, this lad is going to have to work hard to earn his money.

BERT HARDY, 1913–95

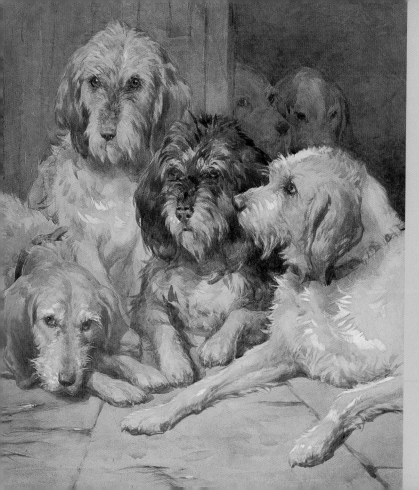

TAYLER
THE OTTER HOUNDS
19th Century

As the name indicates, otter hounds were originally used for hunting otters. In England they can be traced back to the reign of Henry II (1154–89), although the sport reached the height of its popularity in the nineteenth century, when some landowners kept packs of otter hounds. The origin of the breed is obscure, with one early source describing it as "a rough sort of dog, somewhere between a hound and a terrier."

JOHN FREDERICK TAYLER, 1802–89

EMMS
AT THE WINDOW
1899

Although he is best known for his depictions of hunting dogs, Emms also acquired a reputation for producing unusual portraits of pets. Here, he found a suitable pretext for painting a row of pleading canine expressions by locking the animals out in the garden.

JOHN EMMS, 1843–1912

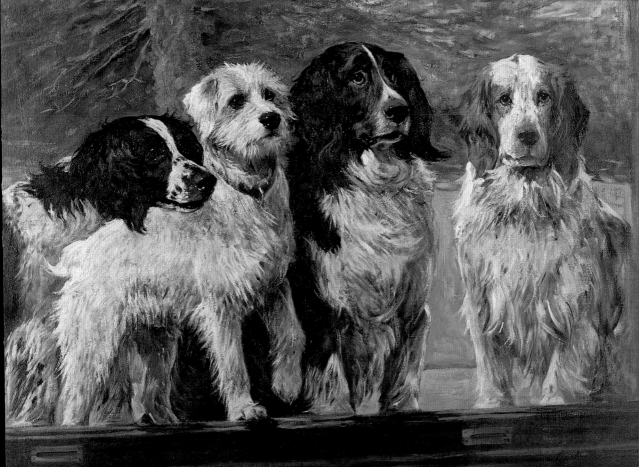

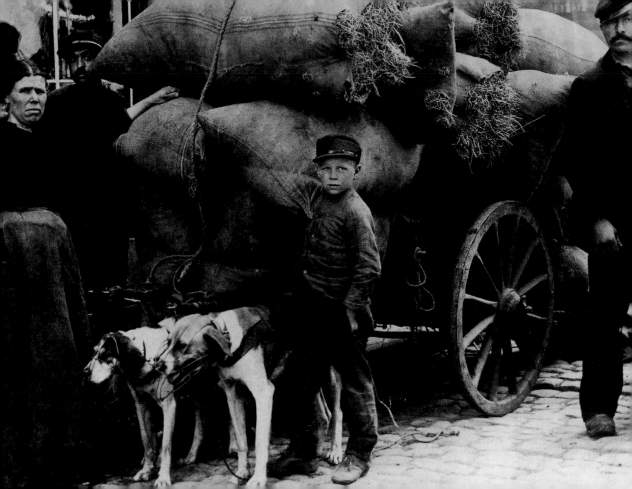

working dogs

BELGIAN
DOGCART WITH
AGRICULTURAL PRODUCE

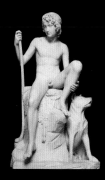

THORVALDSEN
SHEPHERD BOY

The working partnership between humans and dogs extends back into the realms of antiquity. From a very early stage dogs were used to protect and control flocks of sheep. The choice of breed varied from place to place, but the initial preference was for strength and ferocity, since the creature's primary duty was to guard the flock from wolves and thieves. In Roman times these dogs wore heavy spiked collars, to protect their throats and ward off assailants. Then, as the threat from wolves receded, shepherds began to opt for lighter, nippier breeds, which could help them marshal their charges. One of the most successful breeds was the collie, which took its name from a type of mountain sheep (a "colley"), found in the Highlands of Scotland.

In addition to being fine herders, dogs have also proved invaluable in haulage work. The most famous examples are the huskies, which are widely used in the polar regions. Their name

RAYMOND
THE BAD SHEPHERD

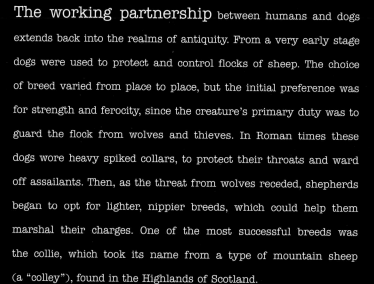

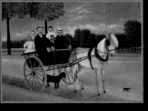

(which derives from "Esky," a slang word for "Eskimo") is often employed as a blanket term for a number of different breeds, including malamutes, Samoyeds, and keeshonds. Huskies are resilient enough to withstand the extreme cold and pull their heavily laden sledges through raging blizzards, but they must also be sufficiently sure-footed to avoid patches of thin ice. In some areas the dogs are interbred with wolves to maximize their strength; wherever possible, sledge teams are drawn from the same litter of puppies.

Dogs were also widely used as draft animals in warmer regions. During the nineteenth century Newfoundlands and mastiffs could be seen pulling milkcarts and small tradesmen's vehicles in many parts of Europe. The practice was banned in Britain in 1837, but in Holland and Belgium it continued well into the twentieth century.

its incredible scenting ability. A hound's nose is so sensitive to the smell of the acids in sweat that it can retrieve a pebble thrown onto a beach, simply by sniffing the person's hand. As a result, dogs have long been employed in tracking and detection. In the first century AD the Greek historian Plutarch (c. 46–c. 120) reported how a dog managed to identify the criminal who had murdered his master; and the bloodhound became known as the sleuth hound or slot hound during the Middle Ages. In the United States tracker dogs gained an unsavory reputation after they were used to hunt down runaway slaves, but they have also played an important part in police work: a bloodhound called Nick Carter was credited with the capture of more than 600 criminals.

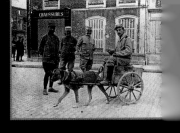

More recently, sniffer dogs have proved invaluable in the war against drugs and terrorism. In a less hazardous vein, dogs have also been used to scent out rats, truffles, and even termites. They are better known, though, for their rescue work in mountainous regions. The most famous breed is the Saint Bernard, which takes its name from Bernard de Menthon (923–1008), a monk who founded a hospice in Italy's Aosta Valley and trained these great dogs to go to the aid of travelers who got lost.

AMERICAN
GOLD FEVER
IN ALASKA

In recent military conflicts dogs have normally been used in passive roles—guarding military bases, carrying messages, or bearing first aid—but some soldiers liked to take their animals into battle with them. During the Napoleonic Wars a French dog named Moustache was even decorated for retrieving the regimental standard.

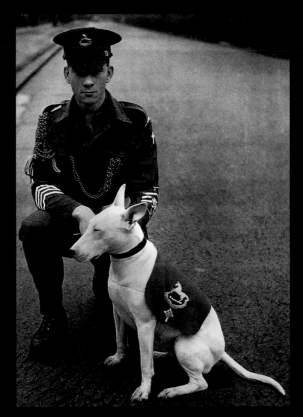

BRITISH
REGIMENTAL DOG
1949

Regimental dogs are the modern descendants of the original dogs of war. Nowadays they are used mainly on ceremonial occasions, rather than in the thick of battle. This was a bull terrier named Judy, the official mascot of the King's Liverpool Regiment, pictured with her handler. On her back she wears an embroidered copy of the regimental coat of arms.

VERNET
THE DOG OF THE
REGIMENT WOUNDED
1819

Vernet was best known as a military painter, specializing in scenes from the Napoleonic Wars (1803–15). Here, he underlines the perils of being a regimental dog, at a time when these animals were still taken into battle. They were usually kept near the standard, and it is no accident that this dog is being revived by a drummer, while Judy's handler (*see opposite*) was a drum major.
ÉMILE-JEAN-HORACE VERNET,
1789–1863

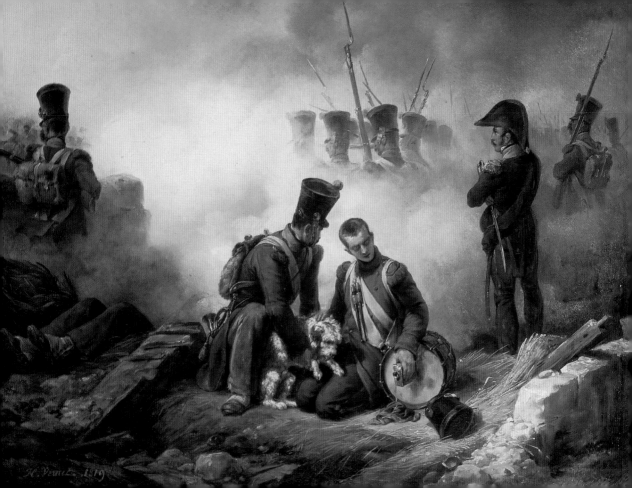

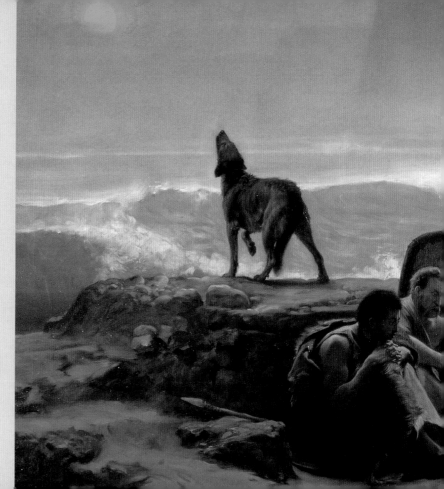

LECOMTE DU NOÜY

GAULISH WARRIORS
GUARDING THE COAST
1888

The Gauls were one of the Celtic peoples, and this painting was inspired by the Celtic revival of the late nineteenth century. A group of tribesmen huddles around a fire, while their dog bays at the moon. In fact Celtic dogs were renowned throughout the ancient world: Gaulish warriors placed vicious, barbed collars on their fiercest curs and used them in battle. They were also famed for their hunting prowess. Xenophon (c. 435–c. 354 BC) wrote, "For hunting hare, the Celtic dogs are preferable to all others."

JEAN-JULES-ANTOINE
LECOMTE DU NOÜY, 1842–1929

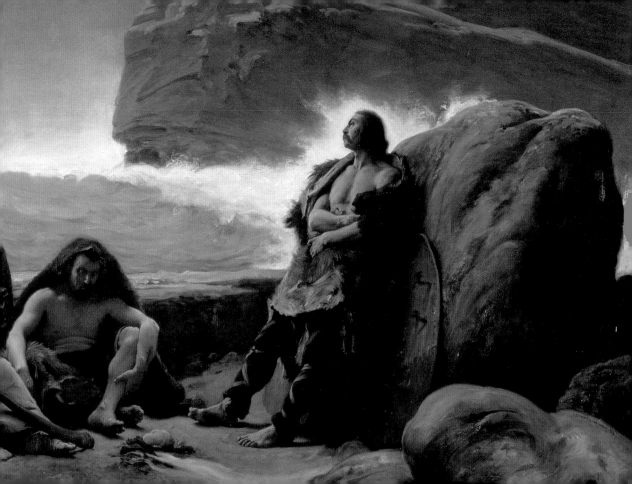

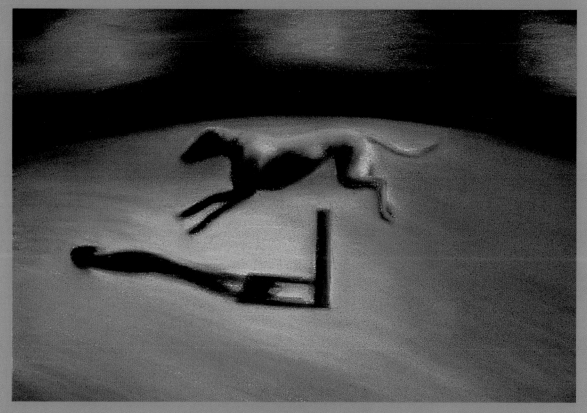

PALANKER
THE STORY OF O
1995

The "O" in question is Otla, Palanker's pet dog, which features regularly in her work. The title is also an ironic reference to Pauline Réage's powerful novel about obsessive love, also called *The Story of O*. This was turned into a controversial movie by Just Jaeckin in 1975.

ROBIN PALANKER, b. 1950

STERN
NIGHT OF THE
SHOOTING STARS
1991

Stern's pantheistic paintings deal with magic and longing. The childlike, half-formed figure of a woman stands on the back of a dog, gazing up at the heavens for inspiration.

PIA STERN, b. 1952

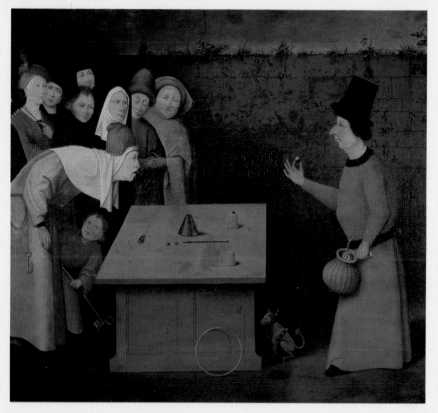

BOSCH

THE CONJUROR

c. 1470–80

At the start of his career, before he began painting his grotesque fantasies, Bosch executed a number of pictures about human folly. Here, a wealthy man is so distracted by the guiles of a magician that he fails to notice that his purse is being stolen. The conjuror's owl, a creature of the night, signifies that he is evil, and the curious, horned headgear of his dog reemphasizes these demonic associations.

HIERONYMUS BOSCH

(JEROME VAN AKEN),

c. 1450–1516

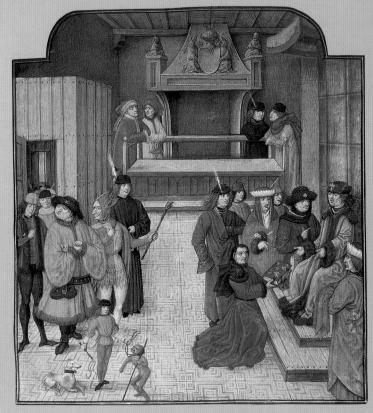

FLEMISH

JEAN, DUC DE BERRY,
IS PRESENTED WITH A BOOK
c. 1480

The dedication pages of illuminated manuscripts frequently portrayed the patron being presented with the volume he had commissioned. In this instance the Duc de Berry (1340–1416) is shown receiving a translation of the works of the Italian writer Giovanni Boccaccio (c. 1313–75). Scenes of this kind enabled miniaturists to provide colorful and authentic depictions of court life. Here, a dwarf sports with the duke's favorite greyhound and a pet monkey.

HACKER

RETURNING FROM
THE HAYFIELD
c. 1885

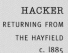 Hacker was an academic painter, who in 1880–1 studied under the French painter and portraitist Léon Bonnat (1833–1922) and exploited the contemporary French taste for scenes of peasant life. At the time these were seen as highly realistic, but to modern eyes they appear rather picturesque and sentimental. Here, a Border collie takes time off from his shepherding duties in order to try and lift the spirits of a weary harvester.

ARTHUR HACKER, 1858–1919

PATON

BORDER COLLIE
1880s

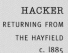 The Border collie is generally recognized as one of the most efficient breeds of sheepdog. It combines an almost feline, creeping motion with a hypnotic stare, which can stop a sheep in its tracks. For many years it was regarded solely as a working dog, so although it has featured in sheepdog trials since 1873, it was excluded from dog shows until fairly recently.

FRANK PATON, 1856–1909

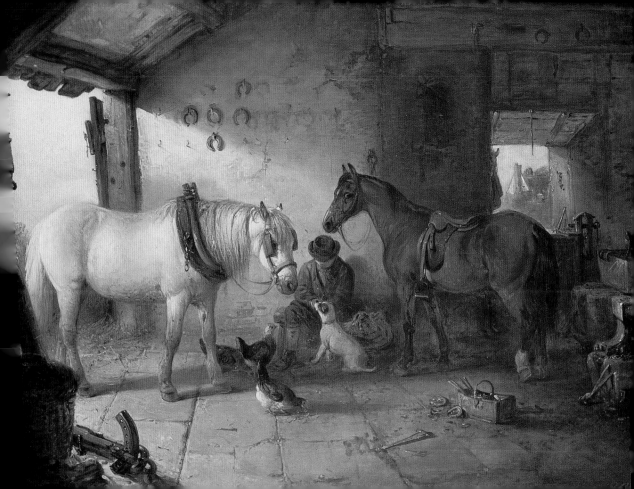

SMYTHE
IN THE FORGE
19th Century

 In Victorian
art, dogs became an
essential component
in virtually every
scene of rural life.
Smythe's forge has a
convincingly cluttered
appearance, although
it is debatable whether
a blacksmith would
have allowed quite
so many animals
to wander around
his workplace.

EDWARD ROBERT SMYTHE,
1810–99

BRUNAIS
MOTHER AND SON WITH A PONY
18th Century

 Naïve artists often enjoyed
painting animals, although they
frequently had difficulty in selecting
the correct scale. Here, the painting
is marred by the ludicrously small
dog. Henri Rousseau encountered
similar problems when depicting
one of Claude Junier's pets
(see page 237).

AGOSTINO BRUNAIS, fl. 1763–80

next pages ▶
GERMAN
GERMAN TROOPS ON THE RETREAT
c. 1943

 Dogs have no sense of
history. In one of the key moments
of the Second World War, German
troops trudge back wearily from the
Eastern Front, dismayed at the
onset of a Russian winter. This
handsome dog pays them little
heed, preferring to pose for
the camera.

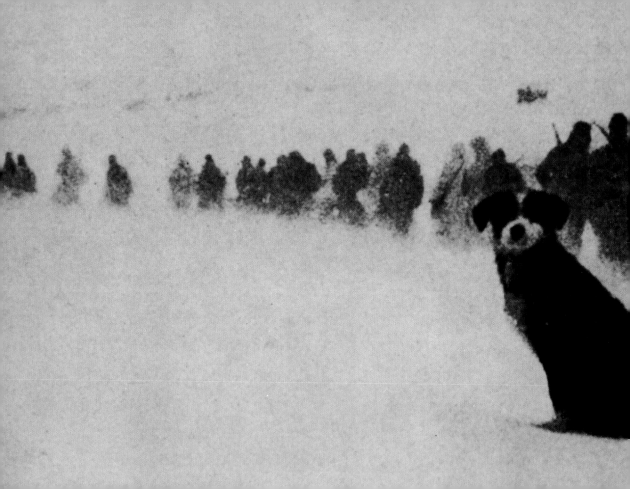

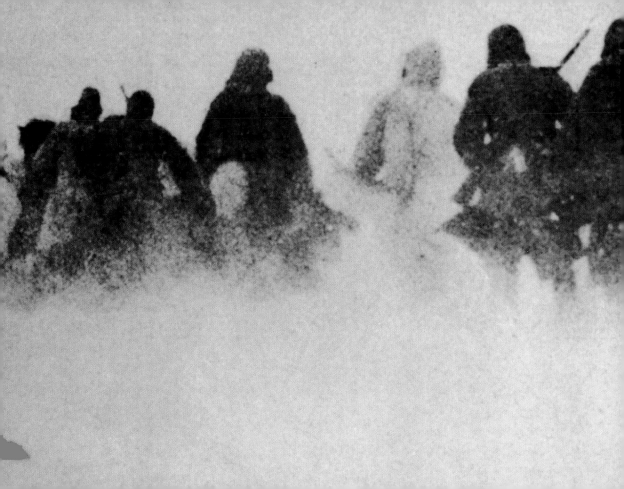

> " I loathe people who keep dogs.
> They are cowards who haven't
> got the guts to bite people
> themselves. "

AUGUST STRINDBERG, 1849–1912

LLOYD
FUNNY SIDE OF LIFE
1925/63

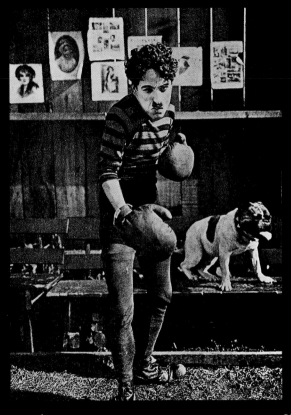

Retrieving a ball can be dangerous. Will Mike go for him or not? This tricky question was posed in 1925, in one of Harold Lloyd's earliest short comedies. It gained a wider audience through *Funny Side of Life*, one of the compilation movies that the American comedian produced in later years.

HAROLD LLOYD, 1893–1971

CHAPLIN
THE CHAMPION
1915

Chaplin broke the unwritten rule about working with animals and children, featuring dogs in a number of his movies. He found great comic potential in making comparisons between humans and dogs. Here, his attempt to mimic the pugnacious expression of his canine companion only serves to underline the implausibility of his boxing ambitions.

SIR CHARLES CHAPLIN, 1889–1977

THORVALDSEN
SHEPHERD BOY
1817

Thorvaldsen was a Danish sculptor, one of the leading figures in the Neoclassical movement. Accordingly, this statue was meant to evoke the pastoral idylls described by Ancient Greek and Roman authors. If nothing else, it emphasizes just how different the sheepdogs of individual nations could be. This robust, smooth-haired version is reminiscent of early herding dogs, whose principal function was to guard the flock from wolves.

BERTEL THORVALDSEN, 1770–1844

HUNT
THE HIRELING SHEPHERD
1851

The sheepdog is doing its best, but it cannot control the flock without the help of its master. Hunt's painting was actually an allegory about the dangers of the Tractarian controversy, which was then causing severe divisions within the Protestant Church. Without proper guidance from its pastors, Hunt believed, the flock would simply go astray. Here, for example, some of the sheep have already wandered into the cornfield, while the shepherd gazes foolishly at the death's-head moth cupped in his left hand.

WILLIAM HOLMAN HUNT, 1827–1910

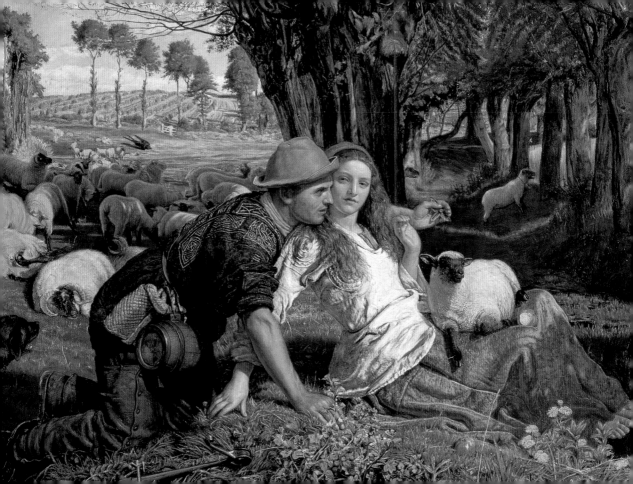

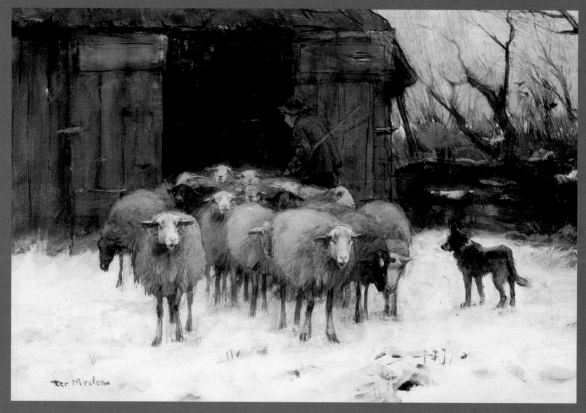

ter Meulen

TER MEULEN
SHEEP ON A
WINTER'S MORNING
19th Century

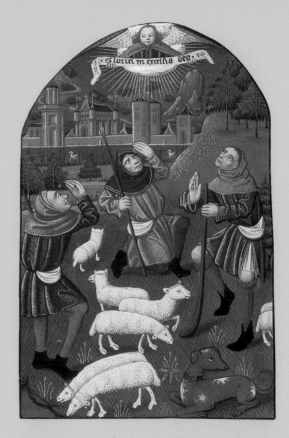

Sheepdogs are able to manage and control flocks by drawing on their primitive, wolf-like instincts. A wolf pack would fan out and surround its prey, but would await its leader's decision before making any further move. In this instance the pack consists of just two creatures—the shepherd and his dog. Here, the sheepdog stands alert, keeping a watchful eye on the flock, while awaiting the command of his pack leader, the shepherd.

FRANÇOIS PIETER TER MEULEN, 1843–1927

FRENCH
THE ANNUNCIATION
TO THE SHEPHERDS
c. 1490

The appearance of the angel Gabriel before the shepherds, informing them of the birth of Jesus, offered Christian artists a tempting opportunity to paint realistic pastoral scenes. This particular example is an illustration from a Book of Hours, a type of prayer book. The sheepdog resembles a greyhound and has star-shaped patterns on its coat, reminding the viewer of the star that the shepherds will soon be following.

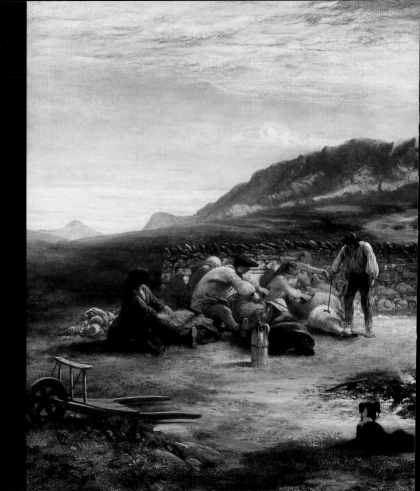

" In the mountains of Scotland, there is a tribe of dogs called shepherd dogs, which . . . look for all the world like long-nosed, high-cheekboned, careful old Scotchmen . . . An old Scotchman tells us that his dog, Hector, by long sharing his toils and cares, got to looking so much like him that once, when he felt too sleepy to go to a meeting, he sent Hector to take his seat in the pew, and the minister never knew the difference, but complimented him the next day for his good attention to the sermon. "

HARRIET BEECHER STOWE, 1811–96

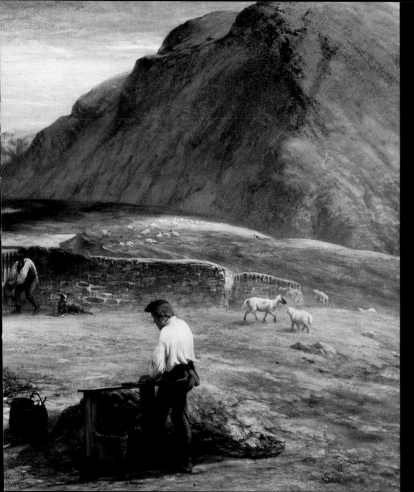

HARVEY
SHEEPSHEARING
c. 1830s

Collies were particularly associated with the Highlands of Scotland, where their nimbleness enabled them to control widely dispersed flocks. Here, two dogs take a well-earned rest, while laborers shear and brand their charges. In the distance a third sheepdog casts a watchful eye over the scattered remnants of the flock, apparently without the assistance of a shepherd.

Sir George Harvey, 1806–76

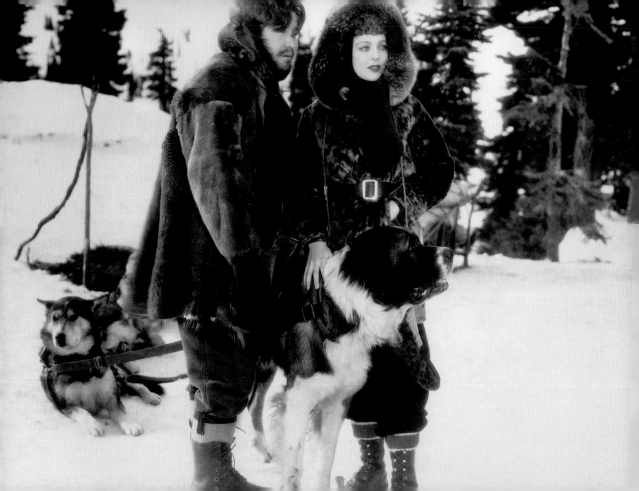

AMERICAN
GOLD FEVER IN ALASKA
1935

This is a still from the 1935 movie version of the famous story by Jack London (1876–1916), *Call of the Wild*, showing Jack Oakie and Loretta Young. The original novel (1903) centered on the exploits of Buck, the canine hero, who was stolen from his Californian owners and sold off as a sledgedog in the Klondike. There he suffered at the hands of several cruel masters, before being rescued by a kindly gold prospector,

FERNELEY
COACHMAN WITH
NEWFOUNDLAND DOG
19th Century

Newfoundlands were extremely popular in the nineteenth century, when the breed's praises were sung by both Robbie Burns (1759–96) and Lord Byron (1788–1824). In their native Canada they were used as draftdogs, and their lifesaving abilities were universally recognized. One of Landseer's most famous paintings, *A Distinguished Member of the Humane Society* (c. 1838), shows a Newfoundland waiting patiently by the water's edge, ready to rescue any swimmers in trouble. Their use as coachdogs was less common, but this magnificent specimen must have made a fine sight running alongside his master's carriage.

JOHN E. FERNELEY, 1782–1860

JACOPO DI PIETRO
THE TRIUMPH
OF CAESAR
1514

The Romans valued dogs highly, using them in hunting, warfare, and for protective purposes. They were also viewed as status symbols, and thus as fitting participants in a triumphal procession. The moneyed classes would defend their homes with dogs, while poorer folk would have to make do with geese.

ATTRIBUTED TO JACOPO
DI PIETRO, 16th Century

ROUSSEAU
PERE JUNIER'S CART
1908

In this charming picture Rousseau painted a family portrait of Claude Junier, who is shown with his wife, his relatives, and his three dogs. Junier was a vegetable vendor, an amateur horse trainer, and one of Rousseau's closest friends. The figure in the straw hat is a self-portrait of the artist.

HENRI ROUSSEAU, 1844–1910

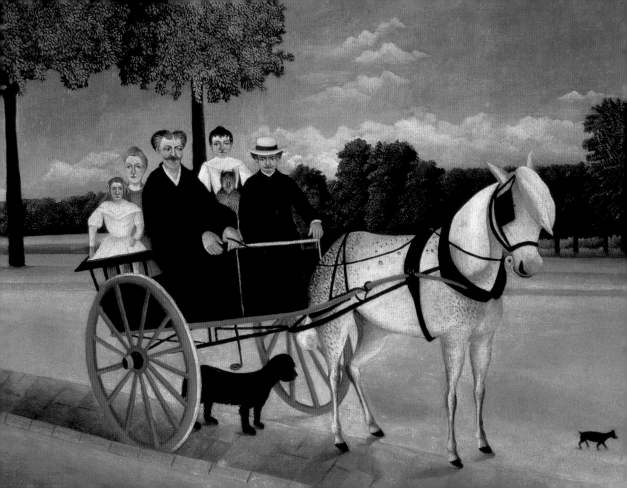

> " All along the moorland road a caravan there comes
> Where the piping curlew whistles and the
> brown snipe drums;
> And a long lean dog
> At a sling jig-jog
> A poacher to his eyelids as all the lurcher clan,
> Follows silent as a shadow and as clever as a man. "

PATRICK CHALMERS, 1875–1942

STANDING
DRIVING THE TANDEM CART
1905

Coach dogs were trained to run behind their master's carriages, during short journeys. Their original purpose, no doubt, was to protect their owner from highwaymen or any other miscreants who might prey on unwary travelers. In practice, however, coach dogs were often little more than fashion accessories, designed to emphasize the refinement of the owner. For this reason elegant breeds, such as pointers or dalmatians, became the popular choices for this task.

HENRY WILLIAM STANDING, fl. 1895–1905

239

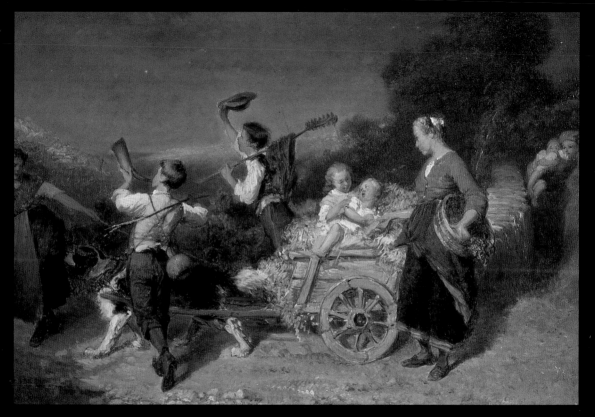

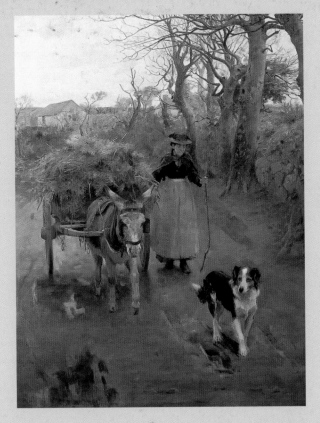

GÉRARD
CHILDREN WITH A DOGCART
19th Century

 Gérard was a Belgian
artist, born and educated in
Ghent. His fellow countrymen
made considerable use of dog-
carts, so there is doubtless
an element of truth in this
scene. Given the improbable
dimensions of the dog, however
(a rather small head for a
very long body), it is hardly
surprising that the artist chose
to play down the animal's role.

THÉODORE GÉRARD, 1829–95

FORTESCUE
FEBRUARY
1893

Fortescue worked
extensively in Cornwall, in and
around the St. Ives area, prior
to the foundation of the official
St. Ives School. He is best
known for his pictures of ships
and the sea, and these may
have helped him conjure up the
damp atmosphere of this
evocative winter scene. Unlike
his Belgian counterpart (*see
opposite*), the dog is able to
enjoy the walk, without having
to pull a heavily laden cart.

WILLIAM B. FORTESCUE, 1855–1924

241

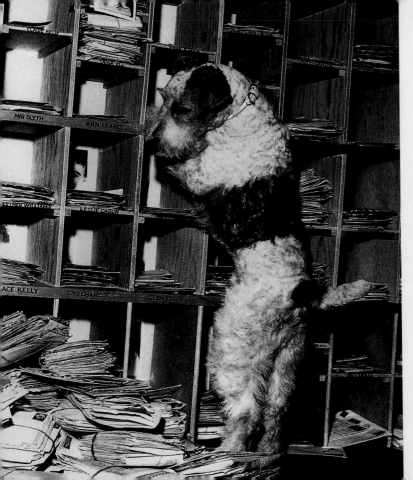

AMERICAN

ASTA

1958

A celebrity checks her mail. This is a publicity shot of Asta, the canine star of the television series *The Thin Man* (1958). In the original movie (1934) a dog had played a major part in solving the crime, and her services were retained by the television producers. Asta's owners were played by Peter Lawford and Phyllis Kirk.

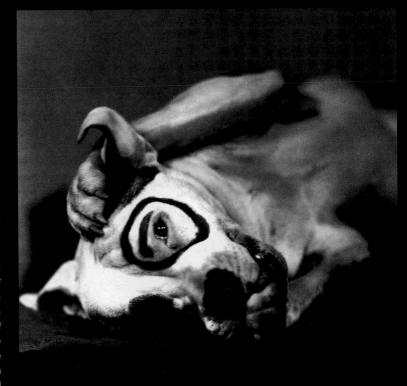

AMERICAN
PETE THE PUP
1934

Staffordshire bull terriers are not
normally regarded as the cutest of
dogs, but Pete the Pup had charm in
abundance. He featured regularly in
the *Our Gang* movies, a series of
short slapstick comedies that were
popular in the 1920s and 1930s. The
movies showcased the talents of a
generation of child actors, but all
of them were upstaged by Pete.

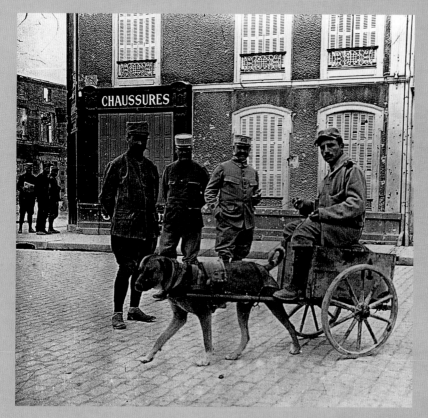

CHAUSSURES

FRENCH
DOGCART WITH
FRENCH SOLDIER
1917

Draft dogs were a
common sight in certain parts
of Europe, up to the end of the
First World War. The Belgians,
for example, used them for
transporting machine guns and
ammunition cases. Here, French
troops find work for a dog left
behind by retreating Germans.

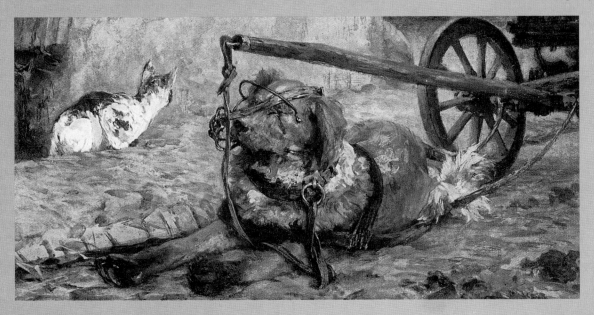

VON MENZEL

DRAFT DOG WITH A CAT

c. 1861

In his day Menzel was probably best known as an illustrator of historical subjects. Now, however, his depictions of industry and everyday working life probably have more appeal. This gouache was painted at a time when there were few restrictions on the weights that draft dogs could pull. This poor creature seems exhausted and even the cat, his traditional enemy, appears to feel some sympathy for him.

ADOLF VON MENZEL, 1815–1905

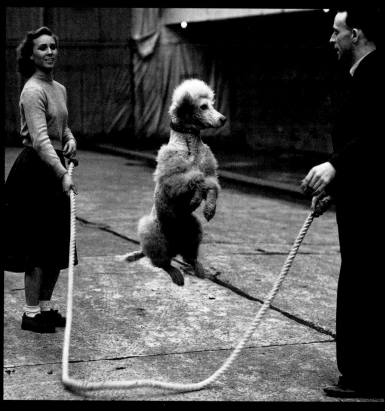

BRITISH
SKIPPING POODLE
1950

Performing poodles first gained popularity in Paris where, in less politically correct times, they were taught to walk on their hind legs, carry parasols, and spell out words. In this photograph John Chipperfield rehearses with a skipping poodle, before a show at Tom Arnold's Harringay Circus in London.

AMERICAN
PETE JUMPING THROUGH A HOOP
1927

With his distinctive ringed eye, Pete was, for a time, the most famous performing dog in the world. He featured in a number of Hollywood comedies, including the *Our Gang* series, and at the height of his career he was insured for $25,000.

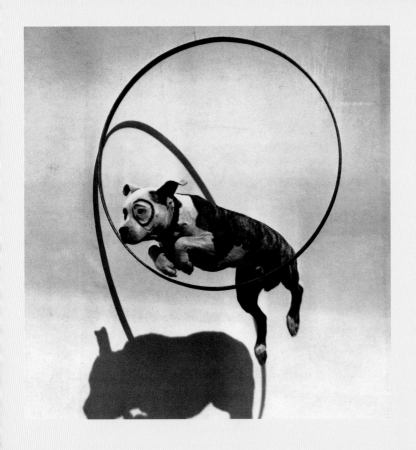

" I have got a little dog, and Mr C. has accepted it with an amiability. To be sure, when he comes down gloomy in the morning, or comes in wearied from his walk, the infatuated little beast dances round him on its hind legs as I ought to do and can't, and he feels flattered and surprised by such unwonted capers to his honor and glory. "

JANE CARLYLE (1801–66)

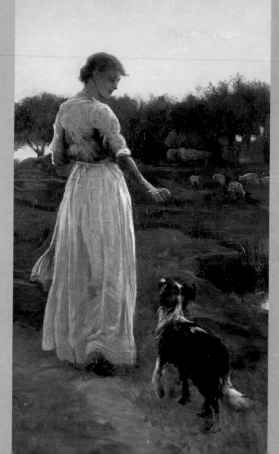

WETHERBEE
A SHEPHERDESS WITH
HER DOG AND FLOCK IN
A MOONLIT MEADOW
19th Century

Born in Cincinnati and educated in Boston, the much-traveled Wetherbee eventually settled in London, where he swiftly adapted his art to Victorian taste. This romantic image of a young woman and her dog, silhouetted against a golden twilight, has very little to do with the realities of farming, but its charm is undeniable.

GEORGE FAULKNER WETHERBEE,
1851–1920

HERRING
CARTHORSES BY A
COTTAGE DOOR
1854

Herring enjoyed huge success with his pictures of racehorses and hunting scenes, winning lucrative commissions from royalty and members of the aristocracy. Then, in the late 1840s, he began to paint a different type of subject— sentimental farmyard scenes. Horses were still the predominant feature, but his idealized view of rural life was rounded out with prim farmers' wives, contented dogs, and families of ducks.

JOHN FREDERICK HERRING Senior.

1795–1865

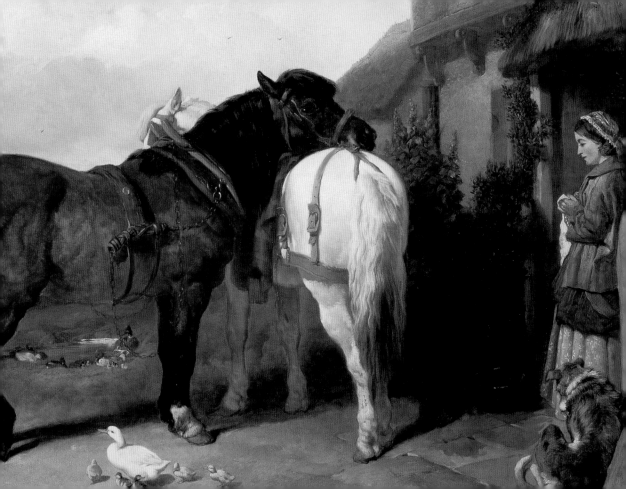

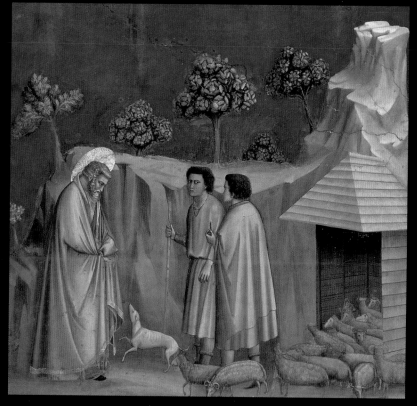

GIOTTO
JOACHIM AMONG THE SHEPHERDS
C. 1305

The subject is taken from an apocryphal biblical tale, which was popularized in *The Golden Legend* (Jacobus de Voragine, 1230–98). A wealthy man named Joachim is childless after twenty years of marriage. Because of this, he is turned away from the Temple in Jerusalem when he brings a lamb for sacrifice. Humiliated, Joachim does not return home, but goes to live with his shepherds in the desert. There an angel appears to him, informing him that his wife will give birth to a daughter and that this child will be Mary, the mother of Christ.

GIOTTO DI BONDONE, C. 1267–1337

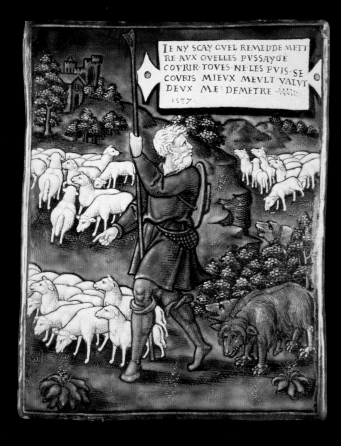

IE NY SCAY QVEL REMEDDE METT
RE AVX QVELLES PVSSAYGE
COVRIR TOVES NE LES PVIS SE
COVRIS MIEVX MEVLT VALVT
DEVX ME DEMETRE
·1537·

RAYMOND
THE BAD SHEPHERD
1537

Because Christ was known as the Good Shepherd, depictions of bad shepherds normally carry overtones of sinfulness. They suggest the well-known passage from the Gospel of St. John *(see below)*. Raymond has represented the Bad Shepherd quite realistically. His flock is scattered in several different locations and the pastor does not seem to know which way to turn. At his feet, his sheepdog, a faithful but unintelligent creature, stands and awaits instructions.

PIERRE RAYMOND, 16th Century

" . . . the good shepherd giveth his life for
the sheep. But he that is an hireling . . .
seeth the wolf coming, and leaveth the sheep
and fleeth: and the wolf catcheth them,
and scattereth the sheep. "

JOHN 10: 11–12

251

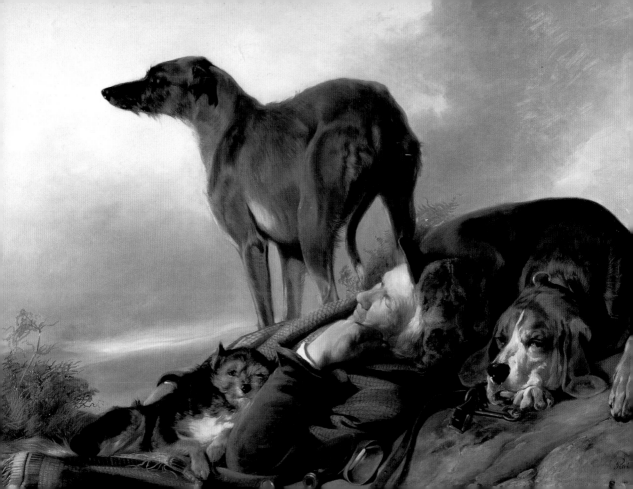

lazy dogs

RICHARD ANSDELL
A MAN AND HIS DOGS

the warmest and most comfortable part of the house. This is not simply a case of modern canine decadence, for, from a very early stage, some dogs were trained to play a passive part in human affairs. Among other things, their role was linked to religious beliefs, ceremonial affairs, life at court, and more recently, dog shows.

This trend is exemplified by the history of the Pekingese. In the first century AD the teachings of Buddhism began to gain popularity in China, gradually replacing Confucianism. Among these beliefs, which had originated in India, there was a special reverence for the lion, Buddha's faithful companion. The Chinese had no

WINSRYG
BILLY IN MILL VALLEY

experience with lions, but they recognized a facial similarity between imported images of the beast and their own Pekingese dogs. Accordingly, the latter became the models for the sacred lion-dogs, which developed into one of the most potent symbols of Chinese Buddhism. The breeding of Pekes was carefully supervised at the imperial court by eunuchs, who tried to promote some specific, symbolic features. In particular, they liked the dogs to have a prominent white blaze on their foreheads, echoing the shining sphere on Buddha's brow. They also developed a miniature version of the breed, the so-called sleeve Pekingese, designed to be carried in the capacious garments of the Chinese nobility.

Cult dogs were also reared in Tibetan monasteries and in the palace of the Dalai Lama. The monks produced their own strain of the lion-dogs, but became better known for the Lhasa apso.

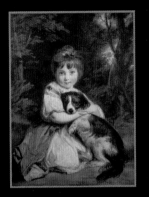

REYNOLDS
MISS JANE BOWLES

finest examples were bestowed upon the Chinese emperor, as a symbol of good luck.

Dogs became an equally familiar sight in Western courts, increasingly being chosen simply as companions. Predictably, there was a marked preference for smaller dogs. Roman ladies opted for Maltese terriers, sometimes carrying them in their sleeves. At the English court, spaniels became the favorite breed: before it was renamed in honor of the monarch, the King Charles spaniel was generally known as the comforter. The fondness of Charles II (1630–85) for his dogs drew scornful comments from the diarist Samuel Pepys (1633–1703), but the king was no isolated figure. In France, Henri III (1551–89) used to arrive at state meetings bearing an open basket containing his beloved papillons.

CHRISTENSEN
JUDY AS THE
TRAGIC MUSE

HEWITT
N THE SANDS
T BLACKPOOL

Of course, pet dogs were not the sole preserve of the rich. From the evidence of portraits and literary accounts, it is clear that they were popular with all levels of society. This reached unheralded proportions in the nineteenth century, when the notion of standardizing and judging individual pedigree breeds became a popular obsession. In Britain, the first official dog show was held at the Corn Exchange in Newcastle in 1859, featuring just sixty competitors. The foundation of the Kennel Club (1873) helped to stimulate further interest and, in 1891, the inaugural Cruft's Show was staged in London. With similar developments taking place in the United States, organized since 1877 by the Westminster Kennel Club, dogs were still playing a passive role in human affairs, but they could no longer simply laze their hours away.

SHONNARD
GOLDEN RETRIEVER

RENOIR
MADAME CHARPENTIER
AND HER CHILDREN

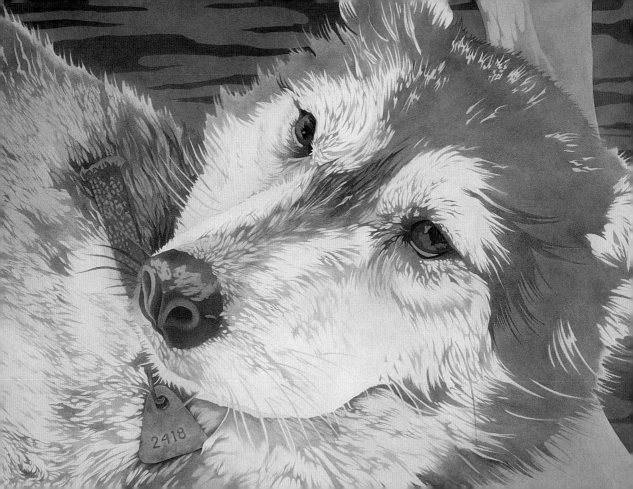

HAHN
SHEILA
1986

Hahn's watercolor painting captures her own pet dog in a characteristic pose. Someone has walked into the room, rousing Sheila from her slumbers. Raising her head from the floor, she gazes sleepily at the newcomer, trying to decide if it is worth getting up to offer a more enthusiastic greeting.

MOIRA HAHN, b. 1956

ALMASY
PEACEFUL COEXISTENCE
1958

A clear case of sleeping with the enemy. Amusingly, the mosaic cat is displaying a typical feline reaction to a dog, arching its back suspiciously—an instinctive posture, which is designed to make it look larger to potential foes.

PAUL ALMASY, b. 1906

ENGLISH
A BLOODHOUND IN A LANDSCAPE
19th Century

The heavy folds of skin on its forehead lend the bloodhound a doleful appearance, even when the animal is perfectly content. It is generally regarded as one of the oldest European breeds, the descendant of the Saint Hubert hound, which was developed at a monastery in the Ardennes region of France. Although best known now for its ability to track humans, it was once used for hunting deer.

DUBIN
DOG WITH YELLOW EYES
1998

When they are not out working as gundogs, few breeds can manage to look quite as laid back and relaxed as the golden Labrador. Its origins are slightly different from that of the more common black Labrador. Experts believe that its coloring comes from a mix of the Chesapeake Bay retriever and the golden retriever.

JORG R. DUBIN, b. 1955

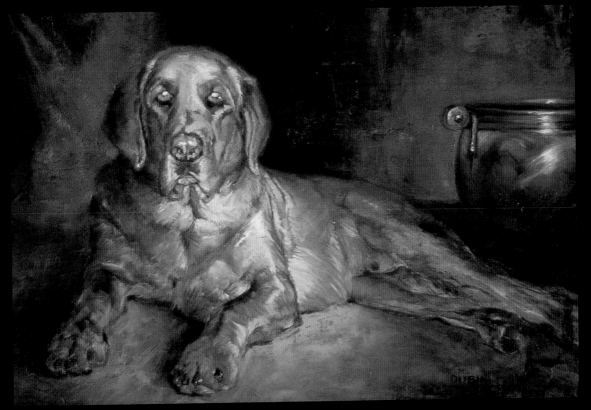

" At night my wife and I did fall out about the dog's being put down in the cellar, which I had a mind to have done because of his fouling the house, and I would have my will; and so we went to bed and lay all night in a quarrel. "

SAMUEL PEPYS, 1633–1703

BURNE-JONES
PORTRAIT OF KATIE LEWIS
1886

 Katie Lewis was the younger daughter of a solicitor, Sir George Lewis. Burne-Jones was a close friend of the family and sent a series of illustrated letters to the girl, which were later published (*Letters to Katie*, 1925). The portrait is very informal and, for its day, rather unconventional.

SIR EDWARD BURNE-JONES, 1833–98

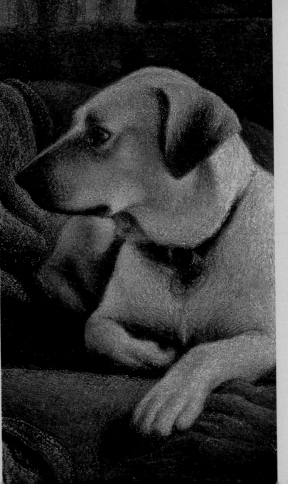

YASKULKA
PORTRAIT OF LANA
1996

 By and large, dogs dislike being left alone at home, although there can be compensations. Human furniture, for example, is considerably more comfortable than a dog basket. Yaskulka's Labrador retriever certainly thinks so, as she spreads herself languidly across the sofa.

HAL YASKULKA, b. 1964

CHRISTENSEN
JUDY AS THE TRAGIC MUSE
1998

Christensen claims to have based this canine pose on a portrait by Sir Joshua Reynolds (1723–92), *Mrs. Siddons as the Tragic Muse.* Reynolds might have been bemused by this comparison, but he could hardly have complained, for Mrs. Siddons's pose was, in turn, clearly modeled on Michelangelo's figure of Isaiah, on the ceiling of the Sistine Chapel.

WES CHRISTENSEN, b. 1949

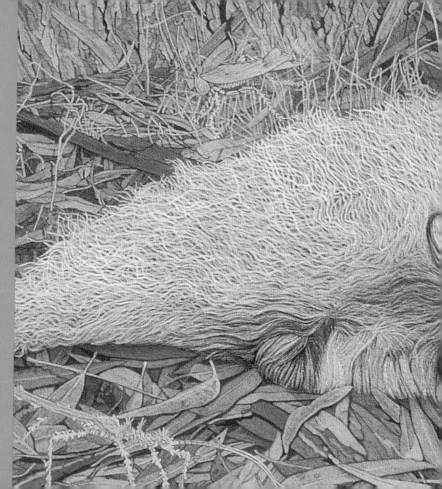

> " Every dog is a
> lion at home. "

GIOVANNI TORRIANO
(17TH CENTURY)

WINSRYG

BILLY IN MILL VALLEY
1998

Because they are designated
as "toy" dogs, there is often an
assumption that small dogs are lazier
and more pampered than their larger
counterparts. Pekes have suffered
more than most from this
misconception, partly because of a
determined attempt in some quarters
to breed dwarf versions of the
species, and partly because they
have occasionally been forced to
suffer the indignity of ribbons and
other such frippery. As Billy's watchful
gaze suggests, however, Pekes are
extremely alert and they fear
absolutely no one.
MARIAN WINSRYG, b. 1941

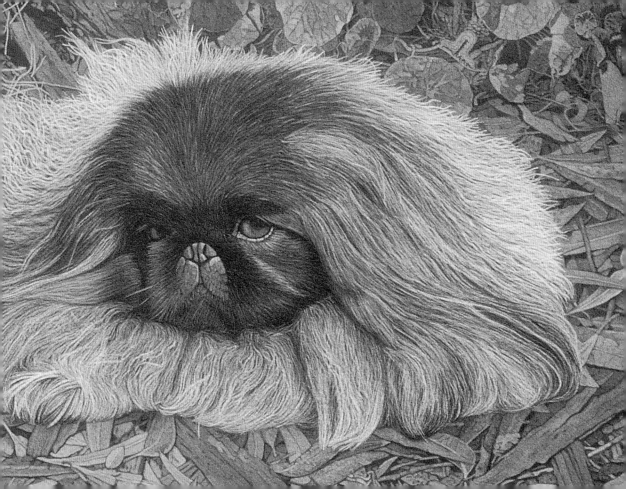

LEWIS
READING BY THE WINDOW
1870s

🐺 What a scene of domestic bliss. In a house overlooking the sea at Hastings a young lady sits and reads. At her feet, a little terrier gazes up imploringly, hoping that she will soon put down the book and pay him some attention.

CHARLES LEWIS, 1830–92

FRENCH
CHRISTINE DE PISAN WRITING AT HER DESK (DETAIL)
c. 1410–15

🐺 It became something of a cliché to include dogs in female portraits, as confirmation of their fidelity and virtue. In this case the sitter is Christine de Pisan (c. 1364–1430). The daughter of a royal astrologer, she is celebrated as the first Frenchwoman to earn a living from her writing. Her most famous work is the *Epistle to Othéa*, which dealt with the Trojan War of the mid-thirteenth century BC.

next pages ▶
CANDID
THE STORY OF ESTHER (DETAIL)
16th Century

🐺 Esther was the Jewish bride of King Ahasuerus of Persia. On learning of a plot to massacre her people, she bravely went to intercede with her husband, even though it was a capital offence to enter the king's presence without permission. Candid has tried to give the scene an exotic flavor, but the lounging dogs might just as easily have been found at a Western court.

PETER CANDID, c. 1548–1628

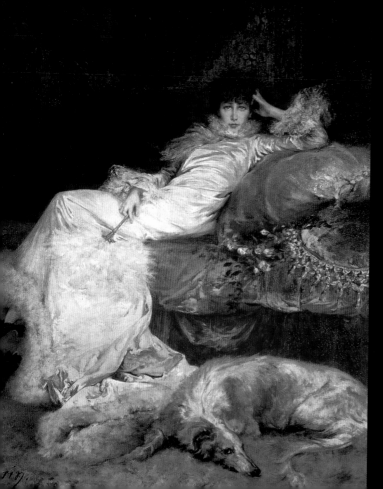

MORISOT
GIRL PLAYING WITH A DOG
19th Century

In spite of the rival claims of Mary Cassatt (1844–1926), Morisot was the most talented of the female Impressionists. She was particularly adept at capturing the mood of quiet domestic scenes. Even in this simple sketch, the playful attitude of the dog is convincingly portrayed.

BERTHE MORISOT, 1841–95

CLAIRIN
SARAH BERNHARDT
1876

The "Divine Sarah" (1844–1923) was not only France's greatest actress, but also a passionate animal lover. When she came to work in England for a time she rapidly amassed a sizeable menagerie. This included three dogs, a parrot, a cheetah, a monkey, and no fewer than seven chameleons.

GEORGES CLAIRIN, 1843–1919

RENOIR

MADAME CHARPENTIER AND HER CHILDREN
1878

Renoir pioneered a novel style of portraiture, where sitters were shown informally in their home surroundings. Madame Charpentier organized a literary and political salon, which had made her a highly influential figure in Parisian society, but she is shown here relaxing with her children. Despite the frock and the ringlets, the younger one is actually a boy.

PIERRE-AUGUSTE RENOIR, 1841–1919

MALBON

BY HIS MASTER'S CHAIR
1850

The trophies on the wall confirm that the absent master is a keen huntsman. Pack dogs were not kept inside the house, however, so this is either a gundog or, more probably, a pampered pet. He has taken up a warm position by the fire and, but for the hat, would doubtless also have made use of the seat.

WILLIAM MALBON, 1805–77

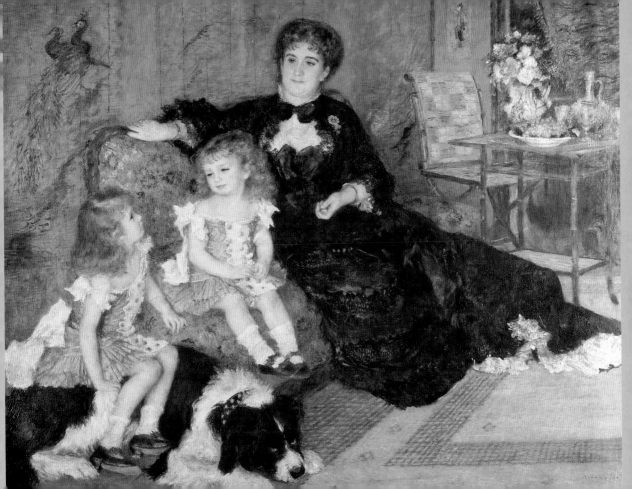

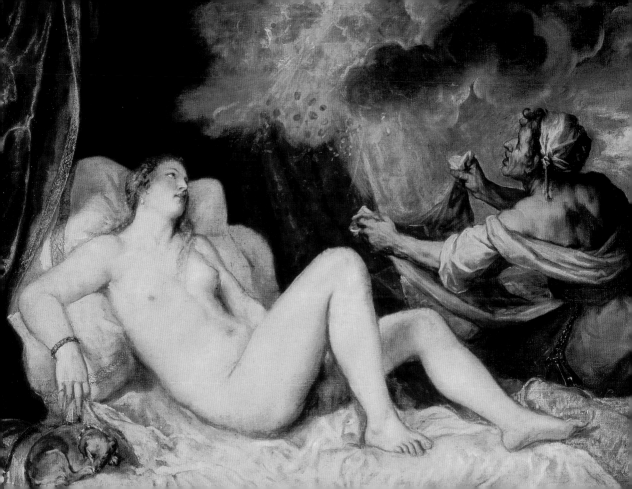

TITIAN
DANAË
1553

 Danaë's father imprisoned her in a bronze tower, after hearing a prophecy that her son would slay him. Despite this precaution, Zeus visited the maiden in the form of a shower of gold and ravished her. Here, the maid holds out her apron greedily, hoping to catch some of the golden coins, but the dog pays no heed to the amorous proceedings. Danaë's son, Perseus, went on to fulfill the fatal prophecy.

TITIAN (TIZIANO VECELLIO),

c. 1485–1576

GERMAN
THE LOVE CHARM
C. 1470

Using her wiles, the goddess Venus ensnares the affections of a young man. Several of her attributes can be seen in the room—the mirror, the dish of pearls, the swallow, and the magic girdle, which makes the wearer irresistibly attractive. The dog was not a traditional attribute, although many Renaissance painters did include one in bedchamber scenes. Here, the creature has to make do with a comfy cushion.

277

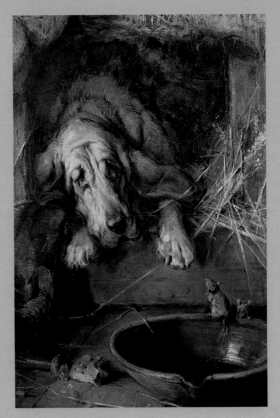

> **" A dog's life is hunger and ease. "**

SHONNARD
GOLDEN RETRIEVER
1994

When resting, dogs may adopt a variety of different postures. The majority will curl up, in an instinctive attempt to protect their most vulnerable areas. Some of the larger breeds, however, feel confident enough to lie flat out on the ground. This golden retriever is so secure that it cannot even be bothered to raise its head to challenge the intrusiveness of the photographer.

TIMOTHY SHONNARD, 20th Century

STRETTON
WHEN THE CAT'S AWAY
THE MICE WILL PLAY
1890s

It would be ill-advised for mice to take liberties of this kind with every canine breed. When ratting was a legal sport, dogs were trained to make short work of rodents. The best ratters were terriers, however, while bloodhounds have traditionally been used to track much larger quarry, notably human fugitives.

PHILIP STRETTON, fl. 1879–1922

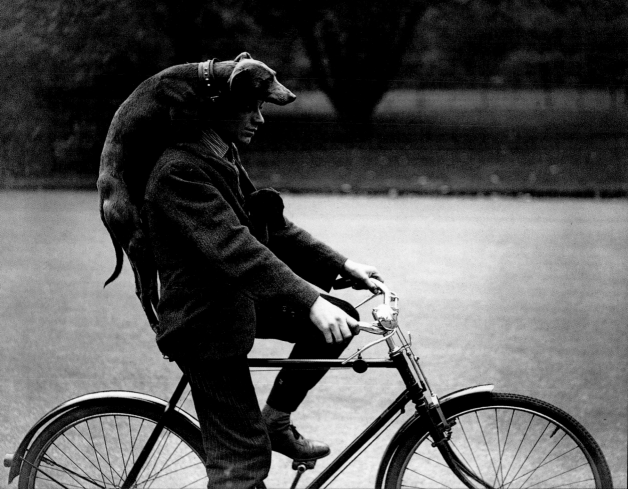

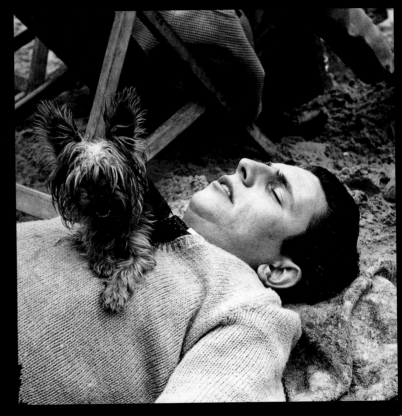

HEWITT

ON THE SANDS AT BLACKPOOL
1956

Because of their pack instincts, dogs always like to sleep close to each other. This is why a pet dog will invariably prefer to sleep in or near the bedroom of its owner (the pack leader), rather than in the kitchen. Of course, perching right on top of the owner is the best solution of all.

CHARLES HEWITT, 20th Century

ENGLISH

A FREE RIDE
20th Century

How lazy can a dog get? This bizarre photo shows a man cycling through Battersea, in south London, with a greyhound draped over his shoulders. The observant will notice that he is also carrying a puppy, tucked away inside his jacket.

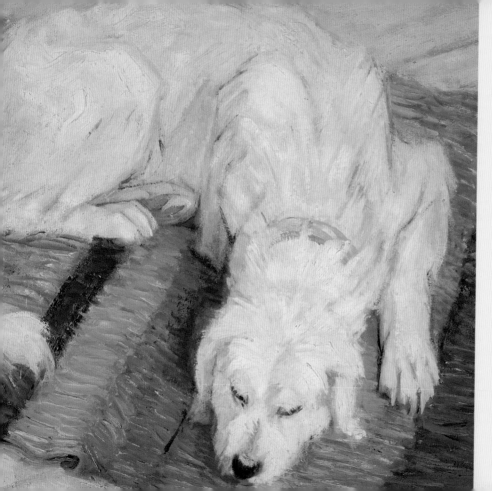

MARC
SLEEPING DOG
1909

Before he developed his pioneering Expressionist style, Marc painted in a highly naturalistic manner. This picture dates from the period when he was sketching regularly in the Berlin Zoo and giving lessons in animal anatomy.

FRANZ MARC, 1880–1916

LOPEZ
DOG
1997

Dog portraits have become something of a dying art in the twentieth century, but this fine study of the painter's pet displays a keen eye for detail. The animal is clearly happier sprawling on the carpet than in his own basket.

RICHARD LOPEZ, b. 1943

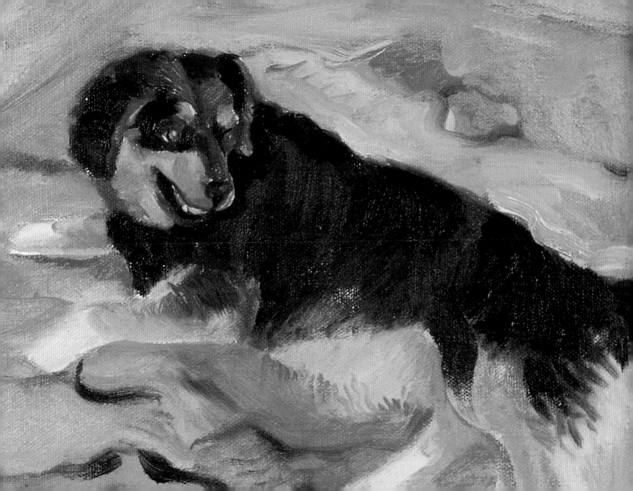

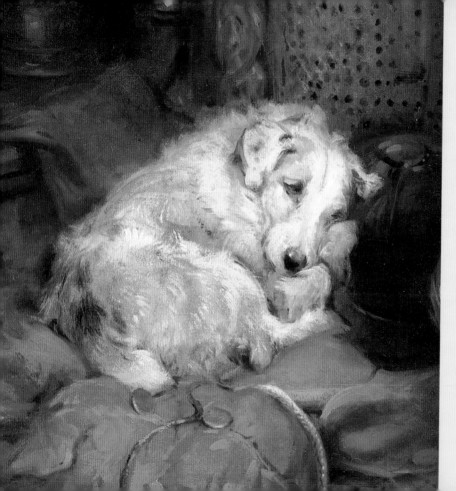

STRETTON
TIRED OUT
1922

The inference to be drawn
from the title is that this little chap
has exhausted itself, after a vigorous
spot of hunting. In reality, however,
members of most packs were rarely
allowed inside the house. It is also
safe to assume that the master
would not have been pleased with
any dog, even a highly favored pet,
that chose to curl up on top of his
hunting gear.

PHILIP STRETTON, fl. 1879–1922

> " She was no longer a pet lamb; she was one of the dogs. The dogs on their part, although much given to quarrels and fights among themselves, never growled or snapped at Libby; she never tried to snatch a bone from them, and she made them a comfortable pillow when they slept and slumbered for hours at a stretch. "

WILLIAM HENRY HUDSON, 1841–1922

CARRION
MONTY
1999

The dachshund (literally "badger dog") was originally used for burrowing underground and chasing after badgers. Times change, and it is safe to assume that many of today's pet dachsies would not know what to do with a badger if they saw one. They are, however, perfectly adapted for burrowing under bedspreads.

MARAVILLAS CARRION, b. 1968

YASKULKA
MONA
1997

🐾 When Mona, a feisty little pug, decides to sleep, she curls up into a tiny, black-and-white ball. Yaskulka draws and paints his studio partner frequently—and a more obedient model could not be found.

HAL YASKULKA, b. 1964

NAVA
PORTRAIT OF KELLY M.
(WITH MAVIS) (DETAIL)
1997

🐾 Dogs hate to feel left out. When Nava was commissioned to paint a portrait of Kelly, her little pet, Mavis, insisted on joining in the fun. She sat at the foot of her mistress's chair during so many of the sittings that, in the end, the artist decided to include her in the portrait.

JOHN NAVA, b. 1947

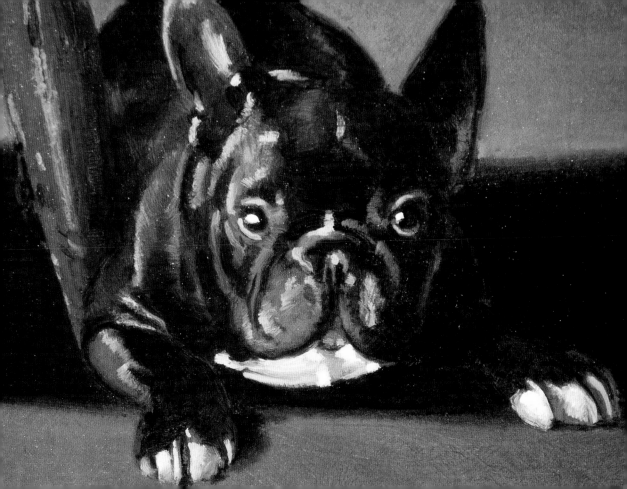

BISSELL
VIGIL AT THE CROSSROADS
1996

🐗 Bissell's title is intentionally ironic. The painting is set not at a crossroads, but in a narrow, claustrophobic avenue, and the dog, far from being vigilant, appears half asleep. Nevertheless, the mood is unsettling. Something has caused a group of jet-black birds—so often the harbingers of misfortune—to rise up and take flight. And the motionless dog is reminiscent of those canine figures that the ancients placed at the entrances of tombs to guard the spirits of the dead.

ROBERT BISSELL, b. 1952

" I knew that a man who cares for dogs is one thing, but a man who loves one dog is quite another. Dogs are at the best no more than verminous vagrants, self-scratchers, foul feeders, and unclean by the law of Moses and Mohammed; but a dog with whom one lives alone for at least six months of the year; a free thing, tied to you so strictly by love that without you he will not stir nor exercise; a patient, temperate, humorous, wise soul, who knows your moods before you know them yourself, is not a dog under any ruling. "

RUDYARD KIPLING, 1865–1936

PARSONS
HOT AFTERNOON
20th Century

 As the pace of city life quickened in Victorian England, with increasing industrialization and overcrowding, many people began to dream of escaping to a rural idyll. Their vision of the countryside was of a place where the flowers bloomed prodigiously, where the noise of the metropolis was replaced with birdsong and the gentle buzzing of bees, and where they could bask in the sun like this lucky dog.

ALFRED PARSONS, 1847–1920

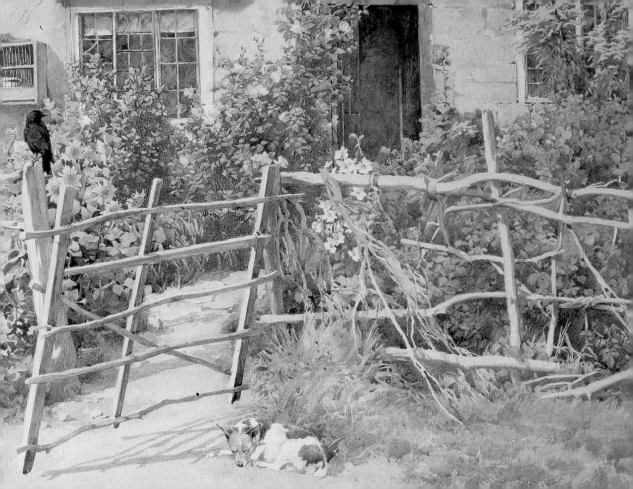

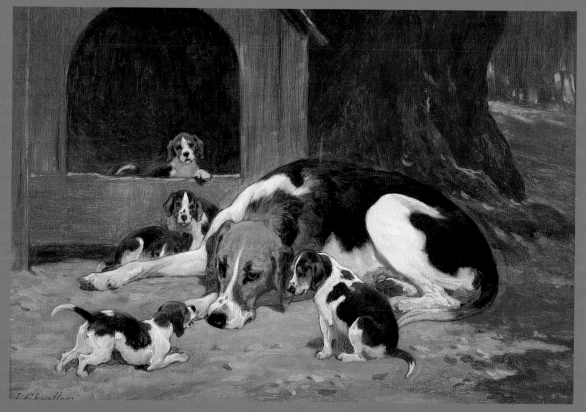

J. C. Dandham

CHARLTON
A FOXHOUND BITCH WITH HER LITTER
1880

There is never much peace for a mother with a litter of pups. Feeding time is over, but already the one on the left is keen to start playing. His yelping has roused some of the other pups, but the bitch is not responding, determined to enjoy a few more precious moments of relaxation.

JOHN CHARLTON, 1849–1917

ENGLISH
A FARMHAND OVERCOME BY FATIGUE
20th Century

In Ancient Rome, wealthier households would keep barking dogs

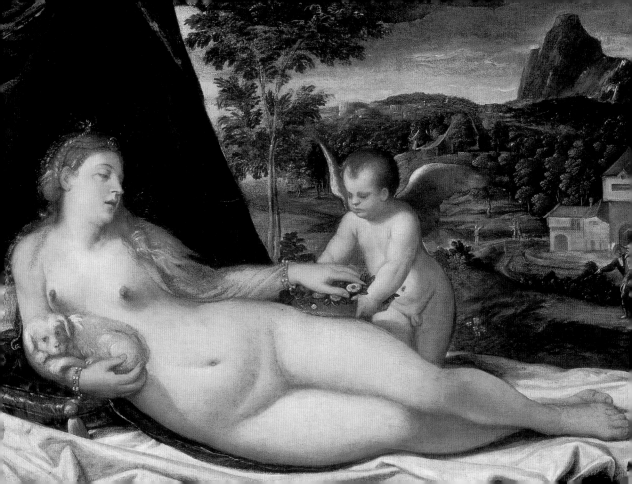

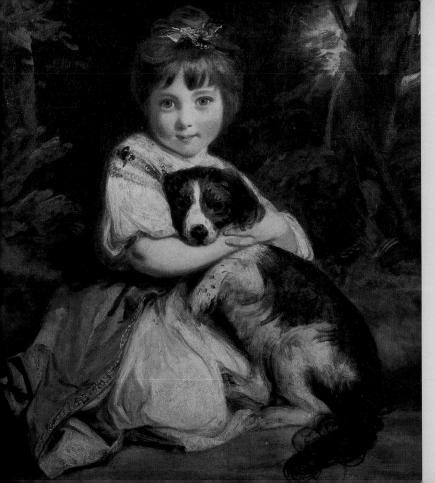

REYNOLDS

MISS JANE BOWLES

1775

Reynolds was masterful at painting children, and he often chose to use a dog as an accessory. Here, the pose has all the spontaneity of a modern-day snapshot. The little girl hugs her pet a bit too tightly, as she smiles sweetly for the artist. The animal looks most uncomfortable, however, and will probably soon squirm its way out of her grasp.

SIR JOSHUA REYNOLDS, 1732–92

" The spaniel of the king is a
pound in value.
The spaniel of an uchelwr, a pound.
The spaniel of a free-man is six score
pence in value.
The spaniel of an aillt, four pence:
The same worth as his cur. "

OLD WELSH LAWS, 10TH CENTURY

LARGILLIÈRE
THE PRETTY STRASBOURG GIRL
18th Century

In the seventeenth century King Charles
spaniels were enormously popular in royal and
aristocratic circles throughout Europe. By the
twentieth century, however, the breed had become
much more snubnosed. So in 1926 Roswell Eldridge
of New York offered a prize to any breeder who
could revive the old, long-muzzled variety. The
result was the Cavalier King Charles spaniel, which
is now the more popular of the two breeds.

NICHOLAS DE LARGILLIÈRE, 1656–1746

" He toils not, neither does he spin, yet
Solomon in all his glory never lay upon a
door-mat all day long, sun-soaked and fly-fed
and fat, while his master worked for the
means wherewith to purchase an idle wag
of the Solomonic tail, seasoned with
a look of tolerant recognition. "

AMBROSE BIERCE, 1842–c. 1914

EARLE
SOLITUDE, WATCHING FOR A
VESSEL ON TRISTAN DA CUNHA
1824

It could be a lonely life, even for a dog, on the British
colony of Tristan da Cunha. In 1816 a garrison was stationed on
this remote island group in the South Atlantic, after previous
attempts at founding a settlement had failed. All but three of the
garrison departed a year later, leaving the tiny community to battle
for survival. Some shipwrecked sailors were persuaded to join the
settlement—which may explain this rifleman's shoreside vigil—but
by 1886 the colony still only consisted of ninety-seven inhabitants.

AUGUSTUS EARLE, 1793–1838

symbolic dogs

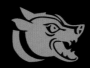

MARIAN WINSRYG
LULU

GIOTTO
THE DREAM
OF JOACHIM

Dogs have played an important role in so many different cultures that they have come to symbolize a bewildering variety of things. They are associated with religious beliefs, abstract concepts, and a wide range of individual people, both mythical and historical.

Many of these associations are fairly predictable. In the West, the dog has most frequently been used as a symbol of fidelity. In portraits it refers specifically to marital fidelity, and throughout the Middle Ages the dog featured extensively in tomb effigies, often depicted nestling at the feet of the deceased. It could also symbolize the feudal loyalty that a vassal owed to his lord. In the East, in contrast, dogs were more often regarded as symbols of vigilance and protection. Statues of them were placed at the entrances to temples and palaces, or were buried along with the dead. These

EGYPTIAN
FIGURE OF A JACKAL

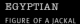

In more abstract terms, dogs were often included in
allegorical depictions of the Five Senses, representing
the sense of smell. The most celebrated example can

be found in the tapestry series of the *Virgin with the Unicorn*

(c. 1510). More surprising, perhaps, are the associations

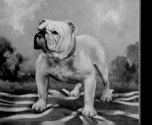

centuries) and the Aztecs (twelfth to sixteenth centuries), the tenth day was symbolized by a dog. Those born under this sign were believed to have great powers of leadership.

In many parts of the world dogs have also become linked with a sense of national identity. One of th

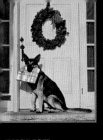

their popularity. In Britain, for example, the bulldog has long been associated with a spirit of patriotism. The German shepherd, on the other hand, was renamed the Alsatian after the First World War, in order to save it from the consequences of anti-German sentiment.

The Germans themselves felt a closer affinity with the dachshund. Kaiser Wilhelm II (1859–1941) had owned several of these sparky little dogs and, before the conflict, they provided a popular, lighthearted theme for many German artists and illustrators. After the defeat, however, attitudes changed. In Otto Dix's poignant *The Match Seller* (1920), a crippled war veteran and a dachshund were shown confronting each other in the gutter, symbolizing the postwar disillusionment felt in their country.

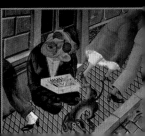

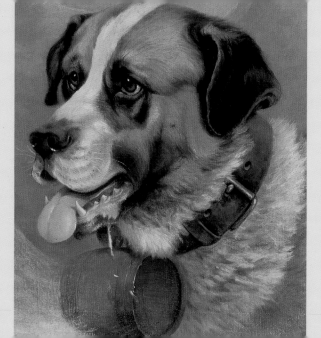

BOURHILL
A SAINT BERNARD IN
AN ALPINE LANDSCAPE
1892

This famous breed takes
its name from Bernard de
Menthon (923–1008), an
Augustinian monk who founded
a hospice for travelers in the
Alpine pass that now bears his
name. During the winter months
in particular the monks would
strive to rescue anyone who had
become trapped in a snowdrift
or avalanche. Dogs were kept at
the hospice from a fairly early
stage, but they do not seem to
have been used in rescue work
before the mid-seventeenth
century. Fittingly, St. Bernard is
now revered as the patron saint

Bernard de Menthon
has been the focus of a
number of canine myths.
According to *The Golden
Legend* of the thirteenth
century, for example, his
mother had a recurrent
dream during her
pregnancy, in which she
became convinced that
she was carrying a whelp,
which barked loudly in
her stomach. Other
commentators have noted
the uncanny resemblance
between the markings of
the Saint Bernard dog and
the design of the
Augustinian badge.

LEGHE SUTHERS, 1856–1924

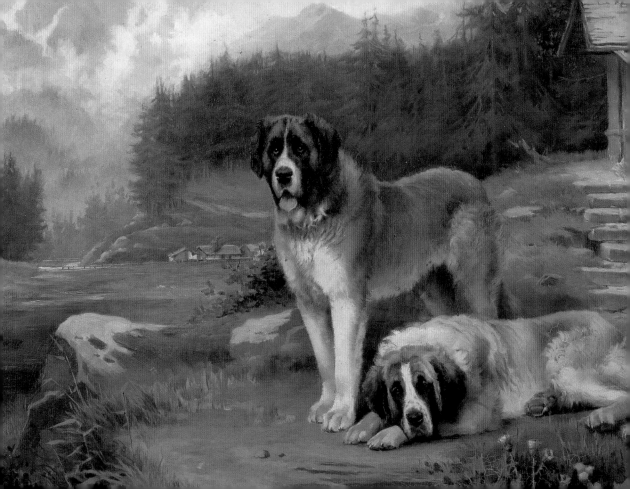

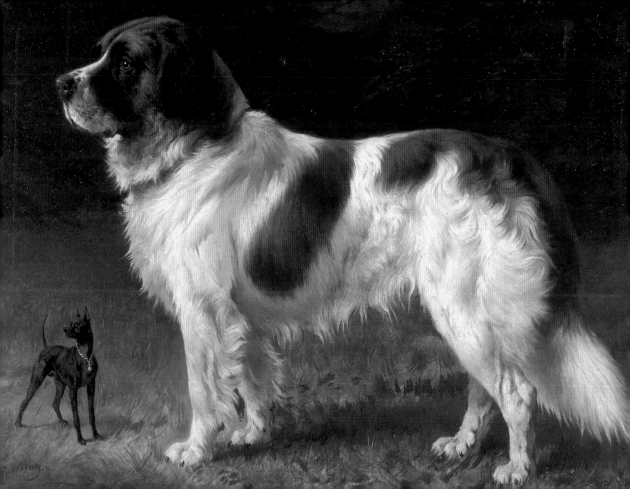

ENGLISH
TEATIME FOR MARCUS
1964

Saint Bernards are famed for bringing sustenance to stricken travelers, so it is only fair that humans should return the favor. In this instance a pet named Marcus has acquired the English taste for drinking tea. In reality, the image of the Saint Bernard with a keg of brandy around its neck is just a popular myth, although blankets and bread have sometimes been strapped to its back.

SPERLING
A SAINT BERNARD AND A MINIATURE PINSCHER
19th/20th Century

The origins of the Saint Bernard are uncertain, although the most popular view is that it developed from the Tibetan mastiff, which was introduced into Europe by King Xerxes of Persia (c. 519–465 BC) in c. 485 BC. By a curious irony, some monks from the St. Bernard hospice were invited to found a similar institution in Tibet in 1932. The long-haired version of the breed (*pictured here*) has proved less successful in rescue work than the smooth-haired variety, because its coat becomes encrusted in ice.

HEINRICH SPERLING, 1844–1924

"eware of a silent dog
and still water. "

LATIN PROVERB

SAVERY

ORPHEUS CHARMING THE ANIMALS

c. 1618

Orpheus was a Thracian poet and musician, whose songs could charm the beasts, the birds, and even the trees. For animal artists, this provided an opportunity to paint a variant of the Garden of Eden theme. The foreground is filled with a wide variety of creatures, while the human element is negligible (Orpheus is barely visible, underneath a tree in the distance). As in conventional depictions of Paradise, animals that would normally fight or hunt each other are shown mingling together happily.

ROELANDT SAVERY, 1576–1639

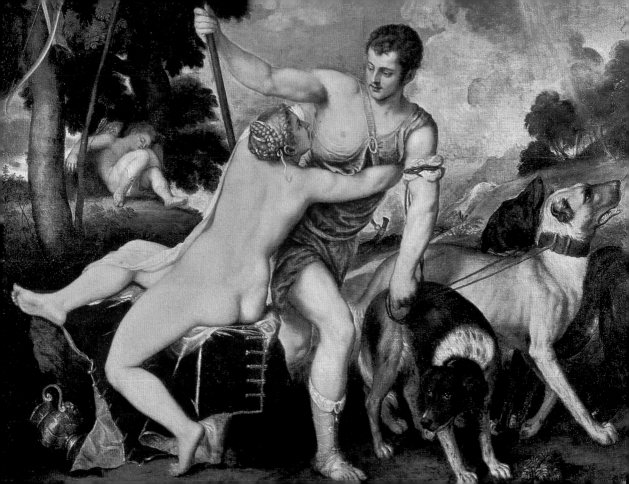

CORREGGIO
JUPITER AND GANYMEDE
c. 1530

Ganymede was a young shepherd boy, famed for his good looks. Zeus desired the lad and, transforming himself into an eagle, swooped down to snatch him away from his flock. Ganymede's dog is shown here, barking fiercely at the abductor, but to no avail. Zeus carried the boy up to Mount Olympus, where he became cupbearer to the gods.

CORREGGIO (ANTONIO ALLEGRI), c. 1489–1534

TITIAN
VENUS AND ADONIS
1553

Venus fell hopelessly in love with a beautiful youth named Adonis. He did not return her love, however, a fact that is symbolized by the sleeping Cupid in the background. Here, Adonis is anxious to leave with his dogs, but the goddess tries to hold him back, sensing perhaps that he will shortly be killed in a hunting accident.

TITIAN (TIZIANO VECELLIO), c. 1485–1576

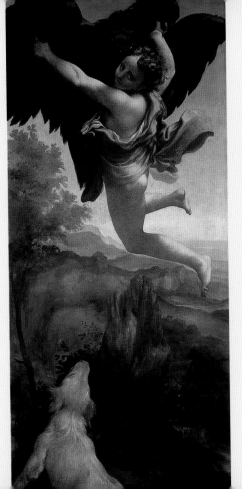

" The Bogue who is let out every night for half an hour's yapping, is anchored in the moonlight just before the door, and, under the belief that he is watchdog at a lone farm beleaguered by moss-troopers, is simply raising Cain. "

ROBERT LOUIS STEVENSON,
1850–94

313

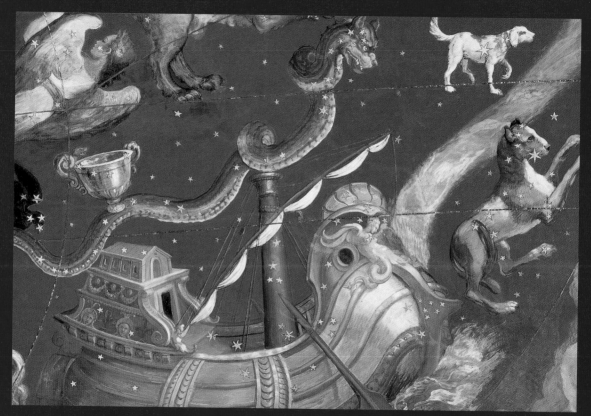

BURNE-JONES
CERBERUS
1875

In Greek mythology, Cerberus was the terrible, three-headed Hound of Hell, who stood at the entrance to Hades, ready to devour living intruders. Burne-Jones's image of the beast is comparatively tame. Some sources suggest that the three heads were maned with serpents and that Cerberus also had a barbed tail, which could rip apart human flesh.

SIR EDWARD BURNE-JONES, 1833–98

VECCHI
MAP OF THE HEAVENS (DETAIL)
c. 1574–5

Celestial maps may feature a variety of dogs, but the main two are the hounds of Orion, namely Sirius (the Greater Dog Star) and Maera or Laelaps (the Lesser Dog Star). According to legend, Orion was a powerful huntsman and a close companion of the goddess Diana. After he was killed in a hunting accident, she carried him up to the heavens and set him among the stars.

GIOVANNI DE' VECCHI, 1536/7–1615

315

JEUX DE LA XVII OLYMPIADE
ROMA
25.VIII-11.IX
ROMA MCMLX

HERBERG
DOG
1987

Drawing her inspiration from the *Lupa Romana* (*see right*), Herberg's Dog is meant as a timeless symbol of maternity. Viewed in sharp profile—she almost appears to be balancing on two legs—the mother is patiently awaiting the return of her litter, so that she can feed them from her swollen teats.

MAYDE MEIERS HERBERG,
b. 1946

ITALIAN
POSTER ADVERTISING
THE OLYMPICS
1960

In publicizing the Summer Games in Rome, the Italian authorities made extensive use of the city's symbol, the *Lupa Romana*. This image of the she-wolf that suckled the founders of Rome was based on a celebrated Etruscan statue, which dates back to the fifth century BC (*see page 137*). For many years it stood outside Rome's Lateran Palace, until Pope Sixtus IV donated it to the city. The carvings of the twins, Romulus and Remus, were added during the Renaissance period.

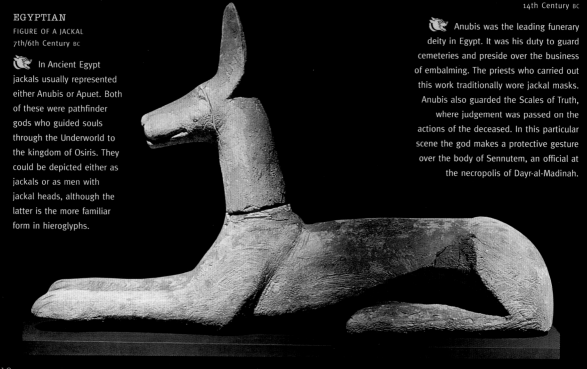

EGYPTIAN
FIGURE OF A JACKAL
7th/6th Century BC

In Ancient Egypt jackals usually represented either Anubis or Apuet. Both of these were pathfinder gods who guided souls through the Underworld to the kingdom of Osiris. They could be depicted either as jackals or as men with jackal heads, although the latter is the more familiar form in hieroglyphs.

Anubis was the leading funerary deity in Egypt. It was his duty to guard cemeteries and preside over the business of embalming. The priests who carried out this work traditionally wore jackal masks. Anubis also guarded the Scales of Truth, where judgement was passed on the actions of the deceased. In this particular scene the god makes a protective gesture over the body of Sennutem, an official at the necropolis of Dayr-al-Madinah.

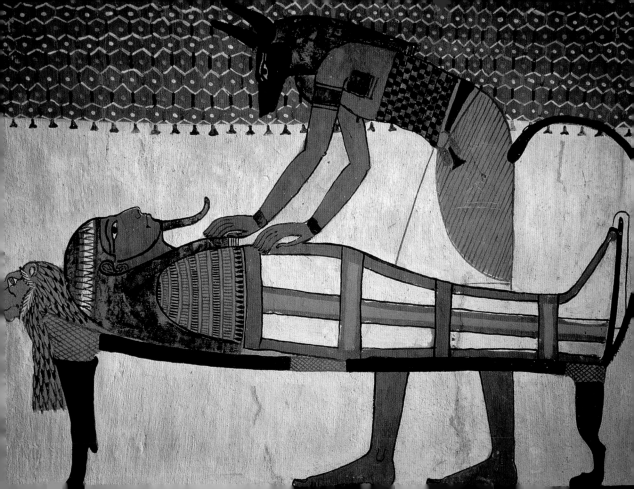

" Dogs watch for us faithfully; they love and adore their masters; they hate strangers; their power of tracking scent is remarkable; great is their keenness in the chase—what can all this mean but that they were made for man's advantage? "

MARCUS TULLIUS CICERO, 106–43 BC

ANONYMOUS
MANDRAKE ROOT
12th Century

 The mystical mandrake plant was once credited with near-magical properties. It could act as a love potion, cure barren women, aid clairvoyants, and help witches with their spells. Gathering it, however, was a perilous task. The plant only grew near gibbets and its man-shaped root would scream aloud when plucked, killing all who heard its cry. So the favorite method was to tie a dog to the root and force it to carry out this deadly chore.

FRENCH
THE VIRGIN WITH THE UNICORN
15th Century

This comes from a famous set of tapestries, which combine an allegory of the Five Senses with scenes from a magical hunt. Because of their powerful scenting ability, dogs were used to represent the sense of smell. The message was underlined by a profusion of fragrant flowers.

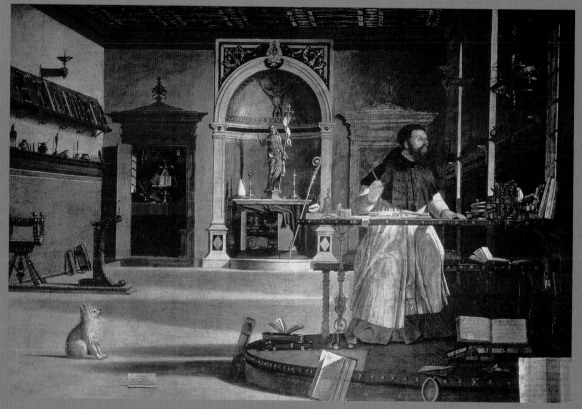

DÜRER
MELENCOLIA I
1514

Melancholy was one of the Four Temperaments, which were frequently depicted in Renaissance allegories. This was not regarded as a negative quality, but one that signified introspection and contemplation. In mythological terms, Melancholy (the winged figure in this picture) was also the daughter of the god Saturn, whose attribute was a dog—hence its inclusion here.

ALBRECHT DÜRER, 1471–1528

CARPACCIO
ST. AUGUSTINE IN HIS STUDY
C. 1502

Carpaccio's pictures are full of anecdotal detail about Venetian life. Here, he depicts Augustine of Hippo (354–430), one of the leading Church Fathers and a prolific writer on theological matters, amid a clutter of books and manuscripts. As the saint gazes out of the window for inspiration, his dog stares up at him, craving more attention.

VITTORE CARPACCIO, C. 1450/60–1525/6

STROZZI
MADONNA OF THE ROSARY WITH ST. ROCH,
ST. DOMINIC, AND ST. SEBASTIAN
17th Century

St. Roch's dog is shown with the loaf of bread that he carried to his master, lying stricken with the plague. St. Dominic (c. 1170–1221) is also associated with dogs. When his mother was praying for a child, she had a vision of a dog with a flaming torch in its mouth, symbolizing her future son's burning faith.

Bernardo Strozzi, 1581–1644

LILIO
ST. ROCH
16th Century

St. Roch (1293–1327) was revered as the patron saint of plague sufferers, following his work with victims of the Black Death. He wears the scallop shell of a pilgrim and displays a plague sore on his thigh. He is always depicted with a dog, because canine saliva was believed to have healing powers.

Andrea Lilio (Andrea da Ancona nella Marca), 1555–1610

next pages ▶
KESSEL
THE GARDEN OF
EDEN (DETAIL)
1659

Within the art world, animal painting was a specialized field, held in comparatively low esteem. Because of its biblical theme, however, the Garden of Eden was a prestigious subject and a popular choice. Not surprisingly, Adam and Eve are relegated to a minor role, while the chief emphasis is on the harmony between the different species. The two dogs, though, are threatening to dispel this peaceful mood by yapping at the swans.

Jan van Kessel the Elder, 1626–79

ANDREA DEL SARTO
THE ARCHANGEL RAPHAEL WITH TOBIAS, ST. LEONARD, AND A DONOR
c. 1511

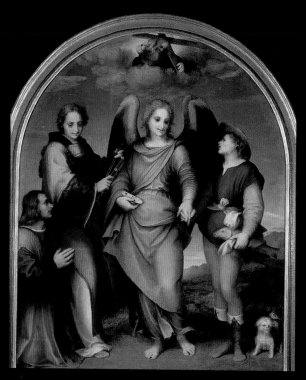

The story of Tobias and the Angel is recounted in the Book of Tobit, one of the texts in the Apocrypha. Tobias and his dog journeyed across the desert, accompanied by a stranger who eventually identified himself as Raphael. On the way they were attacked by a giant fish (probably a crocodile in the original legend). Jews regarded dogs as unclean creatures and the animal has a very negative image in the Old Testament, but the legend of Tobias has its roots in the folklore of Assyria and Persia, where dogs were held in much higher esteem.

ANDREA DEL SARTO (ANDREA D'AGNOLO DI FRANCESCO), 1486–1531

GIOTTO
THE DREAM OF JOACHIM
c. 1305

This is another episode from the legend of St. Joachim (*see page 250*). During his exile in the desert, the Angel Gabriel (identifiable by his fleur-de-lis wand) appears to Joachim in a dream, telling him to return to his wife. The shepherds, meanwhile, carry on with their work, oblivious to this miraculous visitation.

GIOTTO DI BONDONE, c. 1267–1337

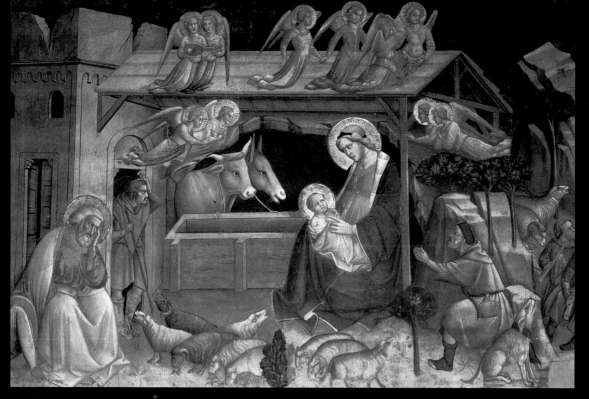

330

" A dog in the morning, sailor take warning;
A dog in the night is the sailor's delight. "

W. ROPER, 19TH CENTURY

[DOG=SUN-DOG, A SMALL RAINBOW]

GADDI
THE NATIVITY (DETAIL)
1392–5

🐾 This is an episode from *The Story of the Virgin and the Holy Girdle*, which Gaddi executed for Prato Cathedral in Italy. The picture illustrates the birth of Christ, and the presence of the dog and sheep indicates that the shepherds are about to arrive.

AGNOLO GADDI, C. 1333–96

BRITISH
ADAM NAMING THE ANIMALS
12th Century

🐾 Bestiaries, such as the *Aberdeen Bestiary* in which this illustration appeared, were popular medieval manuscripts, in which animals were used to convey moral messages. The symbolism varied from text to text, but dogs were frequently portrayed as the wisest of the beasts, because they alone recognized their own name. Another common theme played on canine associations with faith: a watchdog (that is, a priest) would be shown attacking a cat (a conventional symbol for heresy).

HONDT
THE GATHERING
OF THE ANIMALS
17th Century

On the right-hand side of the picture, Noah and his family cut timbers for the Ark, which can be seen, almost complete, on a slope in the distance. Meanwhile the animals congregate in pairs, ready to enter the vessel. Judging by his vigorous scratching, one of the dogs is assisting in this process by carrying a couple of fleas.

LAMBERT DE HONDT,

d. c. 1665

GERMAN
NOAH'S ARK
1483

This woodcut comes from the Nuremberg Bible, one of the first printed books to contain illustrations. In keeping with the maps of the day, the sea is shown as a mysterious place, inhabited by mermaids and other fanciful creatures. On the deck of the Ark a dog gazes out at these creatures, and at the turrets of submerged cities.

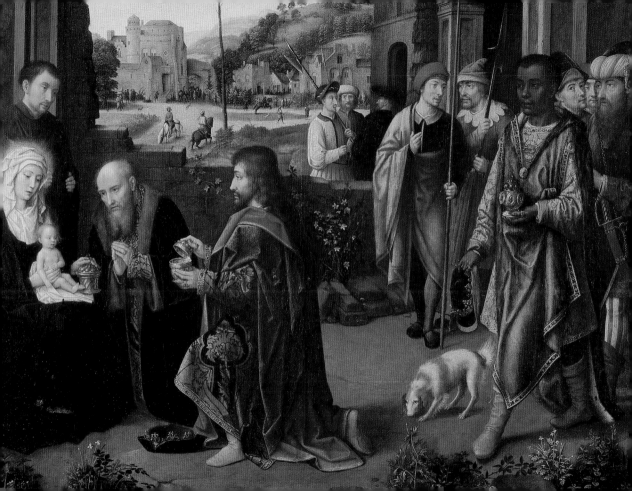

MEMLING
ADORATION OF THE MAGI (DETAIL)
1480

🐺 This is a detail of a painting entitled
The Seven Joys of Mary, which features various
episodes relating to the birth of Christ. In
common with other Netherlandish artists
of the period, Memling modeled the Magi
on the courtiers of his own day. The elegant
greyhound in the foreground would have
graced any princely household.

HANS MEMLING, C. 1433–94

DAVID
ADORATION OF THE MAGI
15th Century

🐺 Renaissance artists liked to endow their
biblical scenes with freshness and immediacy
by casting them in a contemporary mold.
The fashions, the architecture, and even the
Magi's ornate gifts would all have seemed very
familiar to David's patrons. Similarly, the
dogs are shown performing modern roles.
The one in the foreground is a courtier's
dog while, in the background, others are
preparing to go off on a hunt.

GERARD DAVID, C. 1460–1523

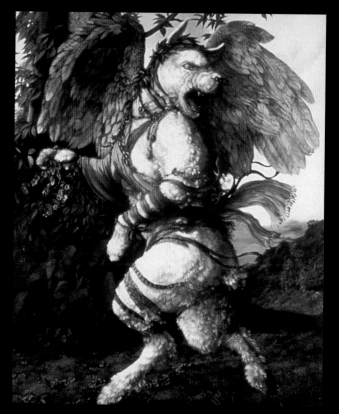

HOGIN
DAPHNE
1994

Hogin's work often includes references to Greek mythology. Daphne was a tragic nymph who was transformed into a laurel tree, but she appears to have little connection with this fearsome beast. With its horns and wings, this Daphne is more reminiscent of the hellish monsters that preyed on unfortunate mortals.

LAURIE HOGIN, b. 1964

ROMAN
LUPA ROMANA
C. AD 170

Roman artists produced many images of the she-wolf *(Lupa)*, which played such an important role in their history. According to legend, Romulus and Remus, the twin sons of a vestal virgin, were abandoned shortly after their birth. A she-wolf raised them, however, and Romulus went on to found the city of Rome.

"Ay, in the catalogue ye go for men;
As hounds, and greyhounds, mongrels, spaniels, curs,
Shoughs, water-rugs and demi-wolves are clept
All by the name of dogs: the valued file
Distinguishes the swift, the slow, the subtle,
The housekeeper, the hunter, every one
According to the gift which bounteous nature
Hath in him closed."

WILLIAM SHAKESPEARE, 1564–1616

FRANKLIN
THE SILENT ACCUSER
1924

Many early horror movies incorporated killer dogs into their plots. This exploited a natural fear of rabies, while also perpetuating the ancient tradition of the ghostly black dog, which brought death to those who crossed its path. This still is taken from a silent movie, directed by Chester Franklin.

CHESTER FRANKLIN, 1890–1949

AFRICAN
KOZO
19th Century

This ritual carving comes from the province of Cabinda, an exclave of Angola situated to the north of the Congo Estuary. It represents a Kozo (a two-headed dog), a sacred figurine that contained spirits from the Land of the Dead.

HUANG
THE UNEXPECTED (DETAIL)
1998

 Dogs have been used to assist the blind since the Middle Ages, although the first attempts to train them specifically for this purpose were made by an eighteenth-century Parisian hospital. More recently, an international system was pioneered by *L'Oeil qui voit* (The Seeing Eye), which was founded in Switzerland by an American lady, Mrs. Harrison Eustis, shortly after the First World War. The key tool is the rigid harness, which enables the blind person to interpret the dog's movements and transmit commands.

CHUCK HUANG, b. 1970

ENGLISH
SANTA'S HELPER
20th Century

The canine ability to carry small objects in the mouth has proved very useful over the centuries. Many huntsmen would be lost without a gundog, seeking out and retrieving the birds they have shot down. In performing this task, the dogs are trained to restrict their bite, in order to prevent damage to the game. Using a dog to deliver Christmas presents is rather more optimistic, although the photo offers an attractive symbol of Yuletide cheer.

" He fought with the he-dogs, and winked at the she-dogs,
A thing that had never been 'heard' of before.
'For the stigma of gluttony, I care not a button!' he
Cried, and ate all he could swallow—and more.

He took sinewy lumps from the shins of old frumps,
And mangled the errand-boys—when he could get 'em.
He shammed furious 'rabies,' and bit all the babies,
And followed the cats up the trees, and then ate 'em! "

RUPERT BROOKE, 1887–1915

DIX
THE MATCH SELLER
1920

Occasionally dogs were used to raise
serious political issues. Dix's powerful
painting focuses on the plight of a crippled
war veteran, reduced to selling matches in the
street. His poverty and his limbless condition
are in marked contrast to the well-attired
legs that walk past, ignoring him. As a final
indignity, a dachshund—a recognized
symbol of the German people—lifts its
leg and urinates on him.

OTTO DIX, 1891–1969

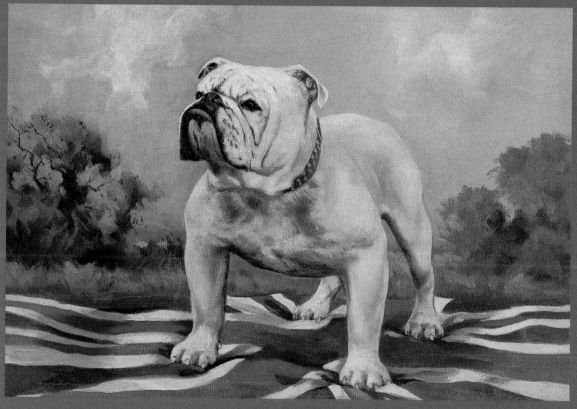

CALLIS

🐾 Callis has worked as a professional photographer, and this may well account for the clarity and attention to detail in her finely wrought dog paintings. The bulldog has come to symbolize tenacity, strength, and courage, and these qualities shine through in her picture.

JO ANN CALLIS, b. 1940

ENGLISH
BRITISH BULLDOG
20th Century

🐾 No one knows precisely how the bulldog came to be associated with the British national spirit. It may have something to do with John Bull, which has been the nickname for the archetypal Englishman since the early eighteenth century. Certainly the notion was popularized during the Victorian era, largely as the result of a patriotic music-hall song, "Sons of the Sea, All British born," which contained a line relating to the "boys of the bulldog breed."

🐾 Along with the mastiff, the bulldc
is one of the earliest breeds recorded
Britain. It dates back at least as far as tl
early thirteenth century, when the fir
instances of bull-baiting were documente
Specialist bulldog societies were
existence by the eighteenth century, th
best known being the Bulldog Club (Inc
which was established in 1894 by a grou
of "wine merchants and gentlemen"

BOB TORREZ, 20th Centu

CHAPLIN
THE CHAMPION
1915

🐾 Chaplin used dogs in a number of
his movies, to complement the character
he was playing. In *The Champion*, where
the theme was boxing, he chose a bulldog
More often, he would use a flea-bitten
stray, to echo his role as a comic tramp.

SIR CHARLES CHAPLIN, 1889-1977

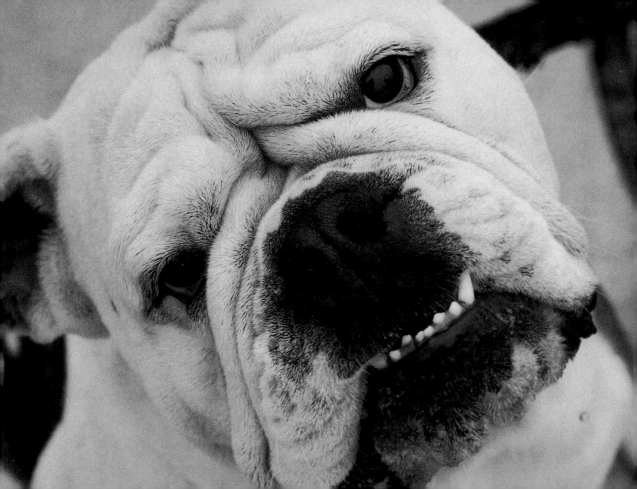

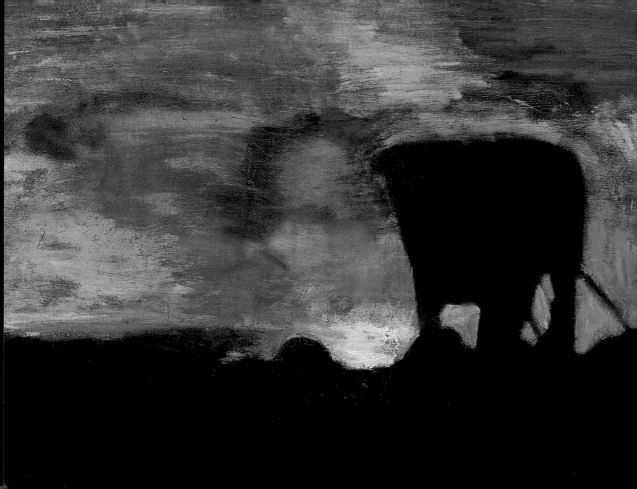

MILLER
THE TROJAN DOG
1987

 Miller's brooding picture offers a novel take on a familiar mythological tale. In place of the wooden horse that the Greeks presented to the city of Troy, the artist has painted a gigantic dog. Its bulky silhouette looms menacingly out of the night sky and, on the right, the soldiers have lowered their ladders. Soon they will climb down from the belly of the beast and put the Trojans to the sword.

PATON MILLER, 20th Century

"❝ He did not seem to be enjoying his luck . . . The black dog was on his back, as people say, in terrifying nursery metaphor. ❞

ROBERT LOUIS STEVENSON, 1850–94

MUSANTE
BLACK DOG
1987

 Black dogs are symbols of ill omen: in European lore they are ghostly, demonic forms, which stalk their victims on lonely roads, in churchyards, or on deserted moors. The howling of these dogs may presage death and the creatures themselves may inflict it. Musante's picture offers a fine evocation of one of these phantom-beasts, with its nether regions dissolving into mist.

ED MUSANTE, b. 1942

anthropomorphism

GAYLEN HANSEN
DOGHEAD AND MANHEAD
1991

"They are so human, it almost seems as if they are trying to speak to you." Even the most down-to-earth pet owners have been known to make such comments, so close is the bond between dogs and humans. Dog-haters may mock, but many civilizations carried the theme of canine anthropomorphism to far greater extremes in the past than we do today.

In some early societies deities were visualized in animal form. In Ancient Egypt, for example, there was a cult of Anubis, the jackal-headed god who guided the souls of the dead to the Underworld. When the Greeks invaded the country, they merged this figure with Hermes to create a new dog-god, Hermanubis, who also presided over funerals and the judgement of the dead. Both Anubis and Hermanubis were represented as dog-men—human figures with the head of a dog.

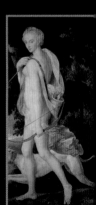

Images of dog-men were not confined to the field of religion. Early geographers composed fanciful tales about strange canine tribesmen in faraway places. Writing in the first century BC, the Greek geographer Strabo (c. 60 BC–c. AD 21) described an Ethiopian race called the

ENGLISH
DRIPPING DOGGY

Cynamolgi, who had dog-heads and were able to converse only by barking at each other. Marco Polo (1254–1324) mentioned a similar tribe located on the Andaman Islands in the Bay of Bengal, while Estonian legend spoke of a race

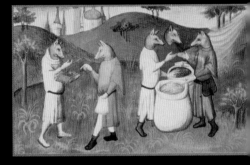

of dog-headed cannibals, living at the edge of the world. Depictions of dog-headed men, used in a purely symbolic fashion, can also be found in Christian lore. St. Dominic (c. 1170–1221), St. Bernard of Menthon (923–1008), and St. Christopher (third

FRENCH
DOG-MEN FROM THE
ANDAMAN ISLANDS

century AD) were all closely associated with dogs; St. Christopher, in particular, was often portrayed by Byzantine artists as having a dog's head. Their pictures owed much to the earlier images of Hermanubis, an association suggested by St. Christopher's role as a spiritual guide, carrying travelers across the River of Death.

In both literature and art, dogs were often featured in moral allegories, mirroring the foibles and follies of humanity. The most famous works in this vein were the Fables of Aesop, compiled in the sixth century BC. Dogs, wolves, and foxes all figured prominently in the tales, a typical example being the original "dog in the manger" (*see page 59*). This surly beast was housed with an ox in some stables, where it jealously prevented the ox from eating any hay, even though it had no desire to sample this food itself.

WILCOX
LASSIE COME HOME

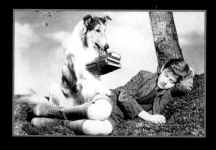

COTES
LADY STANHOPE AND THE
COUNTESS OF EFFINGHAM

A variant of this, made popular in the visual arts, was the portrayal of dogs carrying out human activities. Victorian artists enjoyed painting dogs in human attire, while a number of porcelain factories produced figurines of canines playing musical instruments. Popular myth holds that dogs and their owners grow to look like one another, a theory that has often been used by artists and writers for comic effect.

With the development of film and animation techniques, these trends mushroomed. On the large screen, Rin Tin Tin and Lassie became matinée idols for younger viewers, while Walt Disney created a range of lovable characters, such as Pluto, Goofy and 101 Dalmatians. More engaging still were the comic dogs dreamed up by some cartoonists: Snoopy, Tintin's companion Milou, and Gromit, Nick Park's Oscar-winning creation.

PRICE
THE GAY PARISIENNE

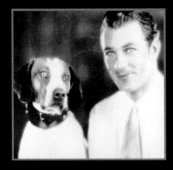

AMERICAN
GARY COOPER
AND DOG

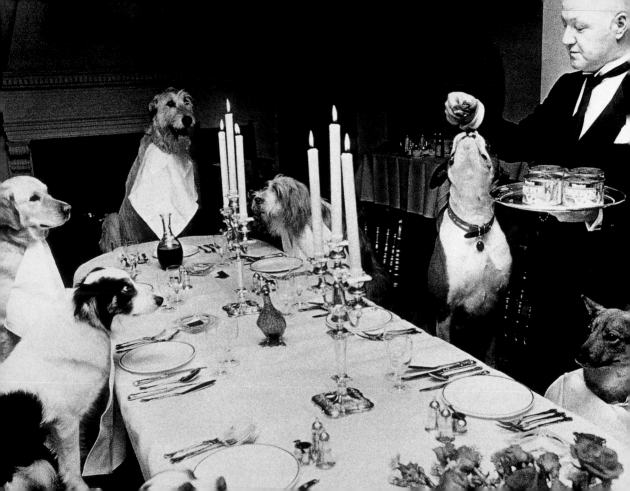

CONDÉ
UNTITLED
1978

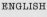 At first glance Condé's surreal sketch appears to be a parody of an Old Master drawing. Pictures of philosophers conferring together were popular during the Renaissance, but Condé pokes fun at their pretensions by portraying one of the learned men in a dress, and by depicting another with a dog's head and a fan in his paw.

MIGUEL CONDÉ, b. 1939

ENGLISH
CANINE BANQUET
c. 1975

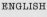 Pet food manufacturers are naturally anxious to emphasize the high quality of their product. Here, one company has dressed up a selection of dogs in their best bibs and tuckers and laid on a feast for them. Most of the diners seem patient enough, but there is always someone who forgets his table manners.

GERMAN

CIRCUS DOG

c. 1925

Tom Belling used a number of dressed-up dogs in an animal routine at the Busch Circus, which was based in Berlin in the 1920s. In this instance, the creature is meant to represent an eccentric conductor, waving his outsized baton.

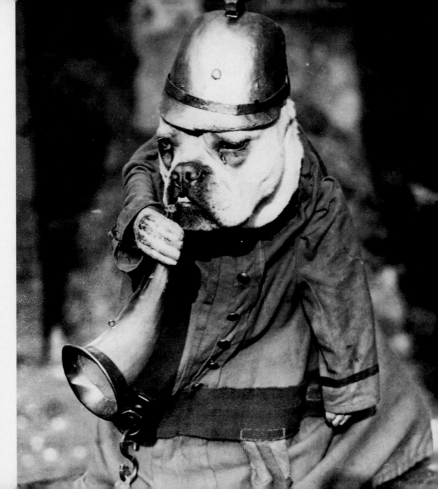

" My master will be
as proud as a dogge
in a doublet. "

THOMAS DEKKER, c. 1570–1632

GERMAN
CIRCUS DOG
c. 1925

Another of Tom Belling's dogs
from the Busch Circus in Berlin. This
time, a pug named Bully is shown in
the garb of a fireman, ready to sound
the alarm. Pictures of this kind may
have helped inspire the photographic
work of William Wegman (b. 1942),
which features his own dog, Man Ray,
attired in a variety of costumes.

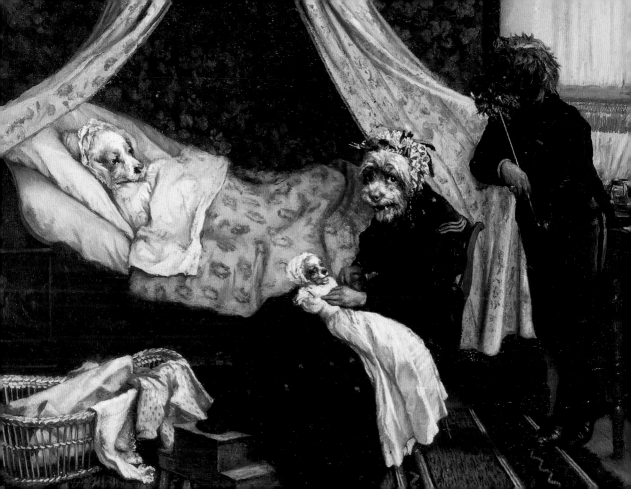

ENGLISH
DRIPPING DOGGY
1955

 It used to be enough just to hose a dog down in the yard, but some pooches now expect all manner of beauty treatments. The luxurious bath towel is designed to prevent this pet from shaking itself dry all over the furniture.

STOBBAERTS
THE NEW ARRIVAL
19th Century

 The practice of portraying dogs in human situations became a popular theme in nineteenth-century art. Often there were satirical undercurrents in these paintings, with artists using the role-switching as a vehicle for social criticism. This picture, however, is a straightforward pastiche of a very commonplace genre scene.

JAN STOBBAERTS, 1838–1914

" Someone told me that your illustrious friend
Goethe hated dogs. God forgive him, if he did.
For my part, as you know, I love them heartily.
They are grateful, they are brave, they are
communicative, and they never play at cards. "

WALTER SAVAGE LANDOR, 1775–1864

FRENCH
DOG-MEN FROM THE ANDAMAN ISLANDS
1413

During the age of exploration, many nations
speculated about a race of dog-men, living on faraway
shores. Most Western sources located them on the
Andaman Islands, in the Bay of Bengal. This particular
vision of their lifestyle comes from the celebrated *Livre
des Merveilles* (Book of Wonders), which was presented
to Jean, Duc de Berry in 1413. Often the dog-men were
characterized as ferocious cannibals, but these canine
merchants appear peaceful enough.

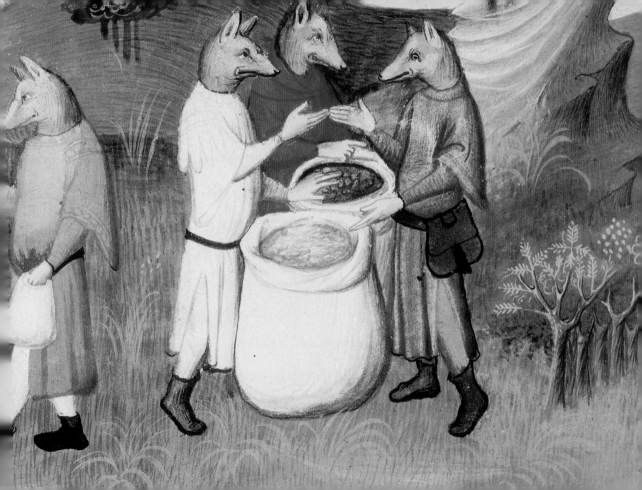

Rin Tin Tin
James Brown

WALKER and LANDERS
THE CHALLENGE OF RIN TIN TIN
1957

This intelligent Alsatian was one of the most
enduring canine heroes of the silver screen. The
original Rin Tin Tin (1916–32) was a German army
dog, which became a huge box-office attraction in a
string of American silents of the 1920s. The idea was
revived for a US television series in the mid-1950s.
Rin Tin Tin is shown here with James Brown, one
of his human helpers.

ROBERT WALKER, 20th Century,

AND LEW LANDERS (LEWIS FRIEDLANDER), 1901–62

WILCOX
LASSIE COME HOME
1943

This scene with Roddy McDowall is from the
first —and arguably the best—of the *Lassie* movies,
which were popular during the 1940s and 1950s. It
recounted the adventures of a remarkable pet, which
managed to rejoin its human family after they had been
forced to part with it. The original star was a collie
named Pal, who was actually a laddie
rather than a lassie.

FRED WILCOX, C. 1905–64

SMIRKE

THE RIVALS

c. 1827

Using animals to mirror the actions of their owners was a popular comic device, employed by many artists. In this illustration of a scene from Henry Fielding's novel *Tom Jones* (1749), a confrontation between two uppity women is echoed by their respective pets.

ROBERT SMIRKE, 1752–1845

GERMAN

FASHION MODELS WITH POODLE

1960

Through no fault of its own, the poodle has long been linked with the world of *haute couture*. Initially a hunting dog, its elaborately clipped coat made it a natural accessory for fashionable women. This reached a peak in the 1890s, when the vogue for the corded poodle (that is, a poodle sporting a kind of dreadlock coiffure) was at its height.

LANDSEER
LADY AND SPANIELS
1830S

In his prints and drawings, Thomas Landseer helped to popularize the work of his more famous younger brother. Edwin was not particularly fond of painting portraits, although he was obviously more enthusiastic if his patrons surrounded themselves with dogs. This pencil drawing appears to be based on one of several pictures of his friend, Lady FitzHarris.

THOMAS LANDSEER, 1795–1880
(after SIR EDWIN LANDSEER)

" Of all the dogs that are so sweet,
The spaniel is the most complete;
Of all the spaniels, dearest far
The little loving Cockers are.

They're always merry, always hale;
Their eyes are like October ale;
They are so loyal and so black;
So unresentful 'neath the whack.

They never sulk, they never tire;
They love the field, they love the fire;
They never criticize their friends;
Their every joy all joy transcends. "

E. V. LUCAS, 1868–1938

HANSEN
MAN/DOG STARING AT EACH OTHER
1993

Many of Hansen's witty paintings show men and dogs mimicking each other, the intention being to deflate any human feelings of superiority. Dogs may sometimes appear almost human in their actions but, even more certainly, some men behave like animals.

GAYLEN HANSEN, b. 1921

" Pomero is sitting in a state of contemplation, with his nose before the fire. He twinkles his ears and his feathery tail at your salutation . . . Last evening I took him to hear Luisina de Sodre play and sing. Pomero was deeply affected, and lay close to the pedal on her gown, singing in a great variety of tones, not always in time. It is unfortunate that he always will take a part where there is music, for he sings even worse than I do. "

WALTER SAVAGE LANDOR, 1775–1864

ENGLISH
BENJAMIN BRITTEN
20th Century

The composer Benjamin Britten (1913–76) used to get some of his best musical ideas during the long "thinking walks" that he took with his dogs. This particular pet is Clytie, whom he described as "the smallest dachshund ever." He named her after the music teacher, Clytie Mundy.

FONTAINEBLEAU SCHOOL
DIANA THE HUNTRESS
c. 1550

 Loosely based on a classical statue, this is one of the most familiar images of the goddess of the chase in Western art. Her athletic build and slightly androgynous appearance accord well with her enthusiastic hunting dog. Some authorities believe that the face may be modeled on Diane de Poitiers (1499–1566), a famous courtesan of the period.

COURBET
COURBET WITH A BLACK DOG
c. 1842–4

 This self-portrait dates from the start of Courbet's career and features his recently acquired pet. In a letter to his parents he wrote: "I now have a splendid little English dog, a pure-bred spaniel given to me by a friend, which everyone admires." With their long, flowing locks, dog and master made a fine pair, seen here on a sketching expedition in the hills.

GUSTAVE COURBET, 1819–77

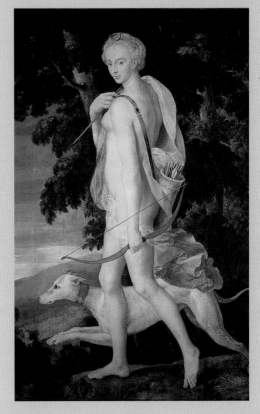

NASMYTH
PORTRAIT OF JOHN COCKBURN ROSS
18th Century

An aristocrat poses elegantly beside a tree, resting his rifle against his leg. At his feet a pointer gazes up impatiently, raring to get on with the day's sport. As in most portraits of this kind, the hunting accessories are not so much an indication of the gentleman's favorite pastime, as a token of his wealth and class.

ALEXANDER NASMYTH, 1758–1840

AMERICAN
GARY COOPER AND DOG
c. 1930

A glossy publicity shot of the actor, who made his name through a series of early Hollywood westerns. Cooper (1901–61) had worked as a cowboy and cartoonist before breaking into movies in the mid-1920s. He was already associated with rugged, outdoor roles, which may explain why the studio posed him with a sporting dog.

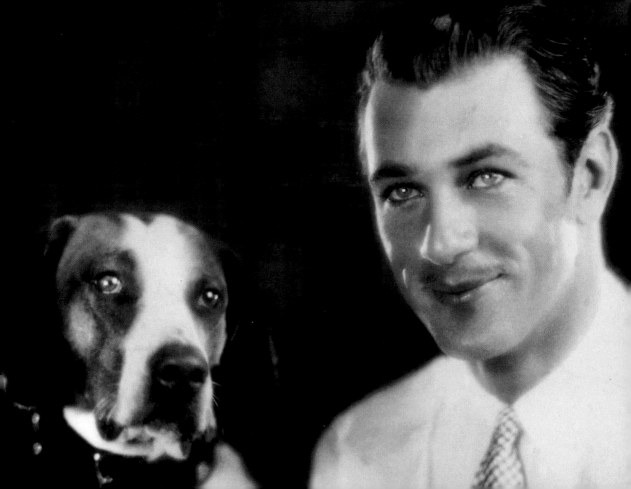

COTES

LADY STANHOPE AND THE
COUNTESS OF EFFINGHAM
c. 1768

Many eighteenth-century portraits
contain an element of playacting. In this
picture the two ladies take on the roles
of Diana and one of her hunting maidens.
The goddess holds a spear and wears
a crescent-shaped tiara, while her
companion unleashes a dog against the
stag in the background. The choice of
theme may have been prompted by some
amateur theatricals, organized by Sir
Francis Delaval, Lady Stanhope's brother.

FRANCIS COTES, 1726–70

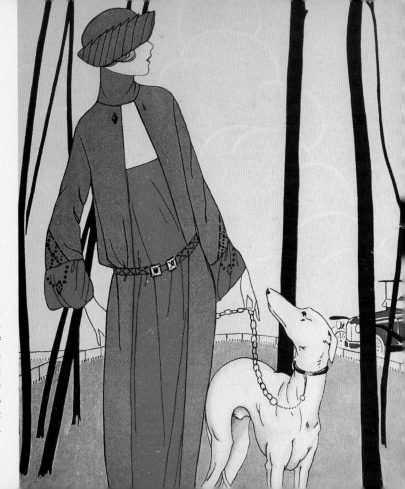

FRENCH
WALKING THE DOG
1921

Greyhounds were a common
sight in the fashion magazines of the
1920s, their sleek appearance
complementing the slim-line styles of
the day. The dogs themselves were
also highly fashionable. Hollywood
actresses arrived at premières with
them, and ladies with greyhounds
were a popular theme for the Art
Deco figurines of the period.

GAINSBOROUGH
LADY JANE WHICHCOTE
18th Century

Gainsborough made
his name as a portraitist,
but he was also a fine
painter of animals. In this
attractive composition, a
Pomeranian offers a paw to
its mistress, as if to shake
hands with her.

THOMAS GAINSBOROUGH,
1727–88

DEVIS
MISS ANDERSON WITH HER DOG
c. 1780

Devis's work has aroused the interest of social historians, because most of his sitters came from the middle classes, rather than the aristocracy. In this charming scene, the girl has untied her little terrier's ribbon and is using it as a leash.

ARTHUR DEVIS, 1708–87

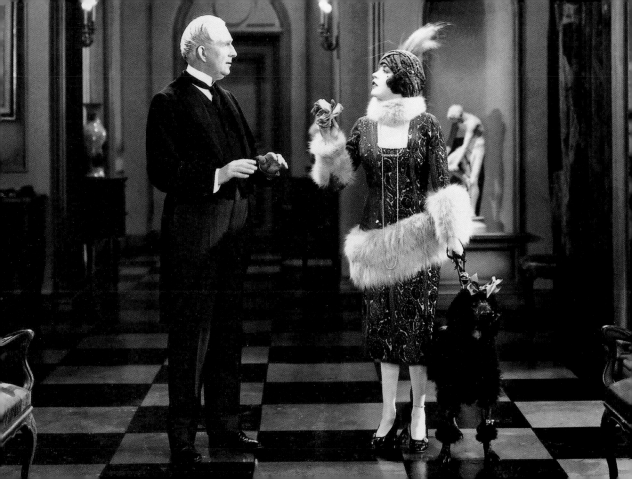

AMERICAN
MAN AND MAID
1925

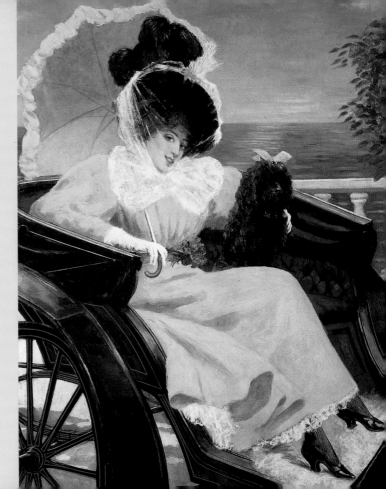

Comic comparisons between dogs and their owners worked best as visual jokes, and were thus more common in silent movies than in the talkies. Here, the bands of fur around the woman's costume are meant to echo the poodle's coiffure. The actress in question, Renee Adoree (Jeanne de la Fonté, 1898–1933), was accustomed to working with animals, because she had previously been a bareback rider in a circus.

PRICE
THE GAY PARISIENNE
20th Century

No humor is intended here. Instead, the dog is being used as a kind of fashion accessory. Its ribbon is color-coordinated with the girl's dress and parasol, and its thick black fur teams up well with her hat and shoes. The patient creature is also sporting an elegant, jeweled collar.

JULIUS PRICE, 1857–1924

ENGLISH
THE DUKE AND DUCHESS OF WINDSOR
c. 1960

At the time of the Abdication crisis in 1936 Edward and Mrs. Wallis Simpson (later the Duke and Duchess of Windsor) kept a number of cairn terriers. But in later years they were usually seen with pugs, which went by such names as Disraeli, Imp, Trooper, and Davy Crockett.

BOMBOIS
PORTRAIT OF A BULLDOG
20th Century

The artist thought this picture bore a striking resemblance to Sir Winston Churchill and presented it to the family in c. 1944. Churchill hung the picture in his study at Chartwell. Much had been made during the war of his "bulldog spirit," rallying the nation in its darkest hours. His favorite dog, however, was actually a poodle.

CAMILLE BOMBOIS, 1883–1970

Bombois. C.^{lle}

index of artists

Bissell, Robert
b. 1952
An English-born artist and photographer, now living in Oregon. His whimsical dream images use animals as narrators, interpreting the human world.
PAGES 288–9

Bogdany, Jakob
1660–1724
Hungarian painter, mainly active in England and the Netherlands. Initially a specialist in flowerpieces, he developed a great interest in birds, after gaining access to the aviary of Admiral George Churchill. Many of his paintings feature exotic birds, set in sweeping landscapes with classical architecture.
PAGE 179

Bombois, Camille
1883–1970
A French naïve painter, Bombois had a wide variety of jobs in his youth; among other things, he worked as a boatman, laborer, docker, and circus wrestler. He won a Military Medal for his distinguished service during the First World War. His subjects include landscapes, nudes, and portraits, but he is best known for his pictures of circus life.
PAGES 382–3

Boner, Ulrich
1300–49
Dominican priest, whose name was Latinized as Bonerius. He was documented in Berne from 1324 to 1349, when he translated a collection of fables, Der Edelstein, for his patron, Johann von Ringgenberg. These stories were extremely popular, appearing in many manuscripts and as one of the earliest printed books (1461).
PAGES 161, 176–7

Bonfigli, Benedetto
1420–96
Italian painter, one of the first Perugian artists to make use of Renaissance developments. His style reflects the influence of Domenico Veneziano (d. 1461).
PAGE 195

Bonifazio Veronese (Bonifazio de' Pitati)
1487–1553
Italian painter, the son of an armorer. He was born in Verona (hence the name Veronese), but all his documented works were produced in Venice, where he continued in the tradition of Palma Vecchio (c. 1480–1528).
PAGES 294–5

Bosch, Hieronymus (Jerome Van Aken)
c. 1450–1516
One of the supreme masters of early Netherlandish art, whose popular name derives from his native town ('s-Hertogenbosch). He belonged to a Catholic brotherhood and was extremely pious. This manifested itself in a series of extraordinary paintings, where holy figures were assailed by bizarre creatures and demons. The most famous of these is The Garden of Earthly Delights (c. 1505–10). Bosch was a major influence on Pieter Brueghel (c. 1520–69) and was hailed as a forerunner of the Surrealists.
PAGE 218

Boucher, François
1703–70
French painter and designer, the greatest exponent of rococo art. He was a pupil of François Lemoyne (1688–1737) and was greatly influenced by Antoine Watteau (1684–1721). At the French court he became the favorite painter of Madame de Pompadour (1721–64). He also produced designs for porcelain and tapestries, becoming director of the Gobelins factory in 1755. Boucher's paintings frequently display a pronounced erotic quality, with female nudes masquerading as classical nymphs and goddesses.
PAGES 22–3, 48–9

Bourhill, James
19th Century
PAGE 306

Brown, Theophilus
b. 1919
A graduate of Yale University and the University of California, Berkeley. Brown lives in San Francisco and his paintings incorporate the particular quality of Californian light. He exhibits frequently in England and the US, and his paintings form part of the permanent collections of various American museums.
PAGES 86–7

Bruegel, Pieter
c. 1520–69
Netherlandish artist, a leading exponent of genre painting showing peasant life and illustrating proverbs. He was influenced by Hieronymus Bosch (c. 1450–1516) and traveled to Italy. His work was highly regarded, particularly by Peter Paul Rubens (1577–1640), and many of his works were bought for royal collections.
PAGE 10

Brunais, Agostino
fl. 1763–80
Landscapist, portrait painter, and engraver. He exhibited in London from 1763 to 1779 at the Free Society, the Society of Artists and Royal Academy.
PAGE 223

Burne-Jones, Sir Edward
1833–98
British painter, illustrator, and decorative artist, one of the leading figures of the Pre-Raphaelite movement. While a student at Oxford, he met William Morris (1834–96) and the pair worked together in the firm of Morris & Co., as pioneers of the Arts and Crafts movement. Burne-Jones became best known for his languid, Italianate figures, which epitomized the elegance of the Aesthetic style. He also exerted a considerable influence on the French Symbolists.
PAGES 93, 262–3, 315

Busby, Thomas
fl. 1804–37
English engraver and painter of miniatures. He exhibited from 1804 to 1837 at the Royal Academy.
PAGES 119, 152–3

Callis, Jo Ann
b. 1940
American artist, working principally as a photographer. Her work is represented in museums in the US, Japan, Australia, Switzerland, and France.
PAGES 68–9, 345

Candid, Peter
c. 1548–1628
Netherlandish painter, tapestry designer, and draftsman. Candid spent most of his life in Italy and Germany, working in a Mannerist style. In 1586 he was summoned to Munich by Duke William V of Bavaria and remained there as court painter for over forty years.
PAGES 269–71

Cardon, Claude
fl. 1892–1915
Genre and landscape painter, who exhibited at the Royal Academy in 1892–3.
PAGE 59

Carpaccio, Vittore
c. 1450/60–1525/6
Venetian Renaissance painter, chiefly known for a cycle of paintings on *The Legend of St. Ursula*. His crowded scenes are packed full of colorful, anecdotal detail.
PAGES 322–3

Carrion, Maravillas
b. 1968
Spanish artist, born in Valencia. After initial training in her hometown, she completed her studies at the Art Center College of Design in the US. At present she has homes in both California and Spain.
PAGES 60, 86, 285

Chadwick, Gregg
b. 1959
American artist, currently based in San Francisco. His paintings reflect his extensive travels to many corners of the globe. He has exhibited in Italy, Japan, and the US.
PAGE 81

Chaplin, Sir Charles
1889–1977
British-born actor, comedian, and director. Chaplin joined the troupe of slapstick performers of Fred Karno (1866–1941) at an early age. Then, in 1913, he began working for Mack Sennett (1880–1960) at the Keystone Studios. From 1914 he was making his own movies, gaining worldwide fame with his comic persona as the Tramp. His most celebrated features include *The Kid* (1920), *The Gold Rush* (1924), and *City Lights* (1931). He was exiled from the US in 1952 for his political views, making a new home in Switzerland. He was awarded an Honorary Oscar in 1971.
PAGES 227, 346

Chapman, John Watkins
fl. 1853–1903
British genre painter and engraver. From 1853 to 1890 he exhibited a large number of works at the Royal Academy, the British Institution and the New Water-Colour Society.
PAGE 201

Chapman, Michael
b. 1957
American artist, based in California. Chapman's paintings have a charming, nostalgic quality, focusing on quiet neighborhoods in his native region, on the Pacific coast.
PAGES 108–9

Charlton, John
1849–1917
British painter of battle scenes and animals, born in Northumberland. From 1870 he exhibited regularly at the Royal Academy.
PAGES 292–3

Christensen, Wes
b. 1949
American painter and watercolorist, and a champion of figurative art. His small-scale pictures contain abundant references to art history and mythology.
PAGES 256, 265

Clairin, Georges
1843–1919
French painter, trained at the École des Beaux-Arts, Paris. Clairin was one of the last of the Orientalists, exhibiting his pictures at the Salon from 1866. In the 1870s he carried out decorative work at the Paris Opéra.
PAGE 272

Condé, Miguel
b. 1939
American artist, now naturalized in
Spain. His work contains surreal
elements, although it retains a strong,
traditional base.
PAGES 131, 357

Cooper, Abraham
1787–1868
English sporting artist. Cooper started
work as a rider at Astley's Circus,
before turning to art. He studied
under Ben Marshall (1768–1835),
developing a very similar style. He
exhibited frequently at the Royal
Academy and was elected as a
member in 1820. There, he tried to
organize financial assistance for his
friend, the poet and artist William
Blake (1757–1827).
PAGE 128

Correggio (Antonio Allegri)
c. 1489–1534
Italian painter, who took his name
from his birthplace. Little is known of
his life, although his initial influence
appears to have come from Andrea
Mantegna (1431–1506). His greatest
work was produced in Parma, where
he made a name for himself with his
sensuous mythological scenes.
PAGE 313

Coster, Jan
17th Century
Netherlandish painter based in
Arnhem.
PAGES 30–1

Cotes, Francis
1726–70
English artist, and one of the
founding members of the Royal
Academy. He worked mainly in pastels
until 1763, then turned to oils and
took an active part in the artistic life
of England from 1760 to 1770.
PAGES 354, 376

Courbet, Gustave
1819–77
Major French painter, a pioneer of the
Realist movement. He gained
notoriety for his monumental scenes
of peasant life, which coincided with
the 1848 Revolution. Courbet was a
radical socialist and was elected as a
councillor in the short-lived Paris
Commune (1871). He was later
imprisoned for his part in the
destruction of the Vendôme Column
and many of his paintings were
confiscated. He died in exile in
Switzerland. Throughout his life
Courbet was a passionate hunter and
often included dogs in his sporting
pictures.
PAGES 186–7, 372–3

Crane, Walter
1845–1915
English painter and illustrator, best
known for his designs for children's
books. He was an important member
of the Arts and Crafts movement and
influenced the development of Art
Nouveau. He executed illustrations for
William Morris's Kelmscott Press, but
also produced designs for wallpaper,
textiles, and stained glass. In
addition, Crane was a prominent
educationalist, holding a number of
teaching posts and becoming
principal of the Royal College of
Art in 1898.
PAGES 117, 144

David, Gerard
c. 1460–1523
Early Netherlandish painter, active
mainly in Bruges. David settled there
in 1484, eventually succeeding
Memling as the city's leading artist.
His work consisted principally of
stylish, if somewhat conservative,
religious pictures, but his best-known
painting is the gory *Judgment of
Cambyses* (1498).
PAGES 334–5

Davis, Arthur Alfred
fl. 1877–91
British painter of genre scenes. He
exhibited from 1877 to 1884 at the
Suffolk Street Gallery and other
exhibitions.
PAGE 27

Desportes, Alexandre-François
1661–1743
French painter and tapestry designer,
specializing in portraits, hunting
scenes, and dog pictures. As a
portraitist, he was employed at the
Polish court of Jan Sobieski in 1695–6.
Then, on his return to France, he
switched to hunting pictures, working
extensively for royal patrons. His style
owes much to the Flemish tradition,
exemplified by Frans Snyders
(1579–1657).
PAGE 47

Devis, Arthur
1708–87
English portrait painter specializing in
conversation pieces (group portraits
in elaborate settings). His doll-like
figures have a certain charm. The best
collection of his work is in Preston,
his birthplace.
PAGE 379

Dix, Otto
1891–1969

German painter and printmaker, a leading figure in the Neue Sachlichkeit (New Objectivity) movement. After serving in the trenches during the First World War, his art expressed powerful antiwar sentiments, epitomized by *The Match Seller* (1920) and by his series of etchings, *The War* (1924). He taught at the Dresden Academy during the 1920s, but his antimilitary stance led to a clash with the Nazis and he was briefly imprisoned in 1939. He served in the Home Guard during the Second World War, ending the conflict as a prisoner of the French.
PAGES 305, 342–3

Domenichino (Domenico Zampieri)
1581–1641

Bolognese painter. After studying under Ludovico Carracci (1555–1619), he worked for Carracci's cousin, Annibale, at the Palazzo Farnese. By 1615 he was regarded as the leading artist in Rome. Domenichino specialized in monumental frescos, although he also made a name for himself as a landscape painter. He typifies the Bolognese Classical style.
PAGES 26–7

Doré, Gustave
1832–83

Leading French illustrator, who rose to prominence after producing designs for new editions of Dante's *Inferno* (1861) and *Don Quixote* (1862). He excelled at grotesque, Romantic subjects, but could also work in a realistic vein. His drawings of the London slums were much admired by Vincent van Gogh (1853–90). In later life he took up painting and sculpture, with limited success.
PAGES 146–7

Douglas, Edwin J.
1848–1914
PAGE 20

Dubin, Jorg R.
b. 1955

American artist, trained at the Art Institute of Southern California. His paintings have been featured in museum and university exhibitions throughout California. He lives and paints in Laguna Beach.
PAGES 260–1

Dürer, Albrecht
1471–1528

Outstanding painter and printmaker, usually regarded as Germany's greatest artist. The son of a goldsmith, he trained under Michael Wolgemut (1434–1519). He then worked initially as a book illustrator, before establishing his own studio in Nuremberg. Through his travels in Italy he absorbed the lessons of the Renaissance. Dürer's range was phenomenal: he produced large-scale altarpieces, stylish portraits, complex allegories, and charming watercolors of natural-history subjects.
PAGE 323

Earle, Augustus
1793–1838

British painter. Earle exhibited at the Royal Academy between 1806 and 1815, before embarking on his extensive travels. These took him to North America (1818–20) and South America (1820–4). In February 1824, while traveling to India, he was accidentally abandoned on Tristan da Cunha in the Atlantic and stranded there for eight months, before a passing ship took him to Australia. He returned to England in 1829 and joined Charles Darwin's expedition on the *Beagle* three years later, although ill health eventually forced him to pull out of this project.
PAGES 298–9

Emms, John
1843–1912

Emms was a prolific painter of dogs and other animals, making a speciality of foxhounds and fox terriers. The quality of these pictures was recognized at the highest level. Over the years he had almost 300 works accepted for exhibition at the Royal Academy. He used to pay his bar-bills with paintings, but two of them recently sold at auction for $150.000.
PAGES 20–1, 50–1, 162, 178–9, 204–5

Ferneley, John E.
1782–1860

British sporting artist, the son of a wheelwright. As a youngster, Ferneley used to practice his painting on the damaged panels of coaches brought in for repair. His favorite subjects were foxhunts, which he painted on "scurries"—long, rectangular formats that he devised himself. He also produced animal portraits.
PAGE 235

Flameng, François
1856–1923

French painter and illustrator. He was a pupil of Alexandre Cabanel (1823–89) and began exhibiting at the Salon from 1873. He was best known for his portraits and his book illustrations, notably those in the 1886 edition of Victor Hugo's works.
PAGES 94–5

Fortescue, William B.
1855–1924
English painter. Fortescue enjoyed working in Cornwall, particularly in the area around St. Ives. He made a name for himself with his atmospheric marine paintings and coastal scenes.
PAGE 241

Foujita, Tsugouharu (or Léonard)
1886–1968
Japanese-born artist, active mainly in France. After graduating from the Tokyo Academy, he moved to France and became associated with the École de Paris. He developed a unique style, blending Oriental and European traits. He was based in Japan from 1933 to 1950, but eventually settled permanently in Paris, taking French nationality in 1955. He is best known for his paintings of cats.
PAGES 168–9

Fragonard, Jean-Honoré
1732–1806
Leading French rococo painter. Fragonard was a pupil of both Jean-Baptiste Chardin (1699–1779) and François Boucher (1703–70), before completing his studies in Italy. He painted landscapes and family scenes, but is best known for his high-spirited, erotic paintings, which delighted the French court. His principal patron was Madame du Barry (1741–93) and, through this connection, he came to epitomize the more sensual and frivolous aspects of the Ancien Régime.
PAGE 187

Franklin, Chester
1890–1949
American movie director. Collaborated on silent comedies with his better-known brother, Sidney (1893–1972). Their partnership ended when Chester was conscripted for war service in 1918.
PAGE 338

Frémin, René
1672–1744
French sculptor, a pupil of François Girardon (1628–1715) and Antoine Coysevox (1640–1720). He was employed by the Bâtiments du Roi (King's Buildings), most notably at the Palace of Versailles. His largest commission came from Philip V of Spain, who hired him to provide statuary for the gardens of La Granja.
PAGE 23

Gaddi, Agnolo
c. 1333–96
Florentine artist, son of the better-known Taddeo Gaddi (c. 1300–c. 1366). His work owes much to the influence of Giotto. His most notable frescos were painted in Santa Croce, Florence, and inthe Prato Cathedral.
PAGES 330–1

Gainsborough, Thomas
1727–88
English portraitist, one of the founding members of the Royal Academy. He was born in Suffolk, but established his reputation in London and Bath. Throughout his career Gainsborough had an ongoing rivalry with Sir Joshua Reynolds (1723–92), the other great portraitist of the day. The latter won more official honors, but Gainsborough is now generally recognized as the more gifted painter. In addition to his portraits, he produced remarkable landscapes and "fancy pictures" (a type of rustic genre scene).
PAGE 378

Gauermann, Friedrich
1807–62
Member of an Austrian family of artists. Trained by his father Jakob (1773–1843), who was an engraver. Gauermann's landscapes were typical products of the Biedermeier era.
PAGES 150–1

Gauguin, Paul
1848–1903
French painter, sculptor, and graphic artist, one of the leading figures of the Symbolist and Post-Impressionist movements. He worked as a stockbroker before taking up art professionally. He exhibited with the Impressionists, but was soon anxious to leave the sophisticated art circles of Paris and steep himself in a more "primitive" environment. He found this initially at Pont-Aven in Brittany, and ultimately in the French Pacific colony of Tahiti. Gauguin's use of pure colors and flat, stylized forms singles him out as one of the founding fathers of modern art.
PAGE 67

Gérard, Théodore
1829–95
Belgian artist. Gérard spent most of his career in his native city of Ghent. He followed the contemporary fashion for scenes of country life, executing them in a rather sentimental manner.
PAGES 240–1

Giotto di Bondone
c. 1267–1337
Florentine painter, widely regarded as one of the seminal figures of the Renaissance. He broke away from the stylizations of Byzantine art, introducing a strong note of naturalism into his paintings. Giotto is most famous for his fresco cycle at the Arena Chapel in Padua (c. 1305–6). He also executed a cycle of paintings on the Life of St. Francis of Assisi, which of course features many animals.
PAGES 250, 302, 328–9

Giovanetti, Matteo

c. 1300–68/9

Italian artist from Viterbo, who died in Rome. His most important surviving work is the decorative scheme at the Palais des Papes in Avignon, which he supervised or executed himself.
PAGE 36

Graeme, Colin

1858–1910

English painter, specializing in pictures of sporting dogs and horses. His father was R. H. Roe (1793–1880), who was also an artist. Graeme dropped his real surname, in order to avoid confusion when they exhibited together.
PAGES 13, 31

Grau, Gustave-Adolph

1873–1919

French genre painter. He was a pupil of Léon Bonnat (1833–1922) and was awarded the Légion d'honneur in 1908.
PAGE 97

Grimm, Jacob

1785–1863

German author. After studying law at Marburg University, he entered the Hessian civil service in Kassel. In 1808 he was appointed librarian to Jerome, King of Westphalia. Together with his brother, he wrote two famous books, *Kinder- und Hausmärchen* (1812–14)

and *Deutsche Sagen* (1816–18). Jacob also wrote *Deutsche Mythologie* in 1835, a pioneering study on German folklore. Both brothers were professors at Göttingen University, until they were dismissed by Ernst August, King of Hanover (1771–1851) for opposing his policies.
PAGE 155

Grimm, Wilhelm

1786–1859

German author, younger brother of Jacob. Their careers are remarkably similar. Both studied at Marburg, were employed in Kassel, and became professors at Göttingen University. There, they were among the Göttingen Sieben (Göttingen Seven), who were fired for protesting against the king's reactionary policies. Jacob was the greater scholar of the two, but Wilhelm had more poetic flair and played a greater part in writing the fairytales.
PAGE 155

Gysels, Pieter

c. 1621–90

Flemish painter, who was registered as a master at the Antwerp Guild of St. Luke in 1649/50. He specialized in landscapes and in pictures of village fairs.
PAGE 149

Hacker, Arthur

1858–1919

English painter. He studied under Léon Bonnat (1833–1922), one of the best-known Salon painters of the day. Under his influence, Hacker developed a naturalistic style and a preference for rural themes.
PAGE 220

Hager, Thomas

b. 1965

American artist who studied photography at the University of North Florida, Jacksonville. He now lives and exhibits mainly in Florida.
PAGE 112

Hahn, Moira

b. 1956

American artist living in Los Angeles. Her watercolors often contain a blend of political satire and an interest in environmental issues.
PAGES 258–9

Hancock, Charles

1802–77

English painter, originally employed at Tattersalls, which introduced him to numerous sporting events and aroused his interest in animal studies. He painted many sporting scenes, most of them small, and exhibited at the Royal Academy from 1819 to 1847.
PAGES 124–5

Hansen, Gaylen

b. 1921

American painter, based in the Pacific Northwest. His pictures feature a remarkable variety of wildlife, portrayed in a naïve style. These are used as departure points for Hansen's witty comments on the follies of human behavior.
PAGES 3, 5, 45, 62, 66–7, 79, 120–1, 147, 164–5, 177, 350, 370

Hardy, Bert

1913–95

English photographer. His first published photographs appeared in *The Bicycle* (c. 1930), and from 1941 to 1957 he worked for *Picture Post*. His most controversial assignment occurred in 1950 when, with James Cameron (1910–85), he covered the Korean War. This caused political difficulties for the magazine. In later life, Hardy became a farmer.
PAGES 163, 202–3

Harvey, Sir George

1806–76

Scottish artist, born at St. Ninian's near Stirling. After training in Edinburgh, he began painting landscapes and scenes from Scottish history. He was made president of the Royal Scottish Academy in 1864, and gained his knighthood three years later.
PAGES 232–3

Henwood, Thomas
19th Century
PAGES 34–5

Herberg, Mayde Meiers
b. 1946
American artist, who trained at San Diego and Claremont in California. She worked initially in clay and textiles, before switching to pastels. Herberg is a Professor of Art and director of the Art Gallery at Santa Ana College, California.
PAGES 82, 316–17

Herring, John Frederick Senior
1795–1865
The best-known member of a family of British sporting artists. His father made carriage accessories, and John had his first art lessons from a coachdriver. John himself worked as a driver for a while, but also painted inn signs, coachdoors, and horse portraits. After deciding to become a professional artist, he moved to London and studied under Abraham Cooper (1787–1868). His work became extremely popular and was widely reproduced in sporting prints. Herring's three sons all became painters.
PAGES 131–3, 248–9

Hewitt, Charles
20th Century
PAGES 256, 281

Hockney, David
b. 1937
English painter and printmaker probably the best-known contemporary artist in Britain, now living in California. His earlier work stressed the male nude, but he now paints landscapes and animal portraits, as well as friends and family.
PAGE 2

Hogin, Laurie
b. 1964
American artist, trained at Cornell University and the Art Institute in Chicago. She divides her time between teaching and exhibiting. Her work is represented in corporate collections and museums in the US.
PAGE 336

Holdsworth, Anthony
b. 1945
British-born American artist trained in both England and San Francisco. He works in the plein air tradition, painting on the streets of California, teaches extensively, and leads art tours to Central and South America.
PAGE 4

Hondt, Lambert de
d. c. 1665
Flemish painter, brother of Jan de Hondt the Elder. He was a pupil of David Teniers (1582–1649).
PAGES 303, 332

Horlor, George W.
fl. 1849–91
English artist, best known for his landscapes and animal portraits. He tended to depict pet dogs, rather than the sporting variety.
PAGES 196–7

Huang, Chuck
b. 1970
Huang was born in Taipei, Taiwan. He studied at the Art Institute of Southern California and the Pennsylvania Academy of Art, and his paintings focus on monumental settings of everyday occurrences.
PAGE 340

Hunt, William Holman
1827–1910
English artist, one of the founders of the Pre-Raphaelite Brotherhood. His precise, highly colored paintings usually carried a moral message. He made several trips to the Middle East, in order to give his biblical pictures a more authentic feel. His best-known painting is *The Scapegoat* (1854–5).
PAGES 228–9

Hush, Gary
20th Century
PAGE 120

Hutton, Kurt
20th Century
PAGES 160, 185

Jacopo di Pietro
16th Century
PAGE 236

James, Christopher
b. 1947
The artist is a descendant of the novelist Henry James (1843–1916). He is both a photographer and a painter, and his work is frequently published in both *Aperture* and *American Photographer*.
PAGE 88

Joy, Thomas Musgrave
1812–66
English painter, known mainly for his portraits. Joy was a regular exhibitor at the Royal Academy and had some distinguished clients, among them Queen Victoria (1819–1901).
PAGE 98

Kessel, Jan van, the Elder
1626–79
Coming from a Flemish family of artists, van Kessel was registered in the Antwerp Guild of St. Luke as a flower painter, but he also depicted animals, birds, and insects. His pictures were often elaborate and minutely detailed compositions, which were based on illustrations from scientific texts.
PAGES 325–7

Kilburne, George Goodwin
1839–1924
British genre and sporting painter, watercolorist, and engraver. He was a member of the Royal Institute of Painters in Water-Colors and a pupil of the wood-engraver Dalziel brothers. He exhibited frequently at the Royal Academy, and especially at the New Water-Colour Society, from 1862.
PAGES 36–7

Klimt, Gustav
1862–1918
Austrian painter and designer, the first president of the Vienna Secession. In keeping with his academic training, Klimt began by producing grandiose decorative schemes, but he was soon attracted by avant-garde ideas, most notably those of the Impressionists and Symbolists. Resigning from the Viennese Artists' Association, he helped set up the Secession in 1897. He is best known for his sensual, if menacing, pictures of the *femme fatale*.
PAGES 128–9

Koscianski, Leonard
b.1952
American artist, now based in Annapolis, Maryland. He has exhibited throughout the US and Europe, and examples of his work can be seen in the Metropolitan Museum of Art, New York, and the Chicago Art Institute.
PAGES 114, 116, 135

Landers, Lew (Lewis Friedlander)
1901–62
American director, mainly of support features. His movies included *The Raven* (1935), *Man in the Dark* (1953, a 3-D movie), and *Captain Kidd and the Slave Girl* (1953).
PAGE 364

Lanfield, Sidney
1900–72
American movie director. Initially a jazz musician, Lanfield switched to the cinema in 1932. His version of *The Hound of the Baskervilles* featured the classic pairing of Basil Rathbone and Nigel Bruce in the Holmes and Watson roles.
PAGES 118, 136–7

Landseer, Sir Edwin
1802–73
English artist and sculptor, one of the most famous painters of animal subjects. Landseer was a child prodigy, exhibiting remarkable work while still in his mid-teens. He became one of Queen Victoria's favorite artists and was knighted in 1850. Many of his paintings have a profoundly sentimental character, which is currently unfashionable, but he did not shrink from depicting the inherent cruelty of hunting scenes. His most celebrated painting is probably *The Monarch of the Glen* (1850), which has long been used to advertise a famous brand of whiskey,

while his best-known sculptures are the lions in London's Trafalgar Square.
PAGES 27–9, 46–7, 63, 73, 103, 138–9, 182

Landseer, Thomas
1795–1880
English engraver, the brother of Sir Edwin Landseer. He did much to publicize the latter's paintings through his graphic work.
PAGES 368–9

Largillière, Nicholas de
1656–1746
Leading French portraitist, initially based in Antwerp and London, where he worked as an assistant to Sir Peter Lely (1618–80). After returning to Paris, Largillière soon established himself as the favorite painter of the upper middle classes. He was appointed director of the Academy in 1743, at the age of eighty-seven.
PAGES 8, 297

Lecomte du Noüy, Jean-Jules-Antoine
1842–1929
French painter who joined the studio of Charles Gleyre (1806–74) in 1861. He painted historical scenes, portraits, and decorative pictures for the Church of the Trinity in Paris and various churches in Romania. He was awarded the Légion d'honneur in 1876.
PAGES 214–15

Lester, Adrienne
19th Century
PAGES 160, 167

Lewis, Charles
1830–92
British genre painter. He was a skillful colorist and exhibited at the Royal Academy in 1853, becoming a member of the Royal Institute in 1882.
PAGES 268–9

Lewis, John Frederick
1805–76
English painter, etcher, and graphic artist. A pupil of Sir Thomas Lawrence (1769–1830), he made his name through his animal pictures and was commissioned to paint sporting subjects by George IV (1762–1830). After 1830 he traveled extensively, particularly in Egypt. This led him to specialize in Arab themes.
PAGE 127

Lewis, Judith
fl. 1775–6
PAGES 32–3

Liédet, Loyset
active 1460–78
Netherlandish miniaturist, based in Bruges. He contributed to a wide range of illuminated manuscripts, but is probably best known for his work in the *Chronicles of Froissart*.
PAGE 104

Lilio, Andrea (Andrea da Ancona nella Marca)
1555–1610
Italian painter and engraver. He was a protégé of Pope Sixtus V (1521–90) and decorated the library of the Vatican and the church of St. John Lateran. A number of mythological scenes are attributed to him.
PAGES 324–5

Lloyd, Harold
1893–1971
American actor, one of the greatest silent comedians. Lloyd appeared in hundreds of comedy shorts, usually in the persona of a timid college boy with horn-rimmed spectacles. His movies were notable for some daring stunts, most notably the skyscraper escapade in *Safety Last* (1923). Lloyd's career was eclipsed by the advent of the talkies, but he retired a wealthy man.
PAGES 226–7

Lopez, Richard
b. 1943
Hispanic American artist, specializing in images of his native culture and of nature. He does considerable work to support struggling Hispanic teachers and artists.
PAGES 282–3, 294

Lynde, Raymond
19th Century
PAGES 170–1

Malbon, William
1805–77
English genre painter, who was born in Nottingham.
PAGE 274

Marc, Franz
1880–1916
German painter and sculptor, one of the founders of Die Blaue Reiter (Blue Rider) group, which also included Wassily Kandinsky (1866–1944), Paul Klee (1879–1940), and August Macke (1887–1914). He is particularly well known for his sensitive depictions of animals, which he regarded as deeply spiritual creatures. Marc was killed in action during the First World War.
PAGES 130–1, 282

Marshall, John
fl. 1840–96
British painter, who exhibited in London from 1840 to 1896.
PAGES 16–17

Marshall, William Elstob
fl. 1859–81
British painter, active in London and Edinburgh.
PAGES 182–3

Memling, Hans
c. 1433–94
Netherlandish artist, active mainly in Bruges. Memling followed in the tradition of Rogier van der Weyden

(1399/1400–64), although his style was rather more bland. He specialized in religious paintings and portraits, and there is a museum devoted to his work in Bruges.
PAGE 335

Menzel, Adolf von
1815–1905
German painter and illustrator, active mainly in Berlin. He painted scenes from Prussian history, but also depicted images of modern life and industry. He worked in a naturalistic style and had a genuine feeling for light, even though he regarded Impressionism as the "art of laziness."
PAGE 245

Miller, Paton
20th Century
American artist, who studied in Honolulu and New York, where he now lives and works in Southampton.
PAGES 348–9

Morisot, Berthe
1841–95
French painter, the granddaughter of Jean Fragonard (1732–1806). She was the principal female exponent of Impressionism, painting mainly women and children. Her work was considerably influenced by Edouard Manet (1832–83) and, in later life, by Pierre-Auguste Renoir (1841–1919).
PAGES 272–3

Moulins, the Master of
active c. 1480–1500
French painter, who takes his name from a famous altarpiece in Moulins Cathedral. Its style contains a blend of late Gothic and early Renaissance features, and is notable for the influence of Hugo van der Goes (d. 1482). Attempts have been made to identify the Master of Moulins with Jean Perréal, born in Paris in 1452.
PAGES 104–5

Musante, Ed
b. 1942
American artist born in Honolulu, Hawaii. His work has been exhibited in many US galleries, including the Schmidt Bingham Gallery in New York and the Campbell-Thiebaud Gallery in San Francisco.
PAGE 349

Muybridge, Eadweard
1830–1904
British-born pioneer of motion photography, who emigrated to the US and changed his name (originally Edward Muggeridge). He began his photographic experiments while director of Photographic Surveys for the US government. The results were published in two groundbreaking studies—*The Horse in Motion* (1878) and *Animal Locomotion* (1887)—both widely used by animal artists.
PAGES 76–7

Nasmyth, Alexander

1758–1840

Scottish artist, a pupil of Allan Ramsay (1713–84). He began work as a portraitist, but became better known for his landscapes. Nasmyth also produced architectural and stage designs. He moved in distinguished literary circles and was a close friend of Robert Burns (1759–96).

PAGE 374

Nava, John

b. 1947

American artist, whose work consists largely of realistic portraits, nudes, and still lifes. An excellent draftsman, he also produces set designs for ballet and the theater.

PAGES 286–7

Ong, Diana

b. 1940

Chinese American artist, born and educated in New York. She is a multi-media artist, whose work has been exhibited in more than thirty counties and displayed on numerous book jackets.

PAGE 113

Palanker, Robin

b. 1950

American artist born in Buffalo, New York. Her work has been exhibited at the Patricia Shea Gallery in Santa Monica, and the Riverside Art Museum in California. It has also been published in Douglas Messerli's *Silence All Around Marked*.

PAGES 216–17

Palizzi, Filippo

1818–99

Italian artist, one of four painter brothers. Palizzi is best known for his landscapes. He pioneered the Realist movement in Italy, and became director of the Naples Academy in 1878.

PAGES 40–1

Parsons, Alfred

1847–1920

English landscapist and watercolorist. He was a pupil of the South Kensington School and made numerous drawings for English and American magazines. He exhibited in London in 1868 at the Royal Academy and the Royal Institute.

PAGES 290–1

Paton, Frank

1856–1909

English artist, active in London and Gravesend in Kent. Paton specialized in dog paintings and hunting scenes. He was a regular exhibitor at the Royal Academy.

PAGES 220–1

Peake, Robert

fl. 1580–1626

English portrait painter. He won many commissions from Henry, Prince of Wales (1594–1612), and in 1607 became Sergeant Painter to James I (1566–1625).

PAGE 24

Piero di Cosimo

c. 1462–1521

Enigmatic Florentine painter. He studied under Cosimo Rosselli (1439–1507) and adopted his Christian name. In Giorgio Vasari's *Lives of the Artists* (1550) he was characterized as an eccentric, living on hard-boiled eggs. Indeed, many of his pictures are strange, mythological concoctions, which defy interpretation, though *Death of Procris* (c. 1500) shows that he was capable of genuine pathos. Andrea del Sarto (1486–1531) was his pupil.

PAGES 6, 71

Pierre, Christian

b. 1962

American artist who started as a jeweler's studio assistant, then went on to work on various collaborative painting projects in England and the US. In his work he tries to reflect both the simplicity of life and human adaptability.

PAGE 165

Price, Julius

1857–1924

English painter. He exhibited at the Royal Academy in 1884 and in exhibitions in Paris.

PAGES 355, 381

Purdy, Gerald

b. 1930

American artist and teacher. He has concentrated in his art on finding the humor in all situations, and his prints and paintings are widely collected in university galleries in the US.

PAGES 110–11

Raymond, Pierre

16th Century

French painter, engraver, and enameler. He worked in Paris from 1534 to 1578, often producing work for Francis I (1494–1547), and signed many of his works Raxman or Rexman.

PAGES 208, 251

Reinagle, Philip

1749–1833

Scottish artist, of Hungarian descent. He moved to England in 1769, to study at the Royal Academy Schools. Initially a portraitist, he soon began to specialize in animal pictures. In a canine context, his best-known works were twenty-four dog paintings, widely reproduced as engravings in *The Sportsman's Cabinet* (1803–4).

PAGES 8, 56–7

Reinagle, Richard Ramsay
1775–1862
British painter, son of Philip Reinagle. He studied in Italy and Holland, before specializing in portraits and animal pictures. Throughout his career he was a regular exhibitor at the Royal Academy.
PAGE 202

Renoir, Pierre-Auguste
1841–1919
French artist, one of the leading Impressionist painters. He worked initially as a decorator in a porcelain factory, before entering the studio of Charles Gleyre (1808–74), where he befriended some of the future members of the Impressionist group. He was particularly close to Claude Monet (1840–1926), and the pair used to paint side by side along the banks of the Seine. Renoir participated in the Impressionist exhibitions, but he later developed a more traditional style, concentrating mainly on nudes and mythological subjects.
PAGES 257, 274–5

Reynolds, Sir Joshua
1732–92
English painter and writer, the first president of the Royal Academy. Reynolds trained under Thomas Hudson (1701–79), before completing his studies in Italy. His profound knowledge of history painting helped him to raise the status of portraiture in Britain. This was reinforced by his influential lectures, the *Discourses* (1769–91), which were delivered at the Royal Academy. His work is notable above all for its versatility, leading Thomas Gainsborough (1727–88) to exclaim, "Damn him! How various he is!"
PAGES 255, 296

Rivière, Briton
1840–1920
British artist of Huguenot descent. His father was the drawing master at Cheltenham College, where Briton's talents emerged at an early age. By the age of twelve he had already exhibited at the British Institution. He was briefly influenced by the Pre-Raphaelites, but soon began to specialize in animal paintings. He became a member of the Royal Academy in 1880.
PAGES 92–3

Romero, Frank
b. 1941
American artist born in Los Angeles. The most recent exhibitions of his work have taken place at the Alitash Kebede Gallery in Los Angeles and the Sylvia White Gallery in Santa Monica. He was a founder of Los Four, a collective of Hispanic artists.
PAGES 84–5, 158

Romney, George
1734–1802
English portraitist, the son of a Lancashire cabinetmaker. He excelled at producing pictures of children, though he is probably best known for his many paintings of Emma Hart, the future Lady Hamilton (c. 1761–1815), who became Lord Nelson's mistress.
PAGE 107

Rousseau, Henri
1844–1910
French painter, the most celebrated of all naïve artists. He spent his working life as a customs officer, hence his nickname Le Douanier (the customs man). After taking early retirement, he devoted his time to painting, producing highly colored, dreamlike pictures of jungle scenes, gypsies, and snakecharmers. Rousseau's extraordinary style was much admired in avant-garde circles and proved a source of inspiration for the Surrealists.
PAGES 209, 236–7

Rubens, Sir Peter Paul
1577–1640
Flemish painter, designer, and diplomat, the leading exponent of the Baroque style in northern Europe. He became a master in the Antwerp painters' guild in 1598, before traveling to Italy, where he worked for the Duke of Mantua. Later he was employed by Archduke Albert and his wife the Infanta Isabella, the Spanish viceroys in the Netherlands. One of his missions was to secure a peace settlement between England and Spain, which led to him being knighted by Charles I (1600–49). As an artist, Rubens was enormously popular throughout Europe. His immense output consisted not only of paintings, but also tapestry designs, book illustrations, and festival decorations.
PAGE 48

Salimbeni, Ventura di Arcangelo
1568–1613
Italian painter and engraver, born in Sienna and taught by his father, Arcangelo (fl. 1567–80/9). Salimbeni worked in Rome for several years, most notably in the Vatican Library, before returning to Sienna in 1595.
PAGE 194

Sartorius, Francis
1734–1804
Member of a British family of sporting artists. Francis was best known for his portraits of horses. He was a regular exhibitor at the Society of Artists and the Royal Academy.
PAGE 53

Savery, Roelandt
1576–1639
Flemish artist, best known for his still lifes, animal pictures, and landscapes. He worked for Henri IV (1533–1610) in France and Emperor Matthias (1557–1619) in Vienna, but is most famous for his connections with Rudolf II (1552–1612) of Hungary and Bohemia. At the latter's court in Prague, Savery was able to study his patron's remarkable menagerie. This included many rare breeds, including the now-extinct dodo.
PAGES 310–11

Scott, Septimus
1879–c. 1932
PAGES 184–5

Seurat, Georges
1859–91
French painter and draftsman, the founder of the Neo-Impressionist school. Briefly influenced by the Impressionist style, Seurat searched for a way to lend its effects greater permanence and grandeur. Drawing his inspiration from a variety of scientific texts on color and optics, he devised the principles of Neo-Impressionism, in which compositions were built up through a system of tiny, colored dots. His *Sunday Afternoon on the Island of La Grande Jatte* (1884–6) is the supreme expression of this. Seurat's premature

death, at the age of thirty-one, cut his career short, when he was at the height of his powers.
PAGES 192–3

Shonnard, Timothy
20th Century
PAGES 257, 278–9

Smirke, Robert
1752–1845
English painter and book illustrator, accepted as a member of the Royal Academy in 1793. Smirke was a prolific illustrator, producing work for new editions of the *Arabian Nights* and *Don Quixote*.
PAGE 367

Smythe, Edward Robert
1810–99
PAGES 222–3

Specht, Friedrich
1839–1909
German animal painter, sculptor, lithographer, and illustrator. He was a pupil at the Stuttgart Academy, and illustrated the *Life of Animals* by the naturalist Alfred Brehm (1829–84) and children's books.
PAGES 144–5

Sperling, Heinrich
1844–1924
German painter of figures and animals.
PAGES 308–9

Standing, Henry William
fl. 1895–1905
PAGES 238–9

Stern, Pia
b. 1952
American artist born in California. She has exhibited widely, most recently at the Erickson & Elins Gallery in San Francisco.
PAGES 80–1, 217

Stevens, Gustav Max
1871–1946
Belgian painter of figures, landscapes, portraits, and flowers. He wrote and illustrated *En province française*.
PAGES 96–7

Stobbaerts, Jan
1838–1914
Belgian painter and etcher. He was trained by the renowned animal painter Emanuel Noterman (1808–63). Stobbaerts specialized in plein air scenes of the Antwerp region. In 1884 he was invited to exhibit with Les XX. He settled in Brussels two years later.
PAGES 360–1

Stone, Marcus
1840–1921
British painter, trained by his father, Frank, who was also an artist. Stone began as an illustrator, aided by some of his father's literary friends, such as Charles Dickens (1812–70) and William Makepeace Thackeray (1811–63). He then became a painter of historical scenes, showing a preference for the Napoleonic era. Modern themes were less common but, in most of his works, Stone attempted to conjure up a lyrical, romantic mood.
PAGES 100–1

Stretton, Philip
fl. 1879–1922
English artist, born in London. A talented animal artist, he specialized in sporting subjects and dogs. The latter were usually depicted in cozy, domestic settings. Stretton was an occasional exhibitor at the Royal Academy.
PAGES 279, 284

Strozzi, Bernardo
1581–1644
Italian painter from Genoa. He joined the Capuchin Order in c. 1597, but left it to look after his mother. He settled in Venice in 1631, where he made his living painting portraits, genre scenes, and religious works.
PAGE 325

Stubbs, George
1724–1806
English painter and printmaker, noted above all for his outstanding skill at depicting horses. Born in Liverpool, Stubbs was virtually self-taught, but his deep knowledge of anatomy enabled him to produce accurate pictures of all kinds of animals. His most famous work in this field was *The Anatomy of the Horse*, published in 1766. He was also a fine portraitist.
PAGES 35, 62, 89–91

Suthers, Leghe
1856–1924
English genre painter. He exhibited in London from 1885 to 1905.
PAGES 306–7

Tayler, John Frederick
1802–89
English painter and printmaker. He trained at Sass's Academy and in Paris, under Horace Vernet (1789–1863). He shared a studio with Richard Parkes Bonington (1802–28). Tayler's forte was hunting scenes.
PAGE 204

Tenré, Charles Henry
1864–1926
French genre painter and illustrator, who was particularly drawn by decoration. He was awarded the Légion d'honneur in 1900.
PAGES 161, 196

Ter Meulen, François Pieter
1843–1927
Netherlandish landscape and animal painter. Destined at first to work in the humanities, he turned properly to painting only in 1874, perhaps inspired by Anton Mauve (1838–88), although his work had a highly personal flavor. He exhibited in Paris.
PAGES 230–1

Thorvaldsen, Bertel
1770–1844
Danish sculptor, one of the leading figures of the Neoclassical movement. He spent much of his career in Rome, where he established a large and influential workshop. On his return to Denmark, he was fêted as a celebrity and a museum was built in his honor (1839–48).
PAGES 208, 228

Titian (Tiziano Vecellio)
c. 1485–1576
Renaissance painter, the greatest master of the Venetian school. Titian trained under Giovanni Bellini (1430/40–1516) and Giorgione (1476/8–1510). After the former's death, he became official painter to the Venetian Republic. Through a series of magnificent altarpieces, most notably those at Santa Maria dei Frari, Venice, his fame spread throughout Europe and, in 1530, he was summoned to meet the emperor, Charles V (1500–58). His work was also greatly in demand from various Italian princes. During the latter part of his career his chief patron was Philip II of Spain (1527–98). Titian excelled at altarpieces, portraits, and mythological scenes.
PAGES 276–7, 312–13

Torrez, Bob
20th Century
PAGES 346–7

Toulouse-Lautrec, Henri de
1864–1901
French painter and graphic artist, one of the leading Post-Impressionists. Born into a wealthy, aristocratic family, he was a keen horseman, but two falls damaged his legs and stunted his growth. Toulouse-Lautrec lived and worked in Paris, achieving great success with his vibrant pictures of music halls, brothels, circuses, and racing scenes. He pioneered the development of the poster. However, his dissipated lifestyle led to his early death, at the age of thirty-six.
PAGES 190–1

Trood, William Henry Hamilton
1860–99
English animal painter, specializing in dog pictures. His style was meticulous and detailed, though often with sentimental overtones.
PAGES 162, 172–3, 179–81

Trübner, Wilhelm
1851–1917
German painter, a leading member of the Munich Secession, which was founded in 1892.
PAGES 78–9

Tuke, Henry Scott
1858–1929
British painter from a Quaker background. Tuke was trained in London and Paris, where he was influenced by Impressionism. In the 1880s he became associated with the Newlyn School, and was a founder member of the New English Art Club in 1886.
PAGE 193

Van Dyck, Sir Anthony
1599–1641
One of the greatest Flemish painters. Van Dyck trained under Hendrick Van Balen (c. 1575–1632), before working for a time in Rubens's studio. He traveled to Italy, where he painted a notable series of portraits of the Genoese aristocracy. From 1628 to 1632 he was at Antwerp, before moving to England, where he entered the service of Charles I (1600–49). There, he produced his most famous works, his elegant portraits of the Stuart court. Van Dyck also painted landscapes and religious scenes.
PAGES 74–5

Vasnetsov, Victor
1848–1926
Russian painter, a leading member of
the Wanderers. The son of a priest,
Vasnetsov trained at the Academy
of Arts in St. Petersburg. From 1884
he participated in the traveling
exhibitions organized by the
Wanderers. He became renowned for
his colorful depictions of Russian
legends and folktales. He also worked
as a stage designer.
PAGES 98–9, 151

Vecchi, Giovanni de'
1536/7–1615
Italian Mannerist painter, who is
known mainly for his frescos and
religious pictures.
PAGES 303, 314–15

Vernet, Émile-Jean-Horace
1789–1863
Leading member of a family of French
painters. Vernet specialized in military
scenes, although he also produced
animal pictures and Oriental subjects.
In 1828 he was appointed director of
the French Academy in Rome.
PAGES 212–13

Vos, Paul de
c.1596–1678
Flemish painter, brother of the better-
known Cornelis de Vos (c. 1584–1651).
He specialized in hunting scenes in
the manner of Frans Snyders
(1579–1657), his brother-in-law.
PAGES 126–7

Walker, Robert
20th Century
PAGE 364

Waller, Lucy
fl. 1882–1906
PAGES 198–9

Warden, John
20th Century
PAGES 134–5

Warner, Christopher
b. 1953
Born in Montana, Warner now lives,
paints, and teaches in Los Angeles.
He is equally successful at capturing
the density of urban landscapes and
the serenity of the prairies. Animals
populate his canvases and works on
paper, which are widely exhibited in
the Midwest and West Coast.
PAGE 111

Wetherbee, George Faulkner
1851–1920
American artist, born in Cincinnati.
He trained in Boston, before
embarking on his travels in Europe.
He eventually settled in London,
where he specialized in lyrical scenes
of country life.
PAGES 210, 248

Wilcox, Fred
c. 1905–64
American movie director. He worked
initially as a publicist, later as an
assistant to King Vidor (1896–1982).
Wilcox directed three of the *Lassie*
movies, but is probably best known
for the science-fiction movie, *The
Forbidden Planet* (1956).
PAGES 354, 364–5

Winsryg, Marian
b. 1941
American artist based in Los Angeles,
widely known as a portraitist of
domestic animals. Her work can be
seen in many collections, including
those of the Los Angeles County
Museum of Art, the Los Angeles Art
Association, and the Louisville Visual
Art Association.
PAGES 200–1, 254, 266–7, 300

Woodward, Thomas
1801–52
English artist, born in Worcester.
Woodward trained under Abraham
Cooper, a celebrated sporting artist.
He is best remembered for his
historical scenes (*The Battle of
Worcester* and *The Struggle for the
Standard* are his most famous works),
but he was also employed by Queen
Victoria (1819–1901) to paint some
of her dogs.
PAGES 52–3

Yaskulka, Hal
b. 1964
American artist from Brooklyn, New
York. His varied repertoire includes
portraits, landscapes, murals for
public spaces, and graphic work
for record labels.
PAGES 264–5, 286

picture credits

Collection 58, 76, 77 / Thorvaldsens Museum, Copenhagen, Denmark 228 / Tretyakov Gallery, Moscow, Russia 99 / Galleria Nazionale dell' Umbria, Perugia, Italy 195 / Rafael Valls Gallery, London, UK 30, 126, 252 / Victoria & Albert Museum, London, UK 25, 73, 127, 150, 204 / Wallace Collection, London, UK 49, 213, 296 / Walters Art Gallery, Baltimore, Maryland, USA 251 / Wingfield Sporting Gallery, London, UK 16–17, 27 / Wolverhampton Art Gallery, West Midlands, UK 100–101 / Christopher Wood Gallery, London 381 / York City Art Gallery, North Yorkshire, UK 52, 174, 376;

NOHRA HAIME GALLERY
New York, p 348;

HULTON GETTY
pp 54–55, 142, 185, 188–189, 203, 212, 243, 246, 247, 280, 281, 293, 361;

LIZARDI/HARP GALLERY
Los Angeles: Carlos Almaraz p 122 / Robert Bissell 288 / Theophilus Brown 86 / Jo Ann Callis 69, 345 / Maravillas Carrion 60, 87, 285 / Greg Chadwick 81 / Michael Chapman 108 / Wes Christensen 265 / Miguel Conde 131, 357 / Jorg Dubin 261 / Moira Hahn 258 / Gaylen Hansen 3, 45, 66, 79, 121, 147, 164, 177, 350, 370 / Chuck Huang 340 / Mayde Meiers Herberg 82, 316 / Laurie Hogin 336 / Anthony Holdsworth 4 / Christopher James 88 / Leonard Koscianski 114, 135 / Richard Lopez 283, 294 / Ed Musante 349 / John Nava 287 / Robin Palanker 216 / Gerald Purdy 110 / Frank Romero 84, 158 / Pia Stern 80, 217 / Christopher Warner 111 / Marian Winsryg 200, 266–267, 300 / Hal Yaskula 264, 286;

TONY STONE IMAGES
pp 356 / Brian Bailey 18 / Daryl Balfour 140–141 / James Balog 156–157 / Gary Hush 120 / Timothy Shonnard 278 / Bob Torrez 347 / John Warden 134;

SUPERSTOCK
Christie's Images pp 273, 282 / Thomas Hager 112 / Diana Ong 113 / Private Collection/Christian Pierre 165.

© ADAGP, PARIS, AND DACS, LONDON 1999
pp 154, 169, 343, 383;
© David Hockney/photo Steve Oliver p 2.

TEXT ACKNOWLEDGEMENTS
For the following quotations:
"All along the moorland road…" by Patrick Chalmers, from "The New Anubis," by kind permission of Methuen Publishing Ltd; "In Bangkok at twelve o'clock" by Noel Coward, from "Mad Dogs and Englishmen," by kind permission of Methuen Publishing Ltd; "Asking a working writer…" by Christopher Hampton, © by Christopher Hampton 1977, by kind permission of Casarotto Ramsay & Associates Ltd; "I knew that a man who cares for dogs is one thing…" by Rudyard Kipling, by kind permission of A.P. Watt Ltd on behalf of The National Trust for Places of Historic Interest or Natural Beauty; "Of all the dogs that are so sweet…" by E. V Lucas, by kind permission of Methuen Publishing Ltd; "At one of the last dog shows…" by James Thurber. Copyright © 1955 by James Thurber. Copyright © renewed 1983 by Helen Thurber and Rosemary A. Thurber. Reprinted by arrangement with Rosemary A. Thurber and The Barbara Hogenson Agency.

Every effort has been made to trace all copyright holders and obtain permissions. The editor and publishers sincerely apologize for any inadvertent errors or omissions and will be happy to correct them in future editions.

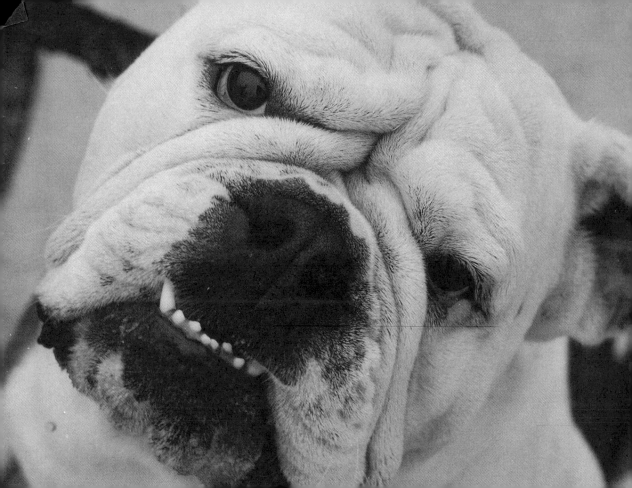